American Silences

American Silences

The Realism of James Agee, Walker Evans, and Edward Hopper

Joseph Anthony Ward

With a new introduction by
Richard Goodman

Transaction Publishers
New Brunswick (U.S.A.) and London (U.K.)

This book is printed on acid-free paper that meets the American National Standard for Permanence of Paper for Printed Library Materials.

Library of Congress Catalog Number: 2010018131
ISBN: 978-1-4128-1097-5
Printed in the United States of America

Library of Congress Cataloging-in-Publication Data

Ward, J. A. (Joseph Anthony), 1931-
 American silences : the realism of James Agee, Walker Evans, and Edward Hopper / Joseph Anthony Ward.
 p. cm.
 Originally published: [Baton Rouge] : Louisiana State University Press, 1985. With new introd.
 Includes bibliographical references and index.
 ISBN 978-1-4128-1097-5 (alk. paper)
 1. Realism in art--United States. 2. Art, American--20th century. 3. Agee, James, 1909-1955--Criticism and interpretation. 4. Evans, Walker, 1903-1975 1955--Criticism and interpretation. 5. Hopper, Edward, 1882-1967 1955--Criticism and interpretation. I. Title. II. Title: Realism of James Agee, Walker Evans, and Edward Hopper.

N6512.5.R4W37 2010
700.973--dc22

 2010018131

#495276805

TO MARGARET AND ELIZABETH

We live in an age in which the impact of materialized forces is well-nigh irresistible; the spiritual nature is overwhelmed by the shock. The tremendous and complicated development of our material civilization, the multiplicity and variety of our social forms, the depth, subtlety, and sophistry of our imaginative impressions, gathered, re-multiplied, and disseminated by such agencies as the railroad, the express and the post-office, the telephone, the telegraph, the newspaper, and in short, the whole machinery of social intercourse—these elements of existence combine to produce what may be termed a kaleidoscopic glitter, a dazzling and confusing phantasmagoria of life that wearies and stultifies the mental and moral nature. It induces a sort of intellectual fatigue through which we see the ranks of the victims of insomnia, melancholia, and insanity constantly recruited.

THEODORE DREISER
Jennie Gerhardt

Leisure is a form of silence, of that silence which is the prerequisite of the apprehension of reality: only the silent hear and those who do not remain silent do not hear. Silence, as it is used in this context, does not mean "dumbness" or "noiselessness"; it means more nearly that the soul's power to "answer" to the reality of the world is left undisturbed.

JOSEF PIEPER
Leisure: The Basis of Culture

The author is grateful for permission to reprint the following, which appear here in slightly different form as parts of chapters one and three: "Silence, Realism, and 'The Great Good Place,'" Henry James Review, III (Winter, 1982), copyright 1982 by the Henry lames Society, reprinted by permission; "James Agee's Aesthetic of Silence: Let Us Now Praise Famous Men," in Tulane Studies in English, copyright 1978 by Tulane University, New Orleans, reprinted by permission; and "A Death in the Family: The Importance of Wordlessness," Modem Fiction Studies, XXVI (Winter, 1980-81), copyright 1980 by Purdue Research Foundation, West Lafayette, Indiana 47907, reprinted by permission.

Photographs by Walker Evans from American Photographs (New York, 1938) and Let Us Now Praise Famous Men (New York, 1969) are part of the Farm Security Administration Collection in the Prints and Photographs Division of the Library of Congress, Washington, D.C. 20540.

Reproductions of the Edward Hopper paintings used herein were published previously in Edward Hopper: The Art and the Artist (New York, 1980).

Contents

Illustrations

Introduction to the Transaction Edition

T HE TITLE OF THIS book is somewhat misleading. While *American Silences: The Realism of James Agee, Walker Evans, and Edward Hopper* by Joseph Anthony Ward, is, indeed, about these three artists, there is also a chapter—the second longest in the book—devoted to Sherwood Anderson and to Ernest Hemingway, and another, the book's first short chapter, devoted to Edgar Allan Poe, Herman Melville, Henry James, and Henry Adams. So, I take the heart and soul of *American Silences* to concern Anderson, Hemingway, Agee, Evans and Hopper—the order in which they appear in the book. The link is too strong among these artists. And the coupling too informative.

So, we have three writers, one photographer and one painter, and they are all of them distinctly American in a way that Melville, Poe, Adams, and, especially James, are not. Sherwood Anderson was raised in Clyde, Ohio; Ernest Hemingway in Oak Park, Illinois; James Agee grew up in Knoxville, Tennessee; Walker Evans was from St. Louis; and Edward Hopper was from Nyack, New York. Three Midwesterners, one Southerner, and the lone Easterner, as opposed to the all-Eastern contingent of Melville, Poe, Adams, and James. I think it no accident that our greatest writers in the first twenty or thirty years of the twentieth century were from the heart of the heart of the country. This would include Theodore Dreiser, who was from Indiana, and F. Scott Fitzgerald, who, regardless of his fascination with Eastern wealth, was still from Minnesota.

It's no accident, because the Midwest, and Agee's mountainous South, were far from the gloss and worry of eastern cities and their desire to be

like European capitals. The Midwest was, and is, straightforward, un-adorned, plain, and simple. And certainly filled with silences. These qual-ities show clearly in the work of Anderson, Hemingway and Evans. And in Hopper, as well, who, save for his love of salt water landscapes, could have been from the Midwest. Agee has the baroque influence of a state where more battles were fought in the Civil War than any state other than Virginia. He was born a mere forty-six years after Union troops wrested the city of Knoxville from Confederate forces. You do not grow up in such an atmosphere—the city would have had Confederate veterans' stories for the boy Agee to listen to—without death and drama in your blood.

These men have had great influence on American art—save, I think, for Agee, who in this writer's opinion is *sui generis,* one of a kind, and nearly inimitable. I would say that if any of his work has influenced generations that have followed, it would be his film criticism, and not his novels, and not *Let Us Praise Famous Men*—a collaboration, as we know, with Walker Evans—which is a tortured, rambling book. Ward calls it "an irritating book." And in fact, Ward begins his chapter on Agee by quoting from his film criticism. But Anderson, Hemingway, Evans, and Hopper—what marks they left, and how they influenced those that followed, and continue to do so.

William Faulkner called Sherwood Anderson, "the father of us all," with Mark Twain being the grandfather. Anderson befriended Faulkner in New Orleans and offered to convince his publisher to take Faulkner's first book, "if," Anderson stipulated, "I don't have to read it." Anderson's fame rests mostly on his book of linked short stories, *Winesburg, Ohio* and on a second book of stories, *The Triumph of the Egg.* The former is his masterpiece. Even Hemingway, who would later ignominiously betray Anderson's kindness to him by parodying his work, wrote, "I liked some of his short stories very much. They were simply written and some-times beautifully written and he knew the people he was writing about and cared deeply for them."

Indeed, *Winesburg, Ohio* is a book about ordinary people, many of them emotionally disabled, whose losses and tragedies are just as, if not

more, universal, than, say, a sea captain's obsession with a white whale or a Puritan's minister's adultery and grand deception. When, for instance, Alice Hindman, in the story "Adventure," finally realizes that her lover of long ago will never come back to marry her, she goes temporarily mad, only to retreat to her room, "and turning her face to the wall, began trying to force herself to face bravely the fact that many people must live and die alone, even in Winesburg." We meet these people today. We know them. We may be one of them. Anderson wrote of the great ordinary struggles to live this life without deception and with courage and how hard that is to do and how sad it is when it doesn't happen. His stories were true when they were published in 1919, and they are still true nearly a hundred years later. Anderson wrote, in his mentee Faulkner's words, about "courage and honor and hope and pride and compassion and pity and sacrifice."

Ernest Hemingway met Sherwood Anderson in Chicago in 1920. When Hemingway decided to go to Paris to live with his new bride, Hadley, Anderson provided him with letters of introduction to Gertrude Stein and other writers. It was in Paris that Hemingway the journalist became Hemingway the writer. This is where he wrote *In Our Time,* his groundbreaking book of short stories, and where he wrote *The Sun Also Rises,* the book that catapulted him into public view and brought him fame. It was published in 1926. This was also the year that Hemingway published a novella titled, *The Torrents of Spring.* This is his parody of Anderson that he wrote because "When he [Anderson] wrote a novel called *Dark Laughter,* so terribly bad, silly and affected that I could not keep from criticizing it in a parody." This does not seem to me to be a sufficient reason to stab someone in the back who helped you take your first steps as a writer. Especially for so young a writer. Was this because he wanted to shake off any talk of influence Anderson might have had on his writing—and can't we see that influence? I suppose Anderson has his small revenge in that probably not a single person outside academia has read this book, but there is no doubt it hurt Anderson at the time.

People who delve into Hemingway's life will discover this tawdry episode, but they may not know that Faulkner was guilty of the same

crime. He was part of an effort called *Sherwood Anderson and Other Famous Creoles* for which he wrote an introduction. Faulkner says of his and Hemingway's acts that "we had made his style look ridiculous." At least Faulkner was contrite and wrote movingly and sincerely about Anderson's talents in "Sherwood Anderson: An Appreciation," an essay that appeared in *Atlantic Monthly* in which he says that Anderson was "a giant in an earth populated by pigmies."

It's difficult to add anything significant to what has already been written about Ernest Hemingway's work. Except to say that having revisited his work again and again and yet again, it is clear that he was, quite simply, a great writer. His final triumph, I think, is his style and his commitment to words and his energized simplification of American writing. "This was a man to whom words mattered," wrote Joan Didion. "He worked at them, he understood them, he got inside them." It's ironic that Hemingway has come to be parodied far more than Anderson, and when one reads a book like *Across the River and into the Trees*, with its painfully repeated, awkwardly expressed declarations of love—not to mention the "did the earth move" scene in *For Whom the Bell Tolls*—we can see why. But anyone with any sensitivity to language, to how difficult it is to negotiate with, as Billy Collins put it, "an essentially uncooperative language," will realize how fine a writer Hemingway was, and is.

It's somewhat of a mystery to me why so many people take Hemingway's simplicity for childlike writing. I think everyone who believes this ought to have a look, or another look, at his late book, *The Old Man and the Sea*. This book, which so many high school students have been required to read, is easily mistaken for, well, a book solely for high school students. With its uncomplex relationship between an old fisherman and ʼ a young boy, and its endless uneventful days on the water in a rowboat and its finally futile battle with sharks over a large marlin the old man has caught, it seems, on the surface, thoroughly unremarkable. Everything is here and ready for the critics, even for the ordinary reader, to scoff at. What a silly thing to devote a book about—even a short one!—a man out fishing alone. Well, delve. Read. Look.

What you will see is that in many ways it is precisely this non-event-fulness that makes Hemingway's writing here so impressive. As Flaubert wrote, "But it takes more genius to say, in proper style: 'close the door,' or 'he wanted to sleep,' than to give all the literature courses in the world." No one described the ordinary—or, rather, the unextraordinary—better than Hemingway. The first paragraph of *A Farewell to Arms* is often cited, with its description of a dusty, leaf-strewn road, as pure poetry. You can find many more such passages throughout his work. But nowhere is there such an abundance of these kinds of descriptions as there is in *The Old Man and the Sea*, and it is simply wonderful. Here's a characteristic short passage from the book. The old man has been alone out at sea for a while:

> He looked across the sea and knew how alone he was now. But he could see the prisms in the deep dark water and the line stretching ahead and the strange undulation of the calm. The clouds were building up now for the trade wind and he looked ahead and saw a flight of wild ducks etching themselves against the sky over the water, then blurring, then etching again and he knew no man was ever alone on the sea.

In reviewing Hemingway's *Letters* in 1981, John Updike, reacting to Hemingway's "braggadocio, brutishness and bathos" in those letters, cautions the reader to read some of his novels as an antidote. There, Updike writes, "The distilled—the fine and good and true and lovely—Hemingway is to be found in the writing he published in books, just where he said it would be."

American Silences, as J.A. Ward writes in his preface, "originated as a study of James Agee." So we can sense Ward's devotion to this artist. Agee, though, is somewhat of a puzzle. *A Death in the Family,* his autobiographical novel and winner, posthumously, of the Pulitzer Prize, has never become as well known or universally respected as one might believe the chief work of a major American artist would be. Why is this, one might ask? Well, perhaps because Agee is not a major American artist, but, rather, a fine writer at the second level of American writing. There is certainly nothing wrong with that. This writer has had one of his books described as a "minor gardening classic," and was extremely

pleased to receive that accolade. The operating word here is "classic." There well may be a major renaissance in the appreciation of James Agee's work, and I am always heartened to see neglected, but deserving artists achieve their rightful place in the collective consciousness. And in a way, I hope I'm mistaken about my assessment of Agee's work. I suppose, too, you could say that he ranks higher than Anderson and produced more good work than Anderson, but when talking of influence, I would have to go with Sherwood Anderson.

James Agee of course was not only a film critic but a screenwriter as well, most famously for *The African Queen*. I think his writing on film is one of the high marks of American critical writing, and *Agee on Film,* his collection of film criticism is still a marvel to read—elegant, informed, passionate, and thoroughly readable. But in many ways I count one of his finest achievements his providing a way for Walker Evans to take his marvelous photographs of sharecroppers and their families that appear in *Let Us Now Praise Famous Men.* This I am sure is a sacrilege to any Agee fan, but what American photographs have become more indelible in our hearts and minds than those Walker Evans took in the summer of 1936 on an assignment for *Fortune Magazine* in Hale County, Alabama?

Walker Evans did in those photographs what Agee so agonizingly tried to do in his prose: he honored those destitute men and women, made them noble, even, without exploiting them, without robbing them of their souls. Agee's prose is so guilt-ridden that the reader flees after a while, unable to stand more of his self-flagellation, and falls into the confident, able arms of Walker Evans. The reader of *American Silences* will be grateful that there are some reproductions of Evans' photographs, but, in truth, he or she should turn directly to *Let Us Now Praise Famous Men* for a fuller impact of Evans' great accomplishment. *Fortune* declined to run the article, so Agee expanded it into a book, and it was published in 1941. It sold just 600 copies, but that, fortunately, was not the end of it. It's in print today, and hopefully will remain so forever. It's not that there aren't lyrical and highly memorable passages in the book. It's that what most people take from *Let Us Now Praise Famous Men,* what

stays with them, haunts them, are the careworn faces, the absolute bottomed-out fatigue of these people, and the idea, for example, that here, in America, a married woman and mother would be reduced to wearing a burlap sack as a dress and to be without shoes. That, and much else, is what we are grateful to Walker Evans for showing us, for revealing to us.

Walker Evans of course showed us more than sharecroppers. In 2000, the Metropolitan Museum of Art in New York mounted the first major retrospective of Walker Evans' work. I was fortunate to attend this exhibition, and I remember one of my strongest feelings being how pleased I was to see the skill and compassion found in *Let Us Now Praise Famous Men* coursing through all his work, including, of course, his own must famous book, *American Photographs*. I strongly suggest anyone interested in learning more about Evans to go to the Metropolitan Museum's website and search for the exhibition.

The painter Edward Hopper is linked to these men in his directness. Anderson, Hemingway and Evans—and Hopper—all looked *directly* at their subjects. There is an absolute immediacy to their work, but what Hopper has, aside from all things painterly he brings to his art, is a sense of melancholy, of the unknowable, something akin to the ineffable sadness we find in Japanese poetry. Has any American painter—has *any* painter—ever depicted loneliness, or, perhaps more accurately, aloneness, as definitively as Edward Hopper? Has anyone better shown us, and more beautifully shown us, how we live and die alone? Here, Ward's concept of silence comes into its own. Because when we look at a painting by Edward Hopper, we sense no sounds at all. It's always a silent world—whether it's a solitary house, a storefront, an empty room, or two people sitting near one another, neither acknowledging the other exists. Hopper, though, never leads us to despair in his art, however, because he paints so gorgeously.

No one that I know of took daily life and turned it into the most breathtaking art better than Hopper did. I would suppose the most famous painting of his is "Nighthawks," that study of light and loneliness in an all-night diner. You also may remember his portraits of people in hotel rooms, of people sitting disconsolately on beds, of people staring vacant-

ly from chairs on porches. Hopper also frequently painted the facades of ordinary buildings in ordinary towns. He seems almost deliberately *not* to have chosen dramatic events as his subjects. Just look at the titles of his paintings: "Drug Store," "Gas," "Railroad Train," "August in the City," "Summertime," "Hotel Lobby," "Barber Shop," "East Side Interior," "Hotel Room."

These subjects suited his dedication to, and fascination with, light. He painted the light of dusk, of early morning, of night, and, most difficult, of midday. Again, some titles: "Seven A.M.," "Early Sunday Morning," "Morning in a City," "High Noon," "Cape Cod Afternoon," "House at Dusk," "Night Shadows." He seemed to have given himself the task of painting the light of every hour in a day, and may, in fact, have done just that. And what a love affair he had with lines and angles, with the geometry of shapes!

Now, one of the first things you notice here, it seems to me, is that the subjects are very ordinary. People in a diner late at night. A woman usher taking a break in a theater. A woman seated by herself having a cup of tea or coffee. A couple in their apartment building, seated, the man reading the paper. A man at a gas pump. An empty street in the early morning. A woman seated on her front porch. Moody, reflective, mysterious, measured, lonely—yes, lonely—but painted so gloriously, with such a grasp of color and of composition. They also seem to reach us very deep within, to a place where all of us are a bit lonely, and a little afraid, and very human. They celebrate life through their beauty, and yet they point out the fragility of it, too.

The great gift J.A. Ward bestows on us is to bring these visual and verbal artists together, something that is all too infrequently done. We Americans are great categorizers and labelers, and we feel each type should be with its own, snug and safe. So we put writers with writers and painters with painters, and so on, and write about them within those boundaries. But that's not how *we* assimilate art, only by genre. Everything contributes to our aesthetic sensibility and to our understanding of art, with a capital A. And it's good to bring this out in the open. And, finally, it's good to see the wealth of great art America has produced, and that this book honors so well.

Richard Goodman

Preface

THIS BOOK originated as a study of James Agee. My vague first intention was to uncover the unifying principle of Agee's diverse writings. The approach was to be through an untangling of Agee's attractions to different genres, particularly his enthusiasms for music, the movies, and photography and his complementary discomfort with language and writing, especially prose. In studying Agee's fiction, journalism, film criticism, film scenarios, polemics, letters, and the unclassifiable *Let Us Now Praise Famous Men* and looking for connections, I was astonished by his obsession with silence. Clearly the experiencing of silence—in actuality and in art—was of the utmost value and importance to him. Silence is the condition of photographs, of early movies, and of the extended observations of static scenes that dominate *Let Us Now Praise Famous Men*. It is also the mode of being that mysteriously lures the major characters of Agee's two novels. *Silence* is Agee's most recurrent, most significant, and most honorific word; it provides him a standpoint of stability and even of sublimity from which to observe the distressing but never finally threatening chaos of noise that, to Agee, characterized the age in which he lived.

After writing two essays on Agee—on the aesthetic of silence in *Let Us Now Praise Famous Men* and *A Death in the Family*—I realized that the next logical step would be to look for similar enthusiasms in other American writers of Agee's time. But such a concern for silence was difficult to find in other literary artists. Indeed the major American novelists contemporary with Agee—Fitzgerald, Dos

Passos, Faulkner, Hemingway, and Wolfe—seemed uncritically attracted to a representation of speech and the other sounds that conventionally dominate modern realistic fiction. In twentieth-century American literature I was aware only of the occasional celebrations of silence in certain philosophical and meditative poets, mainly Stevens, Eliot, and Frost. Although Agee himself may be regarded as essentially a poet—even in, if not especially in, his prose—I was interested in him as a social realist. His paradoxical sensibility sought both to report the visible and to absorb the inaudible. But Agee's way of possessing both the ephemera of phenomena and the permanence of silence was not to be found in the poets. My subject, I began to realize, was not silence in literature but silence in realism. In twentieth-century American fiction the clearest affinities to Agee seemed Sherwood Anderson and Ernest Hemingway, especially in their early short stories. Although neither Anderson nor Hemingway possessed anything like Agee's religious estimation of silence, they seemed drawn to silent characters and disposed to a sympathetic view of withdrawal from social engagement. Also, Anderson's "grotesques" and Hemingway's Nick Adams were much bothered by the problem of communicating through speech. In their negative attitudes toward speech Anderson and Hemingway seemed to anticipate Agee more than their own later work.

But if the study of Agee led indirectly to Anderson and Hemingway, it led directly to Agee's collaborator, the photographer Walker Evans. From Evans it led to the painter Edward Hopper, whose pictures of houses and urban scenes sharply suggest those of Evans. Like Evans, Hopper is an artist who forcefully isolates the documentary-like representation of the contemporary American scene from the almost unavoidable suggestions of sounds, social energies, and temporal processes invariably found in the works of Hopper's contemporaries who paint similar subjects. The aesthetic of silence in realism is more likely, or less awkwardly, found in certain visual artists than in prose writers, for silence can more directly be represented pictorially than described verbally. Nevertheless the relation of Evans to, say, Lewis Hine or Weegee and of Hopper to Charles Burchfield is almost

exactly analogous to the relation of Agee (in *A Death in the Family*) to Thomas Wolfe (in *Look Homeward, Angel*). The artist of silence stresses the noiselessness and stasis rare in social realism, and gives to them the highest status.

This book is essentially about Agee, Evans, and Hopper—three fundamentally realistic artists whose art ironically emphasizes silence, usually an irrelevance in realistic art. The method is mostly the close analysis of specific works of fiction, documentary prose, photography, and painting that in various ways concern themselves with silence or use a technical mode distinctly analogous to silence. Thus I consider silence as both a method and a subject, though when it is a method, it is also a subject.

The first two chapters should be regarded as background. The Introduction is a mostly speculative and theoretical introduction to the psychological and metaphysical implications of silence in realistic art. Chapter One is a brief consideration of the place of silence in some nineteenth-century American authors, especially Poe, Melville, James, and Adams. These earlier American writers use fantasy and myth to suggest an eternal silence remote from commonplace experience. In the twentieth century, the subject of the eternal is largely abandoned, as novelists and painters turn to the social scene as their major subject. My interest in Agee, Evans, and Hopper derives from their novel and ironic revival of certain nineteenth-century attitudes toward silence and the sense of the eternal that it conveys. Anderson and Hemingway, the subjects of Chapter Two, manifest a discontent with the dominant noisiness of the culture and literature of their time, but Agee, Evans, and Hopper convert this nonreflective dismay into the basis of an original and coherent art.

Acknowledgments

I T IS A special pleasure to acknowledge gratitude to my colleague Alan Grob for his unfailing kindness and encouragement, as well as his careful reading of an earlier version of the manuscript. His suggestions for revision were of great help. I also wish to thank Ed Snow, another Rice colleague, for his useful comments on the chapters on Evans and Hopper; Al Gelpi of Stanford for his interest and recommendations; and Robert Ford, who assisted me in a number of ways, especially in securing permissions to reproduce photographs and paintings. Rice University has been generous in supplying funds for typing and photographic reproduction, and I am much indebted.

AMERICAN SILENCES

Introduction

AMERICAN REALISM AND THE AESTHETIC OF SILENCE

BEGINNING with Cervantes, realistic novelists and painters as well as aesthetic theorists have seemed compelled to define "realism." The continuation of the effort indicates the continuation of the failure, for the term *realism* must always remain in philosophical bondage to the term *reality*. Most definitions agree that a realistic work of art is a true representation of men or things, but an absolute, restrictive, and exclusively aesthetic definition of the concept is an impossibility. The most convincing definitions have always indicated not what realism is, but what it is not. Again beginning with Cervantes, realists have most often arrived at an understanding of the real by challenging the realism of traditional subjects or modes of art. To many, bad art is unrealistic art, just as all art is defended by its admirers for being, in some way, realistic. Nearly all realist theory insists on the priority of an objective or nearly objective fidelity to

. . . The extreme of the known in the presence of the extreme
Of the unknown.
WALLACE STEVENS
"To an Old Philosopher in Rome"

1

the phenomena of common social experience. In asserting this prime dictum, George Eliot's attitude is not just typical, but canonical: "Let us always have men ready to give the loving pains of a life to the faithful representing of commonplace things."[1] The problem of definition quickly emerges, however, when the theorist qualifies or supplements the central idea—as George Eliot does through the word *loving*, which indicates the attitude toward the commonplace subject that she feels the artist should convey. The attitude of other realists, such as Flaubert and Zola, toward their material is other than "loving."

Realists widely differ on the question of the validity of artistic and philosophical elements often judged antagonistic to realism. Cervantes himself initiates the problem by not entirely rejecting the aristocratic idealism that his novel seems intended to ridicule. *Don Quixote* is not an unqualified endorsement of Sancho Panza's materialism; the nobler human aspirations that the book implicitly values can be specifically located only in the moral and psychological sources of the absurd chivalric romances explicitly mocked. Although idealism fosters a preposterous (unrealistic) literature, the ethos of idealism—as embodied in Don Quixote—is not only commendable but apparently indispensable for the fulfilled life.[2] Like moral idealism, aesthetic formalism is also conventionally judged an enemy of realism because it is assumed that reality is formless. But form is of first importance in the fiction of Flaubert, James, and Joyce. James held that the ability to produce the "illusion of life" is the "supreme virtue" of fiction, "the merit on which all other merits . . . helplessly and yet submissively depend."[3] Of course, to James aesthetic form ranks supreme among the "other merits," as other qualities do to other novelists. A common theme that runs through writings on modern literary realism is the efforts of various novelists, critics, and

1. George Eliot, "On Realism," in George Becker (ed.), *Documents of Literary Realism* (Princeton, 1963), 116.
2. See Erich Auerbach, *Mimesis*, trans. Willard Trask (New York, 1957), 293–315.
3. Henry James, "The Art of Fiction," in Leon Edel (ed.), *The Future of the Novel* (New York, 1956), 5.

theorists to reconcile realism with such relative intangibles as the personality of the artist, a perspective of history, a moral sense, the psychology of the unconscious, optimism or pessimism, aesthetics, and metaphysics.

From about 1870 to 1920 the critical dispute over realism focused on the naturalism of Emile Zola. In that debate—and not solely in Anglo-American literary quarters—most of the opinions approved of the extension of the field of the novel to the Zolaesque social depths but opposed what was judged a realism that denied the existence of free will, the entire realm of human consciousness, and the appropriateness of artistic form. Even after the Zola furor, the essential hostility toward naturalism remained, as the subject of naturalism continued to provide the justification for attempts to defend realism. Writing in 1944, Hector P. Agosti, in words reminiscent of William Dean Howells a half century earlier, vigorously defended realism but felt compelled to repudiate the "flat and soulless" realism associated with Zola: "Unlike a realism in the modern sense of the word, it was rather a verism caught in the surface of phenomena. Its adherents sought the truthful representation of the phenomenon, without recognizing that the phenomenon is scarcely more than the external, sudden, and fluid revelation of a more profound and stable reality. They took their position before reality as if it had to give itself passively and simply in a spontaneous and automatic reflection."[4]

And according to Samuel Beckett, Proust despised the "grotesque fallacy of a realistic art . . . the realists and naturalists worshipping the offal of experience, prostrate before the epidermis and the swift epilepsy, and content to transcribe the surface, the facade, behind which the Idea is prisoner."[5] Most theorists of realism would probably agree more readily with Proust than with Agosti. They would say that a realism urging total artistic passivity before raw phenomena is a fallacy, an impossibility. Still, Agosti's broad distinction between an undiscriminating absorption of data and "a more profound

4. Hector P. Agosti, "A Defense of Realism," in Becker (ed.), *Documents of Literary Realism*, 492.
5. Samuel Beckett, *Proust* (New York, 1957), 57, 59.

and stable reality" (Proust's "Idea") has become a de facto doctrine—for both theorists and creative artists.

In the context of American literary thought, the terms of the antithesis have markedly altered in recent years. In the age of Howells and James and then of Irving Babbitt and T. S. Eliot, critical judgment insisted on the inclusion of the moral and even the religious faculties within the accepted realist fabric of plausibility, verisimilitude, and the broad consensus of what constitutes actual human experience. Of late the moral and the religious faculties have largely been displaced by the psychological. Specifically, recent definers of the elusive or the metascientific dimension in realistic art have been stimulated by the modernist fascination with the irrational and antisocial self, which refutes the implicit conception of the self required by traditional (if never fully achieved) realistic works of art. From different directions many contemporary critics maintain that the idea of the human being that is essential in novels—that is, in works of fiction assuming a coherent relation between man and an intelligible society—is itself unrealistic. The concepts of character, emotion, and motivation that may be appropriate for examining Jane Austen or Trollope must fail to account for the behavior of certain figures in Dostoevski, Lawrence, and Faulkner.

As Edwin Cady and others have pointed out, realistic fiction inevitably developed into psychological fiction: "The more one confronted the mystery of persons living out their fates and struggling toward death, the more his scrutiny turned from the outward sign to the inward process."[6] And as critics such as Lionel Trilling, Geoffrey Hartman, and Leo Bersani have directed our attention to this "inward process"—in nineteenth- as well as twentieth-century writers—we have become more conscious of a pervasive division in the novel between the pressure of social organization (emphatically including the definition of man assumed by social organizations) and the anarchic, radically independent, and hardly definable needs and passions that govern some of the most interesting protagonists of Western fiction

6. Edwin H. Cady, *The Light of Common Day* (Bloomington, 1971), 13.

of the last two hundred years. Thus Bersani examines "Realism and the Fear of Desire," the inability of the realistic novel to assimilate the chaotic energies of some of its own most assertive characters, including Vautrin, Julien Sorel, Captain Ahab, and Maggie Verver.[7] Bersani's argument in effect amounts to a reformulation of the traditional need for apologists of realism to locate a quality in realism more sublime, at least more sophisticated and more "humanistic" than the rather prosaic, if complicated, texture of ordinary human experience in society.

In any case, it would seem that any defensible idea of realism—any theory of representational art—must acknowledge some kind of dialectical tension or even contradiction. Simply stated, the realistic novel, like the realistic painting, has always resisted its own inclinations toward an uncritical representation of commonplace social experience. Nor has the force of resistance primarily been for the purpose of achieving a coherence: more often (or, if not, more interestingly) it has had the opposite effect.

The indispensable substance of realism is observable phenomena; historically, the emphasized phenomena in both literary and visual realism are public activities and individuals in social situations. But these phenomena—so a variety of conflicting theories maintain—must subserve or at least accommodate an ideology, an aesthetic, or an attitude toward experience that sometimes organizes and always transcends the "mere" play of phenomenal energies. Thus we notice a continuing effort to justify realism by modifying its suspected naturalistic tendencies (though the naturalism of Zola, Norris, and others is itself an explicit ideology—scientific determinism). It is not completely frivolous to distribute such labels as Marxist realism, Christian realism, formalist realism, romantic realism, humanist realism, and existentialist realism—all well-recognized, if indistinct, genres. In a sense all of these are realisms that challenge the presumed dominance of what each regards as a shallow or simply naïve realism. The antagonism toward an absolute realism generally follows the ar-

7. Leo Bersani, *A Future for Astyanax: Character and Desire in Literature* (Boston, 1976). See especially Chapter 2.

gument that objectivity in art is both a pointless and an impossible achievement.

In large measure contemporary taste has directed attention to those works—usually considered realistic—that contain or otherwise indicate impulses that, if not inconsistent with the usual conception · of realism, strain against the conventional assumptions about the preeminence of accurate social observation in art. Some of the most important criticism of American literature has explored the dichotomy between the apparent and the actual content of the major American books—the still provocative issue first developed by D. H. Lawrence in *Studies in Classic American Literature.* The study of American literature continues to explore from various directions the disaffection of novelists with realism and their often awkward and ingenious efforts to force realism to do what it is assumed to be incapable of doing—to challenge the absolute identification of the real with the phenomenal. American writers of the nineteenth and twentieth centuries seek to accommodate realism with symbolism and allegory, with a preference for solipsistic and mystical characters, with a conception of freedom and self almost incompatible with social identifications.[8] Hawthorne clearly represents a major problem felt by many American novelists when he frankly confesses an inability to write like Anthony Trollope—that is, to be comfortable with a totally social and visible rendering of human life. Doubtless the source of the American discomfort with the realist aesthetic is the Puritan conviction that the phenomenal is important only when symbolic—that the spiritual and the eternal count far more than the material and the temporal. As has often been demonstrated, this Puritan strain fuses rather easily with nineteenth-century romanticism. Indeed it continues to act as a strong resistant to the realism that largely governs American fiction and painting of the first half of the twentieth century—nowhere more evidently than in the artists discussed herein.

8. The influence of Emerson in American fiction has been thoughtfully examined by Richard Poirier in *A World Elsewhere: The Place of Style in American Literature* (New York, 1966), *passim.*

These artists form a body of twentieth-century American realists who in complementary ways extend the familiar nineteenth-century tension between a realistic valuation of common experience and a transcendental (or otherwise mystical) passion for enduring meaning. The tension exists obviously in Hawthorne and Melville and less obviously in Twain and James. In examining certain works of Sherwood Anderson, Ernest Hemingway, James Agee, Walker Evans, and Edward Hopper, I find a shared preoccupation with silence—the literal silence of people who do not speak, of mute and static objects, of stillness achieved by artistic modes that abnormally, even radically, eliminate motion and sound. In the works of these artists, the dialectic that I have been discussing is the provocative and unresolved tension between the most conventional categories of realism and an explicit scorn for the "hubbub of voices" that provides the evident force of much realism.[9] Sound is at best a superficial irrelevance to significant experience and in most cases a destructive distraction from accurate perception. The fervor for silence cannot be fully assimilated to the rationalizing and normalizing impulses of realism, and in this respect the artists I discuss are comparable to those novelists—of late much exalted—who locate protagonists of an Emersonian or Nietzschean disposition in the center of otherwise realistic fictions. But in the artists I deal with, the unassimilable element is not anarchic or even passionate. Rather it is a quietism, a passivity approaching a nearly inhuman humility.

I attempt not to define a genre or reveal a new pattern in American art, but to pay some attention to certain books, photographs, and paintings, mostly from the first half of the twentieth century, that basically adhere to what I understand to be the techniques and philosophy of realism and yet preeminently deemphasize, challenge, or eliminate what is usually a very important element in realism. I refer

9. Henry James's description of Zola's novels stresses the extreme level of discordant noise in Zola's rendering of experience. The comment would seem applicable as well to a number of American realists, for example Crane, Norris, Wright, and Dos Passos: "The fullest, the most characteristic episodes affect us like a sounding chorus or procession, as with a hubbub of voices and a multitudinous tread of feet." Henry James, "Emile Zola," in Edel (ed.), *The Future of the Novel*, 111.

to sound, usually in the form of speech but sometimes in the form of the mere discordant noise that is a steady presence in American society. The works that I consider achieve an essential disassociation from the incoherent noisiness of American society, from public rhetorical preachment, and from speech itself. However, at the same time they conform to the most exacting requirements of verisimilitude. They assume man to be essentially a historical creature. Their literary style is closely observant prose and their visual style is graphically prosaic.

The paradox manifested by the various artists of silence is easily illustrated by the ambivalent status of dialogue in Hemingway's short stories. Hemingway's dialogue is rambling, casual, trivial, often pointless—and amazingly lifelike—but the moral and psychological emphasis of the stories refutes the implied importance of conversation as a release from isolation or even a way of communicating opinion. The bias of realism assumes that dialogue conveys reality and meaning; Hemingway's celebrated dialogue seems to have a hieratic stature but in fact almost always directs attention to the inadequacy of dialogue itself. I attempt to illustrate versions of the same paradox in all the literary and visual artists being considered. Despite their great differences, including differences in philosophical conviction, their similarities in this respect are crucial.

These artists share a broad assumption that speech and other disturbances of silence are less than contributive and are even destructive to the sense of American experience that each distinctively · possesses. Authors of novels, stories, and essays in which silence carries more authority than speech and makers of pictures who are drawn to unusually still subjects are necessarily ironists. In depriving their art of the dimension that is surely essential to most social realists on the order of Sinclair Lewis, John Dos Passos, John Sloan, and Helen Levitt, they compel a different perspective on the same subjects, themes, and attitudes that rule the mainstream art.

The irony of the aesthetic of silence may ultimately originate in the historical tendency of realism to undermine its own assumptions about the significance of ephemeral data in vast accumulations.

Flaubert's contempt for his subjects may not be an elitist aberration but a sign of a central disposition. Erich Heller argues that classical realism contains a nihilistic impulse: "The 'realistic' sense of reality which possessed so many minds in the nineteenth century was such that it lured them towards the rational conquest of the human world only in order to prove to them its absolute meaninglessness. Hence it is that the temper of realistic writing is pessimism, at best that pessimistic humour which makes for realism's finest appeal, at worst frustration and *ennui*. It was this pessimism that Nietzsche saw as the surest sign of a nihilistic age in the making."[10]

These potential implications of realism are made sharply apparent in an art that insistently challenges the values of sound with those of silence. The meaning is always that sound is unimportant, that the phenomenon least capable of realistic rendering is the most important. The irony of Anderson, Hemingway, Agee, Evans, and Hopper always points to the superficiality of anyone (including readers and observers as well as fictional characters) who expects to find significance in sound.

However, these artists who deny the conventional primacy of speech otherwise conform to the most obvious canons of modern realistic art. Like all those literary and visual artists who undertake to document the first half of the twentieth century—generally called naturalists and realists—they intimately entangle their real and fictional characters with impersonal settings. The ruling spirit of social incoherence, industrialism, urbanization, business, and politics absorbs the personality and passions of individuals. Characters of writers from Dreiser through Dos Passos, and even from James to West and Faulkner, seek to fulfill themselves and to understand themselves through their desired and undesired complicities with social institutions and processes. So too the artists of silence conform to this dominant concept of realism, as defined by Georg Lukács: "Man is *zoon politkon*, a social animal. The Aristotelian dictum is applicable to all great realistic literature. Achilles and Werther, Oedipus

10. Erich Heller, "The Realist Fallacy," in Becker (ed.), *Documents of Literary Realism*, 596.

and Tom Jones, Antigone and Anna Karenina: their individual exis-
tence—their *Sein an sich*, in the Hegelian terminology; their 'on-
tological being' as a more fashionable terminology has it—cannot be
distinguished from their social and historical environment. Their hu-
man significance, their specific individuality cannot be separated
from the context in which they were created."[11]

In American realism of the 1920s and 1930s sound is a powerful
fact and metaphor, the expression of an especially brash, even vulgar
"social and historical environment." The sound of jazz is almost
uninterrupted in *The Great Gatsby* and many of Fitzgerald's other
works; it always proclaims the Jazz Age's requirement that emotions
of joy and sadness, of exultation and tenderness, be vulgarly blared
by saxophones. In a different but more obvious way, West's *The Day
of the Locust* is a fictional musical comedy: on nine occasions char-
acters break into song, with all the absurd artificiality of a Nelson
Eddy–Jeanette MacDonald duet. Dos Passos blends newspaper head-
lines, "the speech of the people," and the very public lives of his char-
acters into the miscellany of *U.S.A.* The ornate rhetoric of Wolfe and
Faulkner causes their works to be dominated by especially insistent
authorial voices; *The Sound and the Fury* would be an appropriate
title for any number of the novels by either man. Twentieth-century
American fiction tends to emphasize the need for articulation, and
thus the always interpretative Nick Carraway is a more represen-
tative narrator than the taciturn Jake Barnes. Emotions need to be
spoken, even screamed—as Darl Bundren at the end of *As I Lay Dying*
and Tod Hackett at the end of *The Day of the Locust* literally scream
to give expression to their agonies.

Even in works with quiet and sensitive characters in major roles,
the available modes of expression of these characters are often violent
acts (Joe Christmas), loud parties (Jay Gatsby and Jake Barnes), and
ranting soliloquies (Eugene Gant and Gail Hightower). Although sel-
dom approvingly, American realists from Dreiser through Dos Passos
have given much attention to garrulous characters—public speakers,

11. Georg Lukács, *Realism in Our Time* (New York, 1971), 19.

compulsive boasters, and near-hysterical ranters. Jim Pocock, Frank Cowperwood, Windy McPherson, George F. Babbitt, Tom Buchanan, Shrike, J. Ward Moorehouse, Oliver Gant, and Thomas Sutpen seem indeed to constitute a mythical American type, one much lamented by H. L. Mencken.

Speech and sound express the American bias toward power and action. In this respect realistic art simply images reality. In the visual arts the favorite subject of American realists has been the furious energy of the city streets. The dynamism of society (even when oppressive, barbarous, and self-devouring) is suggested by the illusion of undiscriminated motion and even the illusion of discordant noise in the paintings of Sloan, Henri, Bellows, Kent, and Marsh and the photographs of Hine, Weegee, and Levitt.

Noise is emphasized by nearly all of the important American social realists. If in some cases (as in the shouting boxing fans in a Bellows painting) it is associated with urban primitive vitality, in others (as in the grinding factories of Hine) it is associated with the brutality of industrialism. It may seem a facile or perverse reaction for some artists repelled by the bombastic and cacophonous strains of American culture to turn for relief to the positive value of silence. Such a disposition may have metaphysical foundations, but it is also an expression of severe social criticism, a radical rejection of the blatancy and falseness of a society and of a dominant art that seeks to reflect it in its own crude idiom. As an example, the aesthetic of silence would question the artistic strategy of Faulkner, whose assessments of a crazed society require the services of a rhetoric often itself raised to the highest pitch. "The Bear" certainly has its quiet moments, and Isaac McCaslin retreats into a private silence somewhat like that of Nick Adams in "Big Two-Hearted River." But the prevailing mode of the story is that of strenuous rhetoric. The philosophy of quiet piety and passive stoicism is paradoxically voiced in a rhetoric nearly tumultuous.

The main current of twentieth-century American realism elevates speech and motion to a higher status than did nineteenth-century European realism, perhaps with the exception of the novels of Zola. Par-

ticularly in naturalists like Dos Passos and the hard-boiled disciples of Hemingway, there is a stridency and violence almost new to the novel. Meditation and the description of static scenes—fixtures in the nineteenth-century novel—nearly disappear in such writers as Henry Miller and James T. Farrell. The inventions of the talking picture and the Speed Graphic camera symbolized and stimulated the cultural appetite for loudness and frenzy. As James Agee was insistently to complain, the possibility of sound in the movies led to the unfortunate dominance of sound in the movies. And when it became possible to take still photographs of rapid motion, pictures of suddenly frozen action became the standard style in American realistic photography.

The artists treated in this book reacted against contemporary styles of realism because they reacted against the culture that exaggerated the importance of speed, noise, and chaotic movement and against a popular (and sometimes sophisticated) art in alliance with these characteristics. With the exception of Evans, each of these artists developed his chosen career in opposition to an initial profession that was stereotypically American in its exploitation of a medium of communication for purposes of propaganda or titillation. It is appropriate that Anderson turned away from a career as a composer of advertising copy to write stories about passive and inarticulate outsiders. Hopper earned his money as a magazine illustrator; Hemingway and Agee were journalists. Agee's contempt for the American passion for publicity is notorious, but the sense of hostility and alienation is not much less obvious in the other artists as well. Likewise, directly or indirectly, each associated the shallowness of American culture with the noisy, the strident, and the mindlessly stimulating. Also, in repudiating sound, the art of each compels a recognition of the ignored but powerful presence of sound in the culture that they represent. By denying sound its usual status, they make us realize how loud our society actually is.

In reacting against the assumptions of the culture that surrounded them, each artist developed his own kind of quietism. But they all prefer the static to the dynamic. Whatever dramatic sense they have

tends to stress the potential of action and even the denial of action—
with its correlative, speech—as opposed to the achievement of ac-
tion. Thus there is a common disposition to focus on static objects to
an unusual extent—a subversive undertaking in a period of history
absorbed in the rapid motion of objects and the incoherent noise of
machines and persons. Evans' hundreds of photographs of parked au-
tomobiles and Hopper's many paintings of deserted city streets force
us to see as things what we are accustomed to see as actions.

The American practitioners of the aesthetic of silence have re-
covered in a kind of purity the old realist superstition that attributes
a quasi-sacred eminence to "the mute things that surround us most
closely."[12] As Harry Levin reminds us, "Etymologically, realism is
thing-ism. The adjective 'real' derives from the Latin *res*, and finds an
appropriate context in 'real estate.' The first definition of 'real' in
Johnson's dictionary, with a significant citation from Bacon, is bluntly
explicit: 'relating to things, not persons.'"[13] Accordingly we note in
Hemingway's "Big Two-Hearted River" a nearly fetishistic detailing
of the objects of a fishing expedition and in Agee and Evans' *Let Us
Now Praise Famous Men* a passionate attention to the material pos-
sessions of the farm families—as though the significance of both the
fishing experience and the tenant farmers' lives could only be con-
veyed through the indirect approach of representing the things that
ordinarily would be ignored. One must distinguish here between the
preoccupation with things as the properties of realism and the eleva-
tion of ordinary objects to things of beauty. The distinction is clear,
for example, in Walker Evans' disassociation of his own work from
that of Stieglitz and other eminent photographers, whose pictures he
judged "artistic and Romantic."[14]

Some American realists confront what they see as the paradox of
realism—the false assumption that a person's biography is the per-
son's identity and that a character's way of engaging in society, espe-

12. José Ortega y Gasset, *Meditations on Quixote*, trans. Evelyn Rugg and Diego
Marín (New York, 1961), 41.
13. Harry Levin, *The Gates of Horn: Five French Realists* (New York, 1963), 34.
14. Leslie Katz, "An Interview with Walker Evans," *Art in America*, LIX (March–
April, 1971), 83.

cially through speech or, in the visual arts, through action, relates who he is. The assumption must be that while visibility does not always honor a subject, extreme audibility invariably degrades and distorts. In *Winesburg, Ohio* and *Room in Brooklyn*, the vivid rendering of a person in his historical milieu tells us little of what we want to know of the person, for to all of the artists of silence (as, of course, to many others) there is a radical discord between private man and social man, though each confronts the private man through his social appearances. The detailed renderings of surfaces reveals that there is much of the unknowable beneath the surface. Either the artists insert into the narrative or the picture a perception of the character unavailable through the normal methods of realism or, more commonly, they use these methods to demonstrate their own inadequacies. In either case the art of silence necessarily denies the full truthfulness of realism.

Thus far I have represented the aesthetic of silence as primarily a mode of assaulting certain major inclinations of American society and of the tradition of realism. Were this the entire motive of the practitioners of the aesthetic, we would be dealing with little more than a force of negative cultural and aesthetic criticism. But aside from its usefulness in providing a satirical and critical point of view, silence is especially important for its positive powers. In widely different but parallel ways, the artists discussed in this book use silence as the mode of implying the forceful actual values that the prevailing conventional instances of realism tend to exclude.[15] While the silence

15. Three theoretical studies of the phenomenon of silence effectively approach it as a positive actuality rather than a mere negation, a simple absence of sound. Max Picard's aphoristic *World of Silence*, trans. Stanley Godman (Chicago, 1961), essentially relates silence to eternity: silence is man's only access to eternity. Bernard Dauenhauer's *Silence* (Bloomington, 1980) is a formal academic study of investigations into silence by such modern philosophers as Kierkegaard, Husserl, Sartre, Heidegger, and Merleau-Ponty. Although the book approaches silence mostly through its relation to speech, which seems needlessly restricting, it assisted me in establishing certain basic formulations. Susan Sontag's essay "The Aesthetics of Silence" (in *Styles of Radical Will* [New York, 1969]) is illuminating, but has the drawbacks of its uncentered and digressive method and its confronting of silence only in what she calls a "post-psychological conception of consciousness" (p. 4). Sontag reduces silence in art to the avant-garde artist's disbelief in traditional artistic communication. In alliance with a major trend of contem-

they are committed to emphasize seems completely comprehensible, even "normal"—the silence of quiet people and of undisturbed and immobile objects—it also conveys the incomprehensible: if not of some metaphysical dimension of experience, certainly of a dimension only vaguely to be conveyed by language and image. Thus silence, though an actuality, a "realistic" fact, is not an inadequacy or a failure of expression but a uniquely revealing phenomenon. Opaquely and obliquely, silence in the works here discussed is a paradoxical form of expression, though the content of the expression must be the inexpressible. At perhaps the most intelligible extreme, the inarticulateness of Sherwood Anderson's "grotesques" is a sign of emotional depth rather than a mark of social and intellectual deficiency, while at the least intelligible extreme, it seems impossible to tell what to make of the deserted, silent artifacts in the paintings of Edward Hopper other than that they transcend realistic representation.

Silence, though always available to us, generally suggests the remote and inaccessible. The emotions associated with silence are awe, fright, and reverence. As a descriptive word, *silent* is usually a prominent attribute of those states or conditions far from presently known life, such as death, the past, the stars, the sea, and ancient buildings like pyramids and cathedrals. Since it is identified with alien, slightly known, and often frightening phenomena, silence implies mystery and profundity. Since we can know so little of silent things, we assume that there must be a great deal more in them to know; silent things represent an inexpressible wisdom. Silent space is probably our most enduring symbol of ultimate mystery. As Merleau-Ponty writes, the question that philosophers ask of the world is "what in its silence *it means to say.*"[16]

The writers and artists discussed herein, at the most comprehen-

porary critical theory, Sontag is concerned with the questionable validity of all artistic utterance and hence considers silence as a rejection of all artistic statement and the capacity of art to represent the world. My book, in opposition, focuses on silence in art that is quite traditional, that takes art's power of mimesis for granted even while it raises major questions about the revered status of speech in that tradition.

16. Maurice Merleau-Ponty, *The Visible and the Invisible*, ed. Claude Lefort, trans. Richard C. McCleary (Evanston, 1968), 39.

sible level, find silence beneficial as a relief from noise, which, we are told, has become an especial menace in the modern world. In her diary Alice James recurrently speaks of her need to "possess one's soul in silence."[17] A similar disposition is at least implied by the artists under consideration. The withdrawal into silence (the screening out of obtrusive noise) is a psychic necessity more than a tranquil restoration, the condition in which the world can become tolerable and one can discover his own humanity.

But the psychological need for silence is not without its horrors. In all of these artists there is at least a faint apprehension of the frightfulness of silence—its vastness, its vagueness, its nothingness. As Nietzsche wrote, "With the unknown, one is confronted with anger, discomfort, and care."[18] The anxiety induced by silence competes with the intuition of the mystical that silence may also induce, though any apprehension of the mystical must be frightening in itself. Of the artists considered in this book James Agee is surely the most affirmatively religious—he is a passionate mystic whose meditations on the ephemeral lead him to an awareness of the eternal— and Edward Hopper seems the most nihilistic. Hopper's silences and vacancies provoke an apprehension of the metamorphosis of the matter of civilization into the condition of the void. The other artists are generally situated between these extremes. In each there is an obvious hostility toward sound, but a central uncertainty as to the benefits of silence. But it can be established that silence—even if a total nothingness—must be closer to the truth than sound, which can only be a distraction toward the trivial. Thus—if ambiguously— Kierkegaard's axiom about the duality of human nature interprets the relation of sound and silence: "Man is a synthesis of the infinite and the finite, of the temporal and the eternal."[19] The axiom holds true even if the infinite be an infinity of nonbeing. The artists of silence

17. Leon Edel (ed.), *The Diary of Alice James* (New York, 1964), 96.
18. Walter Kaufmann (ed.), *The Portable Nietzsche* (New York, 1972), 497.
19. Sören Kierkegaard, "The Sickness unto Death," in Robert Bretall (ed.), *A Kierkegaard Anthology* (New York, 1959), 340.

confront the finiteness of the world of speech with the infinity of the world of silence.

In acknowledging silence, the artist shows his awareness of an eternal realm beyond our confining sense of time, beyond and perhaps totally unrelated to our human occupations as social and private beings. In *A Death in the Family* Agee recurrently interrupts the temporal and social flow of the novel to represent the nearly mystical involvements with silence of certain characters. Even an occasional consciousness of the eternal makes the ongoing business of novelistic experience less consequential and less deserving of the supreme importance accorded it in most realistic fiction. By implication, the artist's acknowledgment of silence compels him to acknowledge the inadequacies of his representational talents. In strikingly different ways, all of the artists discussed acknowledge and represent silence by deliberately restricting the conventional capacities of their own medium. Thus Anderson undermines the familiar concept of character (a psychologically coherent individual significantly defined by a social category) and Hemingway does away with plot. Evans and Hopper deny themselves the indulgence (much exercised by their contemporaries) of producing the illusion of movement and sound in still representations. As a result the realism of these artists strikes us as unrealistic; it strongly veers toward improbability, though in each case what seems improbable is simply unconventional. In the art of silence we again encounter the familiar story of the realistic artist disputing the prevalent standards of realism. Like the stories of Hemingway, the photographs of Evans require us to readjust our sense of the usual, just as we must acknowledge that a city street seen at dawn (that is, as seen by Hopper) is no less real than one seen at noon.

A preoccupation with silence inevitably alters the effect expected from a given genre; certainly these artists exploit this tendency and intentionally raise questions about the assumptions of traditional genres. *Let Us Now Praise Famous Men* is a sociological analysis that turns into a mystical meditation. "Big Two-Hearted River" promises

to be an adventure story, but it contains no adventure. It concludes a violent book in a silently enacted ritual. *Early Sunday Morning* is a perception of urban life without life. In each case the art of silence produces an inevitable strain between its own compulsions to transcend realism and the finally irreducible substance of the actual world. The idea of silence would have no meaning without the idea of sound.

It is common for Poe to carry his readers and characters from the realm of comprehensible terror to the realm of incomprehensible terror. The first is extreme and highly improbable, but nevertheless imaginable. Such terror is that of the "descent into the maelstrom" and the gradually intensifying terrors preliminary to the entrance into the polar region of whiteness in *The Narrative of A. Gordon Pym*. The horror beyond horror is also beyond imagination, and as Poe regularly insists, also beyond life. It can be experienced only while dying or after one has died. In "Silence—A Fable," the ultimate horror is explicitly silence itself. Before "the curse of *silence*," the scene is the epitome of "desolation," yet endurable for the misanthrope with the tragic vision. To him, presumably, the scene is the appropriate place to stay, a symbolic expression of the true character of existence. But after the conversion of violent tumult into absolute silence, the man is so terrified that he runs off.

We are made to speculate why desolation amid tumult is bearable for the stoic pessimist and desolation in silence is unbearable. Like many of the cryptic tales from Poe's private mythology, "Silence—A Fable" invites the reader to interpret it in terms of his own choosing, but also supplies its own interpretative terms. Horror, for Poe, is usually a logical result of analyzable conditions. The internal clue to this fable is the communicative nature of nonhuman sound. Although Poe goes to extremes to make nature not only bizarre but inexplicable, so that a river palpitates but does not flow and trees violently move though there is no wind, still the sounds, as the Demon describes them, are intelligible. The water lilies especially are personified. "They sigh one unto the other in that solitude, and stretch toward the heavens their long and ghastly necks, and nod to and fro their everlasting heads." When all sound is terminated, the last remaining sign of familiarity and comprehensibility is removed, and the resultant desolation is beyond human understanding. To Poe, the degree of horror is to be measured by the degree of the victim-witness's familiarity with it. The Libyan scene itself takes the *Baltimore Book* reader and the man on the rock far from the familiar, but the mournful and otherworldly sounds of lilies, trees, and clouds are paradoxically reassuring. Even the Demon, clearly no friend to man, regards their

sounds as voices. To man all sound is expression, all utterance is language.[2] Understanding the language is less important than the intuitive and unconscious realization that sounds make the world familiar to us, even a world containing gigantic water lilies.

If in "Silence—A Fable" Poe constructs an opposition between a bearable audible desolation and an unbearable silent desolation, in "Sonnet—Silence" he contrasts two kinds of silence. Phenomenologically the two are identical, though ontologically quite different. They are the silence of the dead, which is harmless, and the silence of the absolutely nonhuman, which is ultimate horror:

> There are some qualities—some incorporate things,
> That have a double life, which thus is made
> A type of that twin entity which springs
> From matter and light, evinced in solid and shade.
> There is a two-fold *Silence*—sea and shore—
> Body and soul. One dwells in lonely places.
> Newly with grass o'ergrown; some solemn graces,
> Some human memories and tearful lore,
> Render him terrorless: his name's "No More."
> He is the corporate Silence: dread him not!
> No power hath he of evil in himself;
> But should some urgent fate (untimely lot!)
> Bring thee to meet his shadow (nameless elf,
> That haunteth the lone regions where hath trod
> No foot of man,) commend thyself to God![3]

Poe's fable and sonnet pose the possibility of man's unsought confrontation with an absolute nonhuman realm of being. The sense of dislocation, of complete severance from the familiar, may not be the total explanation for the terror, but it is clearly a major contributor to it. To acknowledge silence as an independent permanent state of exis-

2. In "The Murders in the Rue Morgue," the witnesses who overhear but do not see the murders assume the killer to be someone who speaks a foreign language because they do not understand the sounds. The killer is in fact an ape.
3. Edgar Allan Poe, "Sonnet—Silence," in *Works*, 15–16.

tence beyond and uncontingent upon our own sense of experience is to be confronted with our own irrelevance. Such comforting presences as self, time, space, and even our notion of being are not required for silence to exist. Indeed it is possible and feasible to speak of silence as existing independently.

THE EXCLUSION of the necessity of human presence makes silence especially terrible for Poe. To other writers who find in silence the same qualities, it is neither necessarily terrifying nor necessarily beyond the human order. Human beings, after all, experience silence every day. (Poe, of course, would make an emphatic distinction between the diluted, imperfect silence that we know and true silence; he might agree with John Cage that pure silence does not exist on earth.[4]) In *The World of Silence* Max Picard considers silence as a phenomenon that is not the entirely otherworldly domain of Poe; it is inherently transcendental. Silence, as Picard stresses, is ahistorical, it predates language, and it seems eternal. "In silence . . . man stands confronted once again by the original beginning of all things: everything can begin again, everything can be re-created. In every moment of time, man through silence can be with the origins of all things."[5]

But this attainment of some primal existence is usually experienced as a tantalizing glimpse. Of classic American writers, Melville is especially tantalized by silence.[6] For Melville, silence is the all-but-transparent mask of truth. Melville's narrators and heroes sense that

4. Cited by Susan Sontag, "The Aesthetics of Silence," in *Styles of Radical Will* (New York, 1969), 10.

5. Max Picard, *The World of Silence*, trans. Stanley Godman (Chicago, 1961), 6.

6. The prose and poetry of transcendentalism is the body of American literature that we might expect especially to celebrate silence and to provide abundant considerations of it. Surprisingly, Emerson and Thoreau have little to say about silence and, for all their encouragements of mystical experience, do not commonly write of the spiritual life as contemplative silence or the transcendence of language and sound. For Emerson, vision is the supreme human faculty, and the spiritual progressions that he urges are from a crude recognition of matter to a perception of spirit. Emerson suggests that the infinite—or oversoul—may be possessed by imagination, the image-making power of mind; in describing this sublime attainment he habitually draws upon metaphors of seeing, as well as on metaphors of growing, drinking, and bathing, but never on the experience of attending to silence. What is missing is the idea of silence as anything more than an implicit accompaniment of the solitude that Emerson always encour-

they are in the presence of ultimate reality when they stand before and meditate upon some static, tangible, silent image that takes on the quality of an abstraction—such as the whiteness of tapa, of the city of Lima, or of the whale; or the metaphoric and actual walls given some mystical significance by Ishmael and Bartleby. The sea is an emblem of the spiritual not when turbulent but when serene. In *Moby-Dick* the whale is observed by means of books, legends, pictures, and postmortem investigations. That is, it is mostly observed not when in motion but when still (causing the novel to be an oddly silent book in some ways). It is characteristic of Ishmael to discuss even the terrible powers of the whale line when it is quiet and motionless: "As the profound calm which only apparently precedes and prophesies of the storm, is perhaps more awful than the storm itself; for, indeed the calm is but the wrapper and envelope of the storm; and contains it in itself, as the seemingly harmless rifle holds the fatal powder, and the ball, and the explosion; so the graceful repose of the line, as it silently serpentines about the oarsmen before being brought into actual play—this is a thing which carries more of true terror than any other aspect of this dangerous affair."[7] Psychologically, that is, the deadly is more terrifying when quiet and inert; silence (as Poe would also emphasize) heightens the horror.

ages. Perhaps because he can regard it only as a negation, silence in itself seems useless and meaningless to Emerson as fact, metaphor, or symbol.

Similarly, and more curiously, Thoreau in *Walden* has nothing to say about silence. Surely a solitary life in the woods is often a life of silence, and one would expect such an enthusiastic reader of Oriental mystical literature as Thoreau to give to silence a considerable tribute and to praise its efficaciousness. But such is not true. After the opening general chapters of *Walden*—the paired manifestos dealing with the sanity of his life and the insanity of ordinary society's—he recounts the specific interests and activities of his day-to-day life by the pond. Chapter 3, "Reading," which praises ancient literature, especially the poetry of Homer, is followed by "Sounds," a mostly jocular commentary on the various nonhuman sounds he regularly hears—the train, church bells, the lowing of cows, the calls of owls, roosters, and frogs. Next is "Solitude," in which we might expect some mention of silence, for Thoreau delights in pairing contrasting and even contradicting chapters. But the chapter following "Sounds" fails to mention silence. In fact "Solitude" turns out not to be about solitude at all, but rather a more subtle kind of companionship than the human associations that Thoreau unenthusiastically discusses in the next chapter, "Visitors." In "Solitude" the absence of loneliness is indicated by the comforting presence of the sounds of rain and lightning.

7. Herman Melville, *Moby-Dick*, ed. Harrison Hayford and Hershel Parker (New York, 1967), 241. Hereinafter cited parenthetically in the text.

It should not be surprising that the mysterious Fedallah ("a muffled mystery to the last" [197]) is on board the *Pequod*. Like Poe's Demon, Fedallah comes into the modern world from a timeless antiquity.

One cannot sustain an indifferent air concerning Fedallah. He was such a creature as civilized, domestic people in the temperate zone only see in their dreams, and that but dimly; but the like of whom now and then·glide among the unchanging Asiatic communities, especially the Oriental isles to the east of the continent— those insulated, immemorial, unalterable countries, which even in these modern days still preserve much of the ghostly aboriginalness of earth's primal generations, when the memory of the first man was a distinct recollection, and all men his descendants, unknowing whence he came, eyed each other as real phantoms, and asked of the sun and the moon why they were created and to what end; when though, according to Genesis, the angels indeed consorted with the daughters of men, the devils also, and the uncanonical Rabbins, indulged in mundane amours. (199)

It is Fedallah who sights "the spirit-spout," a jet of vapor from a whale seen "one serene moonlight night." The episode is one of several in *Moby-Dick* in which what seems a preternatural quietness rules the sea: "All the waves rolled by like scrolls of silver; and, by their soft suffusing seethings, made what seemed a silvery silence, not a solitude; on such a silent night a silvery jet was seen" (199). This occasion—the observation by the Oriental of the mystical spout in the silent sea—is a highly refined, indeed "spiritualized," version of a mundane occurrence in whaling—the sighting of a whale from the mainmast. Here the rendering of the routine act in the medium of "silvery silence" gives it a character of archetypal purity.

Of course calmness, as Ishmael several times reminds us, is deceiving. "The universal cannibalism of the sea" is more menacing because it is hidden and disguised in "times of dreamy quietude, when beholding the tranquil beauty and brilliance of the ocean's skin, one forgets the tiger heart that pants beneath it; and would not willingly remember, that this velvet paw but conceals a remorseless fang" (235,

405). However, as "the ocean's skin," the serene sea is not simply a cruel deception, for the depths of the sea are silent as well, the depths that are, so to speak, "beyond cannibalism," the remote silent region into which Pip falls and perceives the eternal source of life: "Carried down alive to wondrous depths, where strange shapes of the un-warped primal world glided to and fro before his passive eyes; and the miser-merman, Wisdom, revealed his hoarded heaps; and among the joyous, heartless, ever-juvenile eternities, Pip saw the multitudinous, God-omnipresent, coral insects, that out of the firmament of waters heaved the collosal orbs. He saw God's foot upon the treadle of the loom" (347). Pip's descent to the silent depths takes him farther than White-Jacket or Poe's Norwegian sailor who descends into the mael-strom but escapes just before the ultimate plunge.

The vision of eternity is also the whale's. In the chapter called "The Sphinx," Ahab stands alone on the deck gazing at the just de-capitated head of a whale. The tableau contains multiple kinds of silence. The first is that of the immediate scene. "Silence reigned over the before tumultuous but now deserted deck. An intense copper calm, like a universal yellow lotus, was more and more unfolding its noiseless measureless leaves upon the sea" (263). The second silence is that of the head, which to Ahab immediately becomes identified with the mute omniscience of the Sphinx, an archetype of silent wisdom.

> It was a black and hooded head; and hanging there in the midst of so intense a calm, it seemed the Sphinx's in the desert. "Speak, thou vast and venerable head . . . and tell us the secret thing that is in thee. Of all divers, thou hast dived the deepest. That head upon which the upper sun now gleams, has moved amid this world's foundations. Where unrecorded names and navies rust . . . where in her murderous hold this frigate earth is ballasted with bones of millions of the drowned . . . O head! thou hast seen enough to split the planets and make an infidel of Abraham, and not one syllable is thine." (264)

More than the silence of the serene sea or of the spirit spout, "the Sphynx" makes emphatic the connection between wisdom and mute-

ness and strongly implies a causal relation between the two. Truth is not expressed because it is inexpressible.

AS SOMETHING nondramatic, nonsocial, and inherently in opposition to those elements basic to realism—speech, motion, and time— silence inevitably has a slight role in major American fiction of the late nineteenth century. For example, silence occupies only the edges of Henry James's important works. It is the retreat to which a few of the busy participants in the action may only briefly retire and a mode in which the detached observer may consider the doings of the subjects of his observations. But there is nothing of silence in the lives of Maisie Farrange and Nanda Brookenham, and the reader is not privileged to witness a Ralph Touchett in periods of detached solitude. The problems of the private life always intrude, and the characters of a retiring disposition, like Fleda Vetch, are allowed scant relief from pressure and conflict, or in other words, simply from talk, which is almost always urgent. The sought relief of Notre Dame Cathedral and the National Gallery provides only brief and inadequate comfort for Lambert Strether and Milly Theale. The Jamesian character endures the obligations and the exhaustion of continuous dialogue and confrontation, and the peace that may eventually come is permitted only by death or the conclusion of the novel.

Such a resistance to silence is demanded by the nature of the novel, the literary form whose basic conditions are action, speech, and discord. Furthermore, James ever insists that the novel must be dramatic; it must be enacted history, observed process. It can never attain silence. Silence may be the state toward which a novel's intelligent protagonist aspires, but it must be an irrelevance to the drama of experience rendered on the pages. As pause, silence can be a subordinate participant in the drama, as are the brief silences that register Isabel Archer's anxiety and embarrassment during Lord Warburton's proposal and even the extended silence of her midnight vigil. But there can be no silence separate from speech and action, for this silence must be static.

Yet it is important that when James and other realists do occasionally represent the condition of silence the experiencing of silence is

sometimes felt as a valid, if provisional, alternative to the fundamental assumption of realism itself. There are times when life in the world, the realist commitment, becomes too painful and arduous for certain sensitive protagonists. Silence and temporary disengagement are sometimes sought and gratefully accepted. Huckleberry Finn on the raft attains the consciousness of hearing "not a sound, anywheres—perfectly still, just like the whole world was asleep." In Carrie Meeber we find a similar pattern of militant social engagement alternating with silent solitude. With a kind of instinctive need for self-preservation and restoration, Carrie almost ritualistically goes back to her rocking chair, submitting to the quiet rhythms of some mysterious destiny. To live in a realistic novel is a fatiguing experience. The observation is doubtless fatuous and would not be worthy of mention were it not recognized by the authors of *Huckleberry Finn*, *Sister Carrie*, and other novels of American realism. As Henry Adams wrote, "The nineteenth-century moved fast and furious, so that one who moved in it felt sometimes giddy, watching it spin."[8] Some fictional characters, like Adams himself, feel the urgent need of getting off what Maggie Verver in *The Golden Bowl* regards as "the whirligig of time."[9]

James's "The Great Good Place" is the "Silence—A Fable" of 1900. The short story, a whimsical and fablelike tale that James probably regarded as one of his *jeux d'esprit*, reveals the value of silence for a worldlier age than Poe's. George Dane, the protagonist, is one of James's artist-heroes. As is the case with most of the other fictional novelists in James's stories, Dane is so harassed by external pressures that he feels his very sanity threatened. With Dane it is not an involvement with a woman or the philistine literary situation that nearly undermines him, as in other of James's artist tales, but the endless peripheral duties that consume the time and energy of the great novelist. He feels himself in the "endless press and stress, to

8. Henry Adams, *Mont St. Michel and Chartres* (New York, 1961), 45.
9. Henry James, *The Golden Bowl* (New York, 1909), 253. Vol. XXIV of *The Novels and Tales of Henry James*, 24 vols.

have lost possession of my soul and to be surrounded only with the affairs of other people, smothered in mere irrelevant importunity."[10] Each morning's mail brings books to be read and reviewed and invitations and requests from known and unknown admirers. As though by magic, the novelist discovers himself, suddenly and unaccountably, far removed from his rooms, from his work, and from London, in a kind of country house that he calls the "Great Good Place." Dane and his companions (other harassed men inexplicably transported) find their new surroundings indefinable, not exactly corresponding to any place they have known. Much of their conversation is made up of their unsuccessful efforts to find a suitable analogy. It somewhat resembles a religious retreat, a health spa, a hotel, even a nursery and a kindergarten, but it is superior to all of these. Preeminently the greatness and goodness of the place consist in the absence of all the pressures, conflicts, and anxiety-provoking obligations of the author's public life. "What *was* the general charm? He couldn't, for that matter, easily have phrased it; it was such an abyss of negatives, such an absence of positives and of everything" (234).

The "place" is far too vague to be recognized as an actual country hotel or health resort. The prevailing atmosphere is that of silence, a silence that Dane recurrently imagines as a quiet, comforting bath in which he finds himself immersed. "He was in the bath yet, the broad deep bath of stillness" (234). Also, Dane feels that here tact and good taste achieve a perfection: "Every form of softness, in the great good place, was but a further turn . . . of the endless roll of serenity," and "the soundless simple service was a triumph of art" (236, 251).

"The Great Good Place" could well be judged a major instance of Jamesian vulgarity—an unequivocal approval of a highly refined retreat for the privileged man of sensibility whose delicate constitution has been battered by a crass world. It is as though Henry Thoreau had sought spiritual health not at Walden Pond but at a mansion in the country where he spends his time doing absolutely nothing. Although the story must remain open to the charge of self-indulgence

10. Henry James, "The Great Good Place," in *The Novels and Tales of Henry James*, XVI, 243. Hereinafter cited parenthetically in the text.

and snobbery, such an effect is mostly dispelled when we examine closely the implications of the constituents of George Dane's ideal fantasy life. To begin, Dane's blissful silence is totally negative, the appropriate atmosphere for the felt absence of all annoyances, "a world without newspapers and letters, without telegrams and photographs" (252). But unlike Thoreau, who regards the getting rid of the unessential as the first stage of renewal, Dane relishes idleness itself as his fulfillment: "Above all he could do nothing—he could live" (252). The equation of living with doing nothing is surely a startling reversal of an important Jamesian belief. So too, James's cherished regard for freedom is sharply redefined in "The Great Good Place." Like living, freedom in the story is a negative value, a freedom from disturbance: "He had talked of independence and written of it, but what a cold flat word it had been. This [the Great Good Place] was the wordless fact itself—the uncontested possession of the long sweet stupid day. The fragrance of flowers just wandered through the void" (251).

But the silent void is not merely the placid emptiness of the perfect rest house. More important, it is also the abolition of both time and the consciousness of personal identity: "The very essence of the bliss of Dane's whole change had been precisely that there was nothing now to time. . . . It was part of the high style and the grand manner that there was no personal publicity, much less and personal reference. These things were in the world—in what he had left; there was no vulgarity here of credit or claim or fame. The real exquisite was to be without the complication of an identity" (236, 250).

The Great Good Place has the precise qualities that Emily Dickinson finds in dreaded silence ("Silence is Infinity. / Himself have not a face"). To Dickinson and, one supposes, to James, negation can go no further than the abolition of time and identity. The jocular tone of James's story should not mislead us into a casual and uncritical acceptance of the represented and asserted values of the story. The narrative records Dane's own consciousness of bliss; the expressed values are his, not James's. The tentative analogues for the Great Good Place make clear that its attractiveness for him consists in a condi-

tion of total submissiveness to the all-nourishing unknown source of
care. Dane and his friend try to identify this place where the mildest
need becomes immediate fact. The friend, "with kindly humour,"
suggests:

> "It's a sort of kindergarten!"
> "The next thing you'll be saying that we're babes at the breast."
> "Of some great mild invisible mother who stretches away into
> space and whose lap's the whole valley—?"
> "And her bosom"—Dane completed the figure—"the noble em-
> inence of our hill? That will do." (258)

Better than Dane could imagine, the image will indeed do to explain
the nature of his fantasy life. The eminent literary man craves nothing
less than a return to the irresponsible innocence of the nursery, if not
the silent infinity of the womb, where he is not required to be George
Dane or any specific person and can eternally experience the imper-
sonal bliss of "the broad deep bath of stillness."

As the story slowly progresses through its simple movement, Dane
at last feels sufficiently restored to want to leave the Great Good
Place and resume his busy life "with all its rage" (257). He feels "the
vague unrest for action . . . the stir of the faculty that had been re-
freshed and reconsecrated" (260). Accordingly Dane awakens from
what we discover to have been only a dream, but he feels rested and
exhilarated and eagerly resumes his work.

"The Great Good Place" is a strange and mostly pleasant story, but
with unsettling implications. Not only does it project the appeal of
the infantile state and even death, but it conveys the premise that the
consciousness of eternity through silence must accompany the oblit-
eration of self-awareness. Further, one might expect the Great Good
Place to be at least boring if not frightening, but to Dane it is entirely
"wonderful," though the wonderment consists in nothing more than
feeling perfectly comfortable. Only the reader finds death in "The
Great Good Place" and thus is especially relieved when Dane decides
to return to life.

Silence and stillness to James usually mean a momentary relief

from the urgencies of the private and public life. When Milly Theale sits on a bench in Regent's Park after her ominous visit to her doctor and Strether sits for a few minutes in the great stillness of Notre Dame, they seek the same kind of therapeutic release from the demands of the world as does Dane.

There are enough instances in James of sensitive characters' seeking and for a while possessing a great good place of their own that we are made to confront in his fiction a central philosophical problem of realistic fiction itself. It is the old problem of the "reality" of novelistic experiences that Hawthorne found resolvable only through the tenuous solution of the "romance," a kind of fiction blending history with legend, psychology with religion, and verisimilitude with fantasy. The intention is to achieve "the truth of the human heart" as opposed to the falsity or superficiality of the apparent world of mundane fact. James tales like "The Altar of the Dead," *The Ivory Tower,* and "The Bench of Desolation" concern characters who seek and for a time inhabit private worlds that may be ultimately inadequate, given James's demand that the moral life require the risk of the testing commitment to experience. But those private worlds offer a kind of near-religious calm that the larger world can never provide. That is to say, the Jamesian character of fine intelligence has valid needs that social engagement cannot fulfill. And it is to the retreat of quiet solitude that many heroes withdraw in the silences that resound after the conclusion of some of the novels. The true endings of *The Ambassadors* and *The Wings of the Dove* are not the final words on the last pages, but the suggestions of the indefinite stretches of time that succeed the final sentences, the blank spaces that we have been told will be filled by the recollections and meditations of Strether and Densher about the revelations they have received.

IN HIS *Education,* Henry Adams also writes of the periodic need for withdrawal from the world to silence. In the chapter "Silence (1894–1898)," he advocates silence as the most sensible conduct for a sane and honest person living at a time when the noise from politicians, economists, journalists, and, of course, Adams himself, makes

no sense. Adams' reason for commending silence is simple: since all speech is founded on ignorance, it is best to keep quiet. He concludes the chapter with a brief informal anthology of quotations from some nineteenth-century authors—Carlyle, Swinburne, Arnold, de Vigny, and Byron—who uniformly praise silence out of contempt for the chaos of noise about them. Characteristically Adams observes that "each praised silence in others,"[11] implying that if the writers had been sincere, they themselves would not have written. The commentary on silence gives Adams another opportunity to equate the highest possible wisdom (which of course is very little) with the acknowledgment of ignorance: "No man, even at sixty, had ever been known to attain knowledge; but . . . a very few were believed to have attained ignorance, which was in result the same. More than this, in every society worth the name, the man of sixty had been encouraged to ride this hobby—the Pursuit of Ignorance in Silence" (359). Adams' ironic approval of silence is momentary and indeed refuted by his continuation in *The Education* to report his later unsuccessful efforts to learn and speak the truth. "Silence" recedes before "The Dynamo and the Virgin," which comes two chapters after it. The worldly Adams resumes his combat with ideas and men, as do the most intelligent characters of the almost as worldly James. Yet Adams, even with his "aching consciousness of religious void" (352), continues to crave "a city of thought along the great highways of exchange" (361)—a secular City of God perhaps, or a philosopher's Great Good Place.

The available emblem of the city of thought is the Sphinx. "What was [Adams'] view about the value of silence? One lay in the sands and watched the expression of the Sphinx" (360). In writing of the St. Gaudens statue over his wife's grave at Rock Creek Cemetery, Adams also invokes the Sphinx, as well as other human and mythical embodiments of intellect and imagination, "monuments of unaging intellect," so to speak. As R. P. Blackmur writes, "They represent human life at its highest and most precarious sense of its own meaning—at its highest because in seeming self-created and beyond tampering;

11. Henry Adams, *The Education of Henry Adams*, ed. Ernest Samuels (Boston, 1973), 358. Hereinafter cited parenthetically in the text.

most precarious because requiring faith as the medium of appreciation. Without such figures, human life slips and becomes a sink."[12]

There is not a great distance between mad Captain Ahab before the dead whale's head and Adams in Egypt in their solemn and awed reactions to the Sphinx. They are especially similar in the pained awareness that the penetration of the silent Sphinx is impossible, and they are also similar in their agonized need for a truth beyond the capacity of all education.

In silence Ahab and Adams imagine in the Sphinx the existence of absolute being, of a total knowledge that must be unexpressed and cannot reveal itself; it is a wisdom that can be approached only through silent opaque forms remote in time. The Sphinx is not a dominant figure in American art of the twentieth century, an art that represents mostly the political and social energies of the nation in their own terms. But in different and sometimes subtle ways, the Sphinx manifests itself in works of art that are strikingly worldly, that assert the reality and importance of society and history.

12. R. P. Blackmur, *Henry Adams*, ed. Veronica A. Makowsky (New York, 1980), 101.

Two

ANDERSON AND HEMINGWAY

I. *Winesburg, Ohio*
HABITUAL SILENCE AND THE
ROARING OF VOICES

A T THE time of Sherwood Anderson's first furtive and uncertain efforts to become a writer, the most important American novelist was Theodore Dreiser, and it was Dreiser's example that showed Anderson the possibility of a true and honest fictional representation of ordinary American life. But to Anderson, Dreiser's kind of realism was fundamentally uncongenial and probably impossible. For as the appeal of realism grew in his mind, Anderson became increasingly disenchanted with commercial success, which had motivated him from childhood. The success drive was Dreiser's major subject and the dominant instinct of his characters. Although Anderson wrote several novels about the effort to succeed the motive to him was always misguided, even base and disgusting. Also, as a writer of advertising

Articulate words are a harsh clamor and dissonance. When man arrives at his highest perfection, he will again be dumb! for I suppose he was dumb at the Creation, and must go round an entire circle in order to return to that blessed state.
NATHANIEL HAWTHORNE
The American Notebooks

35

copy for two decades, Anderson came to associate words themselves
with lies; he used language for deceit and manipulation and for a
time apparently felt that it could be used for no other purpose. In
several of his writings Anderson acknowledges that the fiction of
Gertrude Stein "made me feel words as more living things" and at
least showed the possibility of some correspondence between lan-
guage and the feeling of actual experience.[1] Nevertheless the middle-
aged novice in the art of fiction began his second career with a deep
distrust of two assumptions that were fundamental to Dreiser and
other important American realists: that the drive for success is one of
the most powerful and valid of human instincts and that words are
easily capable of conveying truth.

In Anderson's mind the worship of success and excessive talking
are closely associated and equally repugnant. His first novel, *Windy
McPherson's Son*, begins as an assault on the garrulous, boastful,
"windy" father of the quiet, sensitive hero. The son fails in his at-
tempt to kill "the blustering, pretending, inefficient old man," but
the novel itself in effect murders the father, and with him the shal-
lowness, vanity, dishonesty, and cant that Anderson believed to be
the ruling expressions of American business and American society.[2]
In Anderson's finest book, *Winesburg, Ohio* (1919), the disaffiliation
with verbosity and the success myth is carried to an extreme limit,
yet with much more originality and subtlety than in *Windy McPher-
son's Son*. With compassion and even admiration, Anderson focuses
on characters who are hopeless failures by common social standards
and are doomed to remain so; furthermore, they not only have no in-
clination to overblown, falsifying speech, but hardly say anything at
all. In contrast to the facilely loquacious Windy, they find it very dif-
ficult—in some cases, impossible—to achieve any coherent speech.

While these isolated and silent grotesques occupy the forefront of
Winesburg, Ohio, taking solitary walks at night and sitting alone in
their small rooms with their dreams and confusions, they live on the

1. Ray Lewis White, *Sherwood Anderson/Gertrude Stein: Correspondence and Per-
sonal Essays* (Chapel Hill, 1972), 49.

2. Sherwood Anderson, *Windy McPherson's Son* (Rev. ed.; New York, 1922), 20.

fringes of the town's active business and social life. Of the community's busy and talkative people, Anderson takes little note. They are occasionally heard in the pool hall, the saloon, or the hotel office—as in a conversation between George Willard's father and two traveling men, overheard by the habitually silent Seth Richmond.

> On the stairway Seth stopped and listened to the voices of the men below. They were excited and talked rapidly. Tom Willard was berating the travelling men. "I am a Democrat but your talk makes me sick," he said. "You don't understand McKinley. McKinley and Mark Hanna are friends. It is impossible perhaps for your mind to grasp that. If anyone tells you that a friendship can be deeper and bigger and more worth while than dollars and cents, or even more worth while than state politics, you snicker and laugh."
>
> The landlord was interrupted by one of the guests, a tall, grey-mustached man who worked for a wholesale grocery house. "Do you think that I've lived in Cleveland all these years without knowing Mark Hanna?" he demanded. "Your talk is piffle. Hanna is after money and nothing else. This McKinley is his tool. He has McKinley bluffed and don't you forget it."[3]

To the central characters of the book, such talk is mostly repulsive. To Tom Willard's wife, her husband's mindless orations about success and the importance of aggression are "the voice of evil" (45). The mostly passive son, George, sides with the silent mother against the garrulous father and decides that he must leave home following one of his father's spirited appeals to him: "I tell you what, George, you've got to wake up. . . . You're not a fool and you're not a woman. You're Tom Willard's son and you'll wake up" (44).

The sensitive outcasts of Winesburg sometimes envy the talkative, but mostly they loathe people who speak frequently, confidently, and (especially) boastfully. To them, as unquestionably to Anderson, speech that defines, interprets, predicts, and judges is at constant war

3. Sherwood Anderson, *Winesburg, Ohio* (New York, 1960), 132. Hereinafter cited parenthetically in the text.

with truth, which resides only in dreams and cannot be uttered. In the first story, Wing Biddlebaum, in a rare moment of articulation, advises George Willard: "You must begin to dream. From this time on you must shut your ears to the roaring of the voices" (30). The lonely teacher, Kate Swift, gives expression to the basic premise of Anderson's conception of fiction when she tells George: "You must not become a mere peddler of words. The thing to learn is to know what people are thinking about, not what they say" (163). When Enoch Robinson works as an artist in New York, "people gathered and smoked cigarettes and talked. . . . He stayed in a corner and for the most part said nothing. . . . On the walls were pictures he had made, crude things, half finished. His friends talked of these. Leaning back in their chairs, they talked and talked with their heads rocking from side to side. Words were said about line and values and composition, lots of words, such as are always being said" (169). In response, "Enoch wanted to talk too but he didn't know how" (169). He finds it impossible to express coherently the subtle intentions of his paintings.

Joe Welling, the central character of "A Man of Ideas," stands as an extravagant exception to the rule that the grotesque be habitually silent. But it may be that Welling is not a grotesque at all. The young man who compulsively bursts forth with the kind of ideas that may be found in the *Farmer's Almanac* and announces them as revelations is a comic rather than a pathetic figure. Joe's boyish loquacity proves his salvation in a scrape with the bullying brothers of the girl he is fond of—a situation that could not be endured by such quiet, sensitive young men as Seth Richmond and George Willard.

Nearly all the grotesques are initially identified as silent people: Enoch Robinson is "inclined to silence" (167), Ray Pearson is "quiet" (207), Tom Foster is "quiet and gentle" (212), Jesse Bentley is "mostly silent" (68), Alice Hindman has a "natural diffidence and reserve" (112), and Seth Richmond maintains a "habitual silence" (133). In *Winesburg, Ohio* there is no middle ground between bombastic falsehood and inexpressible sincerity. Yet the quiet, solitary characters strongly sense the need for expression. Their stories record various

unsatisfactory efforts to overcome isolation through speech. With a balletlike rhythm, most of the stories vary slightly the same pattern: a solitary person sitting or walking alone, encountering someone else—usually another solitary figure (often George Willard or the aloof town beauty, Helen White)—saying very little but walking or sitting with the other person, mostly in silence, and then leaving alone, with a sense of needs unmet and an opportunity missed.

Some of the characters remain silent out of a simple shyness or embarrassment at telling others their deeply felt desires. Some, like Enoch Robinson and Elmer Cowley, become nervously agitated when they seek to explain themselves. Several of the grotesques have a "story"—such as Wing Biddlebaum (a schoolteacher who was driven out of a Pennsylvania town when he showed too much affection for his young pupils) and Wash Williams (whose promiscuous wife caused him to lapse into a lifetime of miserable misogyny). These people were bitterly hurt following their youthful, unguarded expressions of love, and for the rest of their lives they exist only as their "stories." Most of the others never make an effort to reach out to others because they "don't know what they want" or "don't know what to say."[4] They futilely grope in their anguished solitude and silence, only distant members of the community of talk that surrounds them.

4. Of course incomprehensible and inexpressible desire is a particularly banal commonplace of sentimental and anti-intellectual realism (e.g. "I don't know what I want, but there's something deep inside of me . . . "). But the unutterable craving for some unknown possession has in recent years been most seriously considered in some especially abstruse linguistic and psychoanalytic studies, particularly those of Jacques Lacan. The following comment by Tony Tanner on Lacan's theories of the enslaving quality of language is curiously appropriate as an explanation for the inarticulateness of Anderson's characters and their much greater comfort with silence than with speech: "When we do start thinking, we think in and with the discourses that were implanted in us but were none of our making; it does make an important kind of sense to point out that there is no prior fully constituted self that *then* engages in thinking; rather the self is to a large extent constituted in and through its engagement in the existing discourses and paradoxically, therefore, comes into being via a medium that is precisely not itself since it was there waiting as a system into which the self must fit. (We might even rephrase Lacan's rephrasing of Descartes and say that since often I speak where I am not, therefore, I am where I speak not, for much of the real self may be found in the gaps, spaces, and silences when it is, for intermittent periods, not a slave of language.)" (Tony Tanner, *Adultery in the Novel: Contract and Transgression* [Baltimore, 1981], 91–92).

The difficulties with speech are all rooted in an awareness that language (as they know it) cannot convey truth, and yet the stories differ because the conception of truth varies. The inexpressible truth may be a vague but powerful hunger for love, or it may be a reasoned uncertainty as to what one really believes. Thus there is a wide difference between the miserably frustrated Elizabeth Willard, who dies wanting an unobtainable passionate love ("what would be for her the true word"), and the calmly sensible Ray Pearson of "The Untold Lie," who gives no advice to a young friend who has made a girl pregnant because "whatever I told him would have been a lie" (247, 209).

"The Thinker" is an effective parody of the customary problem of inarticulation. Anderson's title character is a familiar silent protagonist, lost and lonely in the talkative world but whose silence is the result not of deep feeling or sensitivity, but of extreme shallowness. Regarded by the townsfolk and for a while by Helen White as "deep" because of his silence, Seth Richmond actually is silent because he has nothing to say. Furthermore, he has absolutely no capacity for speech. Overhearing "the chattering crowd," he is irritated not by its inanity, but by his own inability to chatter inanely and "shout meaningless jokes" (128). As Anderson makes clear, "No great underlying purpose lay back of his habitual silence" (133).

The parodic intention of the story is most striking in the conclusion, in which Seth asks Helen White to walk with him. The walk duplicates the kind of serious evening stroll that George Willard twice takes with the distant but "understanding" girl. For a short while, Helen interprets Seth's silence and his first tentative expressions of discontent with life in the small town as the indication of manly resolve and intelligence. She thinks: "This is as it should be. . . . This boy is not a boy at all, but a strong purposeful man" (141). It is an erotically charged scene, and Helen herself feels that the garden where they stand together "might have become the background for strange and wonderful adventures." But Seth's verbal awkwardness and soon revealed mental emptiness destroy the imagined possibility of tenderness and understanding. Discussing his future plans, Seth can only stammer: "Everyone talks and talks. . . . I'm sick of it. I'll do some-

thing, get into some kind of work where talk doesn't count. Maybe I'll just be a mechanic in a shop. I don't know. I guess I don't care much. I just want to work and keep quiet. That's all I've got in my mind" (141). And there is nothing more in Seth's mind, indeed far less than in the mind of George Willard, who, in an almost identical situation with Helen, is scarcely more articulate than Seth, but does convey an honestly felt hunger to "do something." Although Seth's expressed ambition is "to work and keep quiet," he obviously would most like to be an easy talker, for the only emotions he really feels are anger and envy toward those who do speak, especially (and ironically) toward the taciturn George Willard, whom Seth sees as "someone who talks a lot" (142).

But it would be inadequate and misleading to suggest that there is some correlation between articulateness and intelligence. Seth Richmond's bafflement before his own desires reveals less a paucity of ideas than a paucity of feelings. In Anderson's view, the articulated craving for power, wealth, and status is invariably the mark of the limited talkative majority. The intense dramatic confrontations in *Winesburg, Ohio*—between male friends, mother and son, boy and girl—are those in which there is opportunity and desperate need for vital conversation, which to Anderson is one person's telling another what he desires; it is essential self-revelation, and anything less is meaningless chatter. Such primal confession is almost never possible because none of the sensitive persons really knows what he wants. But unlike Seth Richmond, who contrives a pretended ambition, they deeply feel the need for something. Inarticulation is the only honest speech; silence must be the expression of truth, for the content of one's deepest desire is necessarily uncertain, unclear, and contradictory. Anderson's characters are hidden from themselves. Thus a refrain of self-ignorance runs through the stories: Elizabeth Bentley "did not know what she wanted" (98); Reverend Curtis Hartman "did not know what he wanted" (153).

Although Anderson's silent characters impatiently crave self-articulation, silence is their normal mode, and speech must always be an abnormal experience for them, a drastic and sometimes violent

interruption of their usual state of existing. Some of the stories deal with characters who speak after and before long silences and convey the sense that in their speaking at all an extraordinary event is taking place. Thus Wing Biddlebaum is like a man suddenly possessed when he breaks his years of silence to address George Willard: "The voice that had been low and trembling became shrill and loud. The bent figure straightened. With a kind of wriggle, like a fish returned to the brook by the fisherman, Biddlebaum the silent began to talk, striving to put into words the ideas that had been accumulated by his mind during long years of silence" (28). Even "the man of ideas," Joe Welling, is mostly "silent, excessively polite, intent upon his business" until suddenly gripped by one of the "seizures" that cause people to flee from him. The seizures "were overwhelming. Astride an idea, Joe was overmastering. His personality became gigantic. It overrode the man to whom he talked, swept him away, all who stood within sound of his voice" (104). When silent people suddenly and unexpectedly speak, they seem possessed or insane, for the long habit of silence can be broken only by a swell of feeling that is too hurried and undifferentiated to be articulated; and the speaker's inexperience with the conventions of conversation—the communication of thought by developing a shared knowledge through a shared vocabulary—further makes the speech unintelligible. When Kate Swift talks "of life" to George Willard, she is like one possessed, and George thinks her mad: "She talked with passionate earnestness. The impulse that had driven her into the snow poured itself out into talk. She became inspired as she sometimes did in the presence of the children in school. A great eagerness to open the door of life to the boy . . . had possession of her. So strong was her passion that it became something physical. Again her hands took hold of his shoulders and turned him about. In the dim light her eyes blazed" (164).[5]

5. In several places Anderson describes the writing of a short story as a sudden and seemingly irrational "kind of explosion." In a letter he writes, "When the nerves are tired from long thinking and feeling there comes often a kind of explosion. A hundred images come—stories tales poems. None of them complete the circle. They break off and disappear" (Quoted in William A. Sutton, *The Road to Winesburg, Ohio* [Metuchen, N.J., 1972], 230).

George Willard, also much disturbed with problems of speaking, sometimes feels that the power of speech derives from some external force that both awes and terrifies him. In "An Awakening," George, like Seth Richmond, feels that words themselves are instruments of magical power. Walking the streets alone on a cold night, "he began to talk aloud. In a spirit of play he reeled along the street imitating a drunken man and then imagined himself a soldier" (183). He imitates the postures and the speech of imagined army officers, gaining great pleasure from speaking the empty words of commanding authority. In writing that George becomes "hypnotized by his own words," Anderson means a literal hypnotism, for "it seemed to him that some voices outside of himself had been talking as he walked" (183). After the playful yet stirring parody of military officers giving commands, George is astounded when his voice announces a profound and incomprehensible principle for directing one's life:

> "There is a law for armies and for men too," he muttered, lost in reflection. "The law begins with little things and spreads out until it covers everything. In every little thing there must be order, in the place where men work, in their clothes, in their thoughts. I myself must be orderly, I must learn that law. I must get myself into touch with something orderly and big that swings through the night like a star. In my little way I must begin to learn something, to give and swing and work with life, with the law." (183)

The momentary intoxication with an obscure concept of discipline soon dissolves. As George wanders into an alleyway full of "the smell of manure in the clear sweet air," he bellows more words, but words signifying very different ideas: "The desire to say words overcame him and he said words without meaning, rolling them over on his tongue and saying them because they were brave words, full of meaning. 'Death,' he muttered, 'night, the sea, fear, loveliness'" (185). Incanting the magical words intoxicates the boy, filling him with a feeling of power. However, the exhilaration and sense of omnipotence are soon deflated when he seeks out a girl to tell of "the sense of masculine power" that he believes makes him sexually irresistible (187).

Immediately he is assaulted by the bartender who wishes to marry the girl, and the powerful sensation dissolves.

"An Awakening" comes close to being a stock story of adolescent self-delusion and of the rapid swing from exultation to humiliation that in much fiction virtually defines the adolescent experience. But in the context of *Winesburg, Ohio*, "An Awakening" is not so routine and hints of different implications. The story, like the book as a whole, focuses on words as a key to existence, the most important bridge between a purely private life and a social life. On one hand, as most of the grotesques painfully recognize, words are powerful weapons: not only do the envied and despised town leaders use words to dominate and to manifest their right to dominate, but words are thought to be the means of externalizing the true self and the necessary form of contact between the sexes. Thus in uttering words, words vaguely authoritative and "mature," George feels transformed into a powerful person. On the other hand, the words are meaningless, and the power that they convey is an illusion. To George they sound impressive, though as he speaks he neither intends nor understands the words. George would be impressed if another spoke them, for they ring of authority and profundity, and thus he must admire himself when he hears himself speaking the words.

The proper attitude toward words, as much of the book strongly indicates, is distrust. Words are indeed powerful even when meaningless, but they are also destructive. In a discussion of love—the ultimate inexpressible desire of most of the characters—Dr. Reefy tells Elizabeth Willard: "Love is like a wind stirring the grass beneath trees on a black night. . . . You must try not to make love definite. It is the divine accident of life. If you try to be definite and sure about it and to live beneath the trees, where soft night winds blow, the long hot day of disappointment comes swiftly and the gritty dust from passing wagons gathers upon lips inflamed and made tender by kisses" (223). Dr. Reefy poetically asserts the absolute antithesis of experience and of defining it. He argues that to define the experience of love is to destroy it.

In "An Awakening" meaningless words create in George Willard a

momentary exuberance. In the story that follows, "'Queer,'" Elmer
Cowley is in such a state of rage because he and his father are judged
eccentric, or "queer," by the community that he at first shouts in-
coherently to himself, then seeks out a half-wit as an audience for his
anger. It is as though the actual words expressing Elmer's outrage
mean very little, and the saying of some words—any words—will be
sufficient. To the half-wit, Mook, Elmer believes he can make his
statement because to Mook all words are equally incomprehensible,
and it would not be necessary for Elmer to make sense, always an
exasperating difficulty for him: "Do you know why I came clear out
here afoot? I had to tell someone and you were the only one I could
tell. I hunted out another queer one, you see" (197). Mook, who speaks
to animals, warns the cows that Elmer is crazy, the same opinion that
George Willard has of Curtis Hartman and Kate Swift after their in-
coherent confessions to him.

Unsatisfied by his diatribe to Mook, Elmer turns to George Willard,
who is sought out by most of the Winesburg grotesques as a sympa-
thetic listener. But after finding George, Elmer can only sputter:
"Don't stay out here with me. I ain't got anything to tell you. I don't
want to see you at all" (198). The frustration from his inability to
explain his anger becomes a stronger feeling than the anger itself:
"After the hours sputtering at nothingness that had occupied the after-
noon and his failure in the presence of the young reporter, he thought
he could see no hope of a future for himself" (199).

Later in the same day, Elmer impetuously decides to leave Wines-
burg, with plans even vaguer than George Willard's.[6] Before leaving,
he again visits George to make a final effort to explain himself, but
he can only repeat the nonsense words that constitute Mook's en-
tire range of expression. In announcing to George for the second time
that he has something important to tell him, he can say only: "I'll be

6. Like Seth Richmond, Elmer enacts a parody of the serious situation of George
Willard. George also dislikes his father and feels that he must leave Winesburg. The
parodies reveal the inadequacy of simple obtuseness (Seth) and anger (Elmer) in com-
parison to the more profound bewilderment of George, who in "Sophistication" achieves
the kind of mature understanding of the meaning of alienation that enables him to leave
Winesburg with some deserved confidence.

washed and ironed. I'll be washed and ironed and starched" (200).
Elmer cannot control his speech by will or judgment. Like George
Willard in muttering "death, . . . night, the sea, fear, loveliness," or
Joe Welling in one of his "seizures" of verbosity, Elmer feels a strong
need for speech but has no way of making a connection between
words and feeling.

The story of Elmer Cowley is a radical (if not ludicrous) illustra-
tion of Anderson's conviction that people do not—because they can-
not—say what they believe. The stories are instances of people who,
for reasons that may seem rooted in pathology more than in shyness
or normal inarticulateness, lack the ability to talk. Nor do they know
what they believe or desire; more likely they cannot begin to attach
words to the mysterious substance of their beliefs and cravings. They
are tortured by their unintelligible hungers, but they do not evade
them, as do the articulate. Sherwood Anderson makes quite obvious
the same problem of language that Tony Tanner examines in his dis-
cussion of *Madame Bovary*: "It is precisely *in* the process of striving
for expression that the originality of the feeling cedes to the equiv-
alizing tendencies in language. Thus utterance itself constitutes loss
of originality. The central paradox of our lingual condition is that it
would seem as though we lose our feelings precisely when and be-
cause we try to communicate them. . . . The fullness is in the heart
or the soul; the emptiness is in the language."[7]

Anderson shows the impossibility of the honest communication
of feeling by surrounding his grotesques with a chorus of towns-
people whose constant example reveals the meager possibilities of ac-
tual speech. The speech of the chorus is nothing but clichés and
slogans, the language of the near-official American dogma of success
and masculine bullying as it has filtered down to the small provincial
town. Implicit in a number of the stories is the belief that most speech
is mimicry, that most of the words that people say are imitations of
what they have heard others say. Thus George reiterates the military

7. Tanner, *Adultery in the Novel*, 268.

officer's command and Elmer the idiot's foolish saying. The over-
heard loud chatter of the town is mostly boasting, the telling of lies
that are regarded to be assertions of deeds that deserve society's ap-
proval. Anderson relates little of such discourse, but he refers to it as
gossip, boasting, and joking—modes of speech essentially self-serving,
as well as impersonal and unoriginal. Winesburg culture offers no ac-
ceptable mode of private communication. Dr. Reefy writes notes to
himself, which he crumples in his pockets; other characters wave
their arms, pace the streets, and get drunk—all improvised, inade-
quate substitutes for a speech that always fails them.

In several of the stories sexual contact is represented as an easier
form of communication between man and woman than conversation,
and probably for that reason not as satisfying as the dreamed of con-
versation would be. In the fragile and rare moments in which love is
experienced in *Winesburg, Ohio* its expression is in silence. The main
example is "Sophistication," the climactic story that concerns George
Willard's final experience before his departure from Winesburg. In
other ways as well, the story is the coda of the principal themes of
the book and its most coherent resolution of the difficult problem of
communicating for characters most comfortable with silence.

"Sophistication" is George Willard's story, and it shows his state of
mind and feelings after his encounters with numerous lonely people
and before his departure from Winesburg. The recent death of his
mother has brought home to George a strong sense of his own mor-
tality. "The sadness of sophistication has come to the boy. With a
little gasp he sees himself as merely a leaf blown through the streets
of his village. He knows that in spite of all the stout talk of his fel-
lows he must live and die in uncertainty, a thing blown by the winds"
(234). He recalls with shame his own "stout talk" in his previous
walk with Helen White, whom he desires to be with this night. On
the previous summer evening he could speak to Helen only by boast-
ing of his confident ambitions: "I'm going to be a big man, the biggest
that ever lived here in Winesburg" (236). The distasteful recollection
makes addedly repugnant the overheard boasting of a man whose

horse had just won the race at the county fair, to which George had responded: "Old windbag. . . . Why does he want to be bragging? Why don't he shut up?" (238).

The important setting of "Sophistication" is the Winesburg County Fair, the day-long celebration in which "an American town worked terribly at the task of amusing itself" (233). At first the "sense of crowding, moving that closed in about him" is oppressive to George, an intensification of the usual threat of the townspeople to his private self (237). But as in most of the stories the life of the town—even on its annual day of festivity—barely touches George, and in this story more than any we see Anderson's representation of community as a hollow fiction.

Helen's mother had invited an instructor from her daughter's college to stay with the family during the fair, and through the instructor and Helen's mother Anderson gratuitously introduces another instance of fraudulent speech—the language of class and intellectual pretension. When the instructor tells Helen, "Your life is still bound up with the life of this town," Helen thinks "his voice sounded pompous and heavy" (239). She flees to the garden thinking "that the world was full of meaningless people saying words" (239). In the garden she encounters George, who has impetuously decided to enter Helen's house to speak with her. Thus the meeting is prepared by the separate repudiations of "bragging" and "words" by the young man and woman. When George finds Helen he wonders "what he had better do and say" (239). In fact he says nothing, nor does Helen, as they walk to the grandstand in the fairground, where they sit for awhile, and then walk down the hill. For more than three pages the couple is together and Anderson includes not a word of dialogue. Earlier in the evening George had felt the need for Helen's understanding, and at the very end of the story, "for some reason they could not have explained they had both got from their silent evening together the thing they needed. Man or boy, woman or girl, they had for a moment taken hold of the thing that makes the mature life of men and women in the modern world possible" (243).

Nearly as reticent as his characters, Anderson does not further

elaborate "the thing they needed"; to do so would cheapen the various desperate efforts of the other characters to define the object of their desires. But in the course of the interlude shared by George and Helen, some striking feelings that affect George give substance and definition to that which makes maturity in the modern world possible. First, George experiences the strange silence of the fairground a few hours after it had been crowded with people: "The place has been filled to overflowing with life. It has itched and squirmed with life and now it is night and the life has all gone away. The silence is almost terrifying" (240). This is a new and different silence for the Anderson character—the silence not of inarticulateness but of loss, negation, the absence of life. It is a silence external to oneself and therefore a mode of experiencing the relation of the world of nonself to the self, which is also silent. Explicitly George interprets the sensation as a reinforcement of his sense of "his own insignificance in the scheme of existence" (241), but the insignificance is a paradoxical kind of significance. Retaining the mood induced by the deserted fairground, he tightly holds Helen. The two share the same feeling and thus further enlarge their sense of identity as they experience its frailty: "In the mind of each was the same thought. 'I have come to this lonely place and here is this other,' was the substance of the thing felt" (241).

Helen and George remain silent. "They kissed but that impulse did not last." Slightly embarrassed, they "dropped into the animalism of youth. They laughed and began to pull and haul at each other they became, not man and woman, not boy and girl, but excited little animals" (242). They laugh again; George rolls down the hill; Helen runs after him. Then, with Helen holding George's arm, they walk away "in dignified silence" (243). Except for the momentary embarrassment after each rejects the tentative impulse to kiss, the entire episode is remarkably easy and spontaneous—certainly the only occasion in the book of such intensely felt companionship. The close emotional attention to external silence takes George and presumably Helen beyond the confines of self, and presents George for the first time with a consciousness of his neighbors as "his people," most vividly felt in their absence (241). The refusal of sex underscores the

inadequacy of sexual relationships apparent in the several stories that, deal with the subject. The recovery of the ability to play like children, even animals, is a physical expression of life and joy that is not sexual but is more satisfying than sexuality, perhaps because it is free of tension, aggression, and the awkward assumption of adult powers.[8] Although George realizes that "there is no way of knowing what woman's thought went through her mind," he feels little need to know and is not once disturbed by his own silence during the entire episode (242).

The experiencing of love and friendship through silence is very much in accordance with Emerson's and Thoreau's prescriptions for "love" and "friendship."[9] But ideal silence in Anderson is no transcendence of materiality and mortality, rather an untroubled acquiescence in one's normal mode of being. Otherwise in *Winesburg, Ohio* silence is almost always a handicap, a terrible disability resulting from what the inarticulate characters mistakenly regard as a crippling affliction that prevents intercourse with others. In "Sophistication" it is the opposite. Silence itself becomes the only and the essential mode in which love and understanding can be achieved.[10]

8. In an important passage in *A Story Teller's Story,* Anderson writes admiringly of animals, and associates man's unhappiness with his having a mind at all. The passage is also another advocacy of manual craftmanship: "Could it be that force, all power, was disease, that man, on his way up from savagery, and having discovered the mind and its uses had gone a little off his head in using his new toy? I had always been drawn toward horses dogs and other animals and among people had cared most for simple folk who made no pretense of having an intellect, workmen, who, in spite of the handicaps put in their way by modern life, still loved the materials in which they worked, who loved the play of hands over materials" (Sherwood Anderson, *A Story Teller's Story,* ed. Ray Lewis White [Cleveland, 1968], 197).

9. See Henry David Thoreau, *A Week on the Concord and Merrimack Rivers* (Boston, 1961), 289: "Silence is the ambrosial night in the intercourse of Friends, in which their sincerity is recruited and takes deeper root. . . . The language of Friendship is not words, but meanings. It is an intelligence above language." This transcendental view is also to be found in Emerson's "Love" and "Friendship."

10. In *Poor White,* published a year after *Winesburg, Ohio,* Anderson undertook to solve the problem of how to use a morbidly shy, habitually silent grotesque as the hero of a full-length novel. The problem is less solved than evaded, as the hero, Hugh McVey, becomes successful and influential not through asserting himself in society, but through his genius as an inventor—a nonsocial gift completely compatible with Hugh's absolute privacy of person. Although Hugh gains fame and wealth and even becomes a husband and father, he remains an enigma to himself, the reader, and the other characters, in-

II. *In Our Time*
THE AVOIDANCE OF SCENES

The connection between Sherwood Anderson and Ernest Hemingway is usually judged to be stylistic and formal. Particularly in their short stories, the use of simple language, basic sentences, and plotless situations suggests the influence of the older writer on the younger and a common literary philosophy. *In Our Time*, published six years after *Winesburg, Ohio* and like it a collection of interrelated short stories, may seem a more sophisticated or less heavy-handed adaptation of Anderson's aesthetic of simplicity. Certainly Hemingway maintains a greater distance from his characters than Anderson, who indicates little hesitation in directly assessing his characters and stating their innermost dreams. With few exceptions, Hemingway relates only their actions and their speech, and leaves the assessment and analysis to the reader.

The extreme economy of *In Our Time* implies that only the barest fragments of Nick Adams' life and "our time" have been represented. Although most of the characters in *Winesburg, Ohio* appear only in one story, we see much more of the character and the town than we do of Nick and his shifting communities. The Anderson story tells of an explicitly major event in someone's life (such as Reverend Curtis Hartman's spying from the bell tower into Kate Swift's room)—an event that epitomizes or radically alters a life. Hemingway's stories of accidental encounter and easy withdrawal seem too casual to be crucial, though they may be.

cluding his wife. His shyness with women must exceed that of any fictional hero on record. The novel develops less from Hugh's life and relationships with others than from Anderson's examination of the social and economic changes wrought on an Ohio town as the result of Hugh's inventions. The aggressive characters, full of pride and greed, are the kind of talkative people who occupy only the background of *Winesburg, Ohio.* Clearly Anderson regards Hugh with his "dreams" as vastly more interesting than the wealthy merchants who exploit his creations. But with the exception of his genius— itself a secondary dimension of Hugh's inner self—the character is totally inert, accurately imagined by his wife as "a horse that was humanized by the mysterious, hungering thing that expressed itself through his eyes" (Sherwood Anderson, *Poor White* [New York, 1920], 254).

Also the brevity of the stories and of the even slighter intervening sketches extends our sense of receiving only momentary glimpses of a mostly concealed private biography and public narrative. As critics suggest, *In Our Time* resembles an outline of a novel dealing with Nick Adams' development from childhood to adulthood. The Nick Adams stories may indeed constitute a skeleton of a novel, but a novel of such rigorous selectivity that we are required to speculate on what happens between the stories. The interpolated sketches of war and other violent situations are identified as chapters, as though to indicate the forward progression of a novel. In calling an unconnected paragraph a chapter, Hemingway almost belligerently disavows the responsibility imposed by tradition to regard a chapter as a segment of several thousand words related by character and story to other such segments.

The experimental nature of *In Our Time* obtrudes through its physical form, especially the slimness of the volume and the prominence of so many blank pages and portions of pages. Hiatus and interruption by silence are essential to Hemingway's form and subject. Nick Adams and characters like him experience life as a discrete intrusion into their privacy, and their inclination is always to withdraw into themselves. Hemingway's prose style and extreme discretion in reporting events reflect his characters' sense of experience and reveal the author's respect for it. The many empty spaces coming between brief patches of print indicate the willful silence of the author.

What is true of the book as a whole is true of most of the stories, particularly ones like "The End of Something" and "Big Two-Hearted River," which begin in a condition of unexplained tension that is only partly explained and partly resolved. The unexplained and the unmentioned become essential components of the stories. Reading a story in *In Our Time* is like studying one of Edward Hopper's paintings of solitary women in apartment rooms. The paintings, like the stories, reveal a tension of some kind, an emotion whose cause and most of whose components we must be ignorant of.

Hemingway seems to follow Anderson not only in rejecting conventional plots as untrue contrivances, but also in rejecting the con-

ventional assumption that an active participation in some kind of
social relationship is necessary for the shaping and fulfilling of char-
acter. As we have seen, most of Anderson's grotesques are radically
private persons, whether because of some wounding experience in
the past, because of a deep psychological inclination, or—as some of
the stories imply—because of human nature itself. Their frustration
from failing to gain love or friendship is, in part at least, the fault of a
society that ordains the importance of such close bonds with other
people and the importance of speech as the major means of achieving
them. The climactic story, "Sophistication," implies silence and iso-
lation to be honest and valid responses to the universal human condi-
tion of separateness. Using that story as a psychological standard, we
realize that the tormented protagonists of most of the other stories
feel and act neurotically because they mistakenly regard isolation as
a failure to be fully human. Isolation is nevertheless an inexorable
state and the grotesques achieve more humanity, or depth of emotion,
than do active participants in society like Tom Willard. Through Nick
Adams and a few other characters in *In Our Time*, Hemingway ac-
knowledges and endorses Anderson's attitude of necessary isola-
tion. With Nick, however, Hemingway extends (perhaps logically)
Anderson's position by showing isolation to be not only necessary,
but desirable and even pleasurable.

 A paradigm underlies most of the stories: Nick observes or is per-
sonally threatened by a situation of latent or actual violence and
withdraws from it. In "Indian Camp," the observed brutality of the
difficult delivery of a child and the suicide of the child's father are
often seen as Nick's initiation into the violent character of real life,
but in fact the boy chooses to remain uninitiated. At the end of the
episode, a willed naïveté prevails over the evidence of experience, as
"he felt quite sure that he would never die."[11] Of course, the reader
knows better. But as we read the succeeding stories, we discover that
for Nick and some other characters such a knowledge is best undis-

 11. Ernest Hemingway, *In Our Time* (New York, 1970), 19. Hereinafter cited paren-
thetically in the text.

covered or evaded. In "The Three Day Blow," Nick and his friend Bill maintain an artificial well-being as they drink whiskey and discuss baseball and literature before a warm fire in a snug cabin while a storm rages outside. The unpleasantness of the weather is comfortably evaded. When the conversation turns to the menacing subject of Nick's recent break-up with his girl friend, he easily casts off the pain with the help of the whiskey and the consoling companion, concluding that "none of it was important now" (49).

A strongly implied irony in this and other stories seems to point to Nick's immaturity. If the stories are ironic, the implied definition of maturity is the full acceptance of a life of pain, death, compromise, and frustration. Presumably one should willingly renounce the pursuit of pleasure because it is selfish and inconsistent with the actualities of suffering and death. But one must question whether the irony is Hemingway's or the reader's, though Hemingway has clearly devised the details (especially the endings) of the stories so as to raise in the reader's mind the issues of maturity, responsibility, and a truthful facing of facts. But if we challenge the hero's hedonism and escapism with our own concept of moral responsibility, the stories—especially in their aggregate—challenge the premise of the rightness of moral responsibility.

Like the Anderson hero, the Hemingway hero seeks happiness, but unlike the Anderson hero, he knows where to find it—in the pleasures of fishing, hunting, and skiing. The hinted irony reveals the immaturity, even cowardice, of these retreats from the limits of available happiness—what George Willard calls "sophistication." But the stories also reveal the inadequacy of understanding supplied by irony. That the irony is double-edged, or ultimately turned against itself, is clear from "Soldier's Home" and the relation of the story to the Nick Adams stories. In "Soldier's Home" the familiar paradigm is once again evident, but the story differs from "Indian Camp" and "The Three-Day Blow" by making a strong argument for escapism, uncomplicated by any suggestion of irony. In this story Hemingway associates maturity not with the acknowledgment of personal mortality or the responsibilities required by love and passion, but with bourgeois

respectability. The lesson of unpleasant reality is not now spoken indirectly through the hero's facile denials, but directly by the pious and platitude-dependent mother of the young man who wants a life without complications.

Emotionally exhausted less by the war than by the strain of returning to the small midwestern village where he is expected to resume his life as if there had been no interruption, Krebs wants to lead a quiet life with none of the complications or "politics" he associates with pursuing a girl friend and getting ahead in business (71). His mother finds Krebs's continued indolence rather indecent, while for Krebs—unlike an Anderson character—it is perfectly satisfactory. In his inactive isolation, he is neither bored nor lonely. He has no interest in a future, and he is content to relate to the world as a casual detached observer. Because of his war experience we are perhaps led to attribute Krebs's malaise to an exceptional traumatic disruption in his life. But to Krebs the war was mainly an exhilarating experience, not a distressing one. It is true that in the war "he had been badly, sickeningly frightened all the time," but he mostly thinks of his engagements in combat as "times that had been able to make him feel cool and clear inside himself when he thought of them; the times so long back when he had done the one thing, the only thing for a man to do easily and naturally, when he might have done something else" (69–70). His war experience supplies Krebs with a standard of simplicity against which to measure the complexity of living at home with his parents, feeling the pressure of finding a job and, especially, seeking a girl friend. His sexual relations were uncomplicated in Europe because there was no possibility and thus no expectation of speaking with the German and French girls. Combat was exciting though terrifying to Krebs, and being a soldier gave him a sense of his own worth; and there were no pressures beyond the requirements of each day's duties. Far from being shattered by the war, Krebs likes to read books about the battles he fought in and, if he could, would like to discuss the war with other veterans in an open and honest way. Krebs's pursued detachment is not very different from that of the uninitiated Nick Adams. The major difference is that Krebs lives in a

household ruled by an officious mother, whereas we see virtually nothing of Nick's mother in his stories; rather we see Nick with his father, his favorite hunting companion.

Krebs has the negative attitude of Melville's Bartleby the Scrivener and says almost as little. His preference to do nothing toward advancing himself with a woman or in a job comes from a considered judgment that any advantage gained would not be worth the effort, mainly the effort of talking. "He would have liked to have a girl but he did not want to have to spend a long time getting her. He did not want to get into the intrigue and the politics. He did not want to have to do any courting. He didn't want to tell any more lies. It wasn't worth it" (71). Whereas having a girl friend is mildly but insufficiently appealing to Krebs, he has utterly no interest in achieving economic and social success.

When Hemingway specifies the reasons for Krebs's preference for inactivity and nonengagement, he emphasizes Krebs's hatred of talking. Krebs liked being with the French and German girls because "there was not all this talking. You couldn't talk much and you did not need to talk" (72). Krebs is not one of Sherwood Anderson's inarticulate grotesques, but a man who regards any effort to convince someone else of his own views as a complicated ordeal and probably futile. Speech is either idle (in which case it is a waste of time), deceitful, as in the talk of boastful war veterans, or defensive, as in the conversation with his mother, who urges Krebs to become more responsible. The story progresses by capsuling each kind of dialogue. In the beginning we are told of Krebs's developing discomfort with the burden imposed upon him to boast of war atrocities he has witnessed, but before long "Krebs acquired the nausea in regard to experience that is the result of untruth or exaggeration" (71). The same kind of compulsion to be honest makes Krebs a monosyllabic respondent to his younger sister's innocent enthusiasms and questions. During a breakfast conversation with her, in which she strongly wants from Krebs an acknowledgment of a love that he does not feel, he distantly replies (while reading the paper) to a series of questions: "Yeah? . . . You bet. . . . I don't know. . . . Sure. You're my girl now. . . . Sure. . . .

Uh, huh. . . . Maybe" (74). When his sister leaves, his mother re-
sumes the questioning, but her tearful earnestness about the subject
of her son's future makes it impossible for him to answer with mere
evasive mumbling. Krebs, who can be comfortable with people only
when "you did not need to talk" (72), is now confronted with a series
of questions and demands full of quasi profundities and pious plati-
tudes, such as "There can be no idle hands in His Kingdom. . . . defi-
nite aim in life. . . . credit to the community. . . . All work is honor-
able," and—most aggravating of all—"Don't you love your mother,
dear boy?" (75).

Forced to respond to appeals to God and mother, Krebs first an-
swers honestly that he neither believes in God nor loves his mother.
But telling the truth is a more disastrous response to his mother than
to the townspeople who want sensational war stories from him. For
her only lies will do. "It wasn't any good. He couldn't tell her, he
couldn't make her see it. It was silly to have said [that he didn't love
his mother]. He had only hurt her" (76).

The episode forces Krebs's decision to leave. In *Winesburg, Ohio*,
George Willard makes the same decision in a similar confrontation
with his father, who demands ambition from the son as an obligation
to the parent. Like George Willard, Krebs rebels against the pursuit of
success not from laziness, but from a recognition of fraud in the ide-
ology of success so obvious in Mrs. Krebs's pietistic maxims. The
episode is more than disagreeable to Krebs; it places him in a false
position: "He had felt sorry for his mother and she had made him lie"
(77). The same is true of all of Krebs's conversations—the actual ones
with townspeople, which he has ended, and the hypothetical ones
with girl friends. To Krebs the only remedy is a total withdrawal from
his family, his only remaining human association. "He would go to
Kansas City and get a job and [his mother] would feel all right about
it. There would be one more scene maybe before he got away" (77).

The need to avoid scenes is the strongest motivation in *In Our
Time*. In "The End of Something," Nick provokes a mild scene with
his girl friend, Marjorie, as he ends their love affair, but the purpose of
the scene is really to avoid the more extended and threatening scenes

of a relationship that has passed from being "fun" to being an obliga-
tion (34). After Marjorie leaves, Nick's friend Bill arrives and asks:

> "Did she go all right?"
> "Yes," Nick said, lying, his face on the blanket.
> "Have a scene?"
> "No, there wasn't any scene." (35)

Like Krebs, Nick will be troubled for a brief time by the unpleasant-
ness of a short scene, but the suggestion is that he has escaped basi-
cally unscarred.

A number of the stories present the reader with far more difficulty
in assessing the validity, the morality, and especially the manliness of
walking away from disagreeable scenes than does "Soldier's Home."
In "The Doctor and the Doctor's Wife," Nick's father twice walks
away from unpleasant confrontations—first, from the Indian who
suggests that he is a thief and challenges him to fight and, second,
from his wife, who begins to discuss the first episode with a senti-
mental denial of any ill will by the Indian. When the doctor breaks
off the conversation with his wife and joins his son to hunt squirrels,
he certainly seems a coward. He will not fight the physically stronger
Indian and will not argue his case with his tedious and naïve wife.
Within its own limits, the story offers little to challenge the implica-
tions of cowardice that it raises, but in the context of *In Our Time* as
a whole, the cowardice is made to appear a legitimate and sensible
alternative to hopelessly entangling and profitless situations. Dr.
Adams duplicates Krebs's response to similar kinds of pressures to
assume postures of pugnacity and aggressiveness, and to participate
in conversations when he cannot accept the terms and moral at-
titudes of the person with whom he converses. Dr. Adams walks
away from the taunting Indian as Krebs does from the men who want
stories of incredible bravery, believing the vision of military life main-
tained by the townspeople to be a lie. Likewise, Dr. Adams walks
away from his wife, and Krebs from his mother, because they find the
simplistic moralizing of the women impossible to argue against.

The pattern is generally present also in "The Battler," in which Nick
Adams, threatened first by physical assault and then more subtly up-

set by discordant gentility, withdraws from the scene. He is momen-
tarily stunned, but there is no suggestion that the disturbing episode
has any lasting effect on him. The incident that leads directly to the
encounter with the battler and his companion may seem no more
than a functional transition, but its rhythm and ambiguity establish
the social pattern of the major events in the story. Nick has been
sneaking a ride on a freight train when a brakeman calls to him.

That lousy crut of a brakeman. He would get him some day. He
would know him again. That was a way to act.
"Come here, kid," he said. "I got something for you." He had
fallen for it. What a lousy thing to have done. They would never
suck him in that way again.
"Come here, kid, I got something for you." Then *wham* and he
lit on his hands and knees beside the track. (53)

After walking for a while, Nick comes upon the camp of a badly dis-
figured prizefighter and his black companion, and in this encounter
Nick experiences, as with the brakeman, a feigned hospitality and a
threatened assault. But in the more extended situation the relation of
offered kindness and actual menace is much more complex and there-
fore more sinister. As Nick walks toward the campfire, the battler,
Ad Francis, immediately acts belligerently towards him and (like the
Indian in "The Doctor and the Doctor's Wife") seems to be trying to
pick a fight:

"Get him [the brakeman] with a rock sometime when he's
going through," the man advised.
"I'll get him."
"You're a tough one, aren't you?"
"No," Nick answered.
"All you kids are tough."
"You got to be tough," Nick said.
"That's what I said." (55)

Ad soon becomes gentler with Nick and offers him food, but later
he imagines that he has been insulted by Nick and challenges him to
fight. Nick avoids a pummeling when the black man, Bugs, knocks

Ad out with a blackjack. In manner, the black man is the reverse of Ad, extremely polite and inappropriately formal. He apologizes to Nick—whom he calls "Mr. Adams"—cooks for him, and gives him a sandwich to take with him, "all this in a low, smooth, polite nigger voice" (62). As is his common practice, Hemingway tells nothing of Nick's thoughts or feelings. His words throughout are self-effacing and sparse; he agreeably responds to the others' talk and never introduces a feeling or attitude of his own. We see only his reactive motions: trying to avoid conflict, eating the offered food, leaving when Bugs suggests that he should. The scene has been momentarily threatening, but Nick has avoided a beating and is able to walk away.

The parallel between "The Battler," "Soldier's Home," and "The Doctor and the Doctor's Wife" is the disengagement of the hero from two antithetical kinds of unpleasantness, that of actual or spoken pugnacity and that of unctuous politeness. Like Krebs and Doctor Adams, Nick is addressed first in tough talk and then in sweet talk. Bugs's extreme gentility and formality are not only inappropriate for an encounter of tramps, but contribute an air of sinister hypocrisy to the relationship between the hideous and crazy former prizefighter and the sycophantic black man who must periodically knock him out and who is probably his lover. Bugs, with what Philip Young calls his "oppressive deference," has nevertheless been in jail "for cuttin' a man" and admits that he enjoys "living like a gentleman" off of Ad's money (61).[12] As in the other two-phased stories—those that present first an encounter with violence and then with gentility—the polite voice that urges decorum is not the antithesis of physical threat but a more sinister refinement of it. Like Mrs. Adams and Mrs. Krebs, Bugs uses his perfect decorum as an instrument of power.

With his friend George in "Cross-Country Snow," Nick can more comfortably speak his mind about the relative appeals of adult responsibility and youthful freedom—the stated issue of "The Three-Day Blow" and "Soldier's Home," and a concealed issue in other stories, such as "The Battler," which also represents a kind of family situa-

12. Philip Young, *Ernest Hemingway* (New York, 1952), 8.

tion with tensions not totally unlike those between Nick's parents. In "Cross-Country Snow," we learn that Nick's wife is to have a baby and that he must return to the United States. Nick does not quite agree with George that to give up skiing in the Alps for this kind of respectable life is "hell," but he has little enthusiasm for it (111). We surmise that Nick's future life as husband and father will be an interminable scene. As the story ends, he and George are extending the temporary avoidance of it by continuing their ski run. Nick's flight in the final lines of the story is, for the only time, merely a symbolic escape. For that reason, "Cross-Country Snow" seems anomalous and indeed contradictory to the repeated rhythm of the Nick Adams stories as well as some of the others. Violence and marriage repeatedly threaten Nick, but only here is he seen as subdued, unable to walk away.

The scenes that Nick and characters like him try to avoid (often successfully) seem mild discomforts in comparison to the brutal episodes that constitute the "chapters" that Hemingway inserts between the stories in *In Our Time*. But the nightmarish sketches, nearly all of which focus on gruesome murder, represent in extreme the kind of life that is to be avoided. They differ in degree but not in essence from the menacing, entangling, destructive situations that Nick and others instinctively wish to flee from. They are actually violent, while the stories are only latently violent and represent the private life of personal discord rather than the public life of war and its cognates— bullfighting and crime.

One major common subject of the stories and the sketches is childbirth, a process of nature that Hemingway seems compelled to represent as violent and grotesque. In "On the Quai at Smyrna" and "Indian Camp," the first two stories, and "Chapter II," which follows them, giving birth and the relation of mothers and their infants are depicted as gruesome. "On the Quai at Smyrna," an impersonal war narrative more like the chapters than the stories in form, style, and subject matter, introduces *In Our time* with the theme of the horrors of childbirth and child care. Describing the evacuation at Smyrna, the nameless narrator says: "The worst . . . were the women with dead

babies," even worse than "the women who were having babies . . .
Surprising how few of them died" (11–12). "Indian Camp," which
follows, is an especially brutal maternity story and, because of its
tranquil pastoral location and its place in the sequence, implies an in-
significant difference between wartime and peacetime. The most
horrible detail in the forced evacuation of Smyrna is matched in grue-
someness by the events in peaceful Michigan. In "Chapter II," a para-
graph concerning the evacuation of Adrianople, the unidentified nar-
rator reports, "There was a woman having a kid with a young girl
holding a blanket over her and crying. Scared sick looking at it" (21).
Since the next story is "The End of Something," in which Nick breaks
off from his girl friend, we draw an association between the horrible
actualities of childbirth and the youthful innocence of pastoral court-
ship, and perhaps speculate that the engagement of Nick and Mar-
jorie is well terminated. In "Cross-Country Snow," Nick's impending
fatherhood compels Nick to forego the sporting life and submit to
more conventional duties.

The epitomizing of childbirth as the locus of evil and the concen-
tration on mothers and infants (and a father) as totally undeserving
victims of suffering perhaps accounts for Hemingway's sympathetic
handling of the impetus to escape from difficulty that his characters
possess. All of the usual healthful and affirmative associations of pro-
creation—love, sexuality, growth—are savagely undermined in the
opening incidents and episodes of *In Our Time*. Those who survive
birth, like Nick, continue to be confronted with what Hemingway
shows to be the integral components of birth—mainly death, but also
the inevitable pain that results from sexual union and from simply
becoming an adult. In characters who repudiate mothers and lovers,
who resist the emotional eruption that witnessing a terrible birth and
consequent suicide would seem to necessitate, we see a desire to
undo the birth process. Especially within the comfortable and protec-
tive shelters of "The Three-Day Blow" and "Big Two-Hearted River,"
Nick Adams finds peace and pleasure in provisional wombs that for a
time are as satisfying as the freedom and exhilaration of skiing or
fishing, which are expressions of his need to be extricated from the

world of grim, heedless, destructive necessity, universally demon-
strated in the fact of childbirth.

Childbirth is not the only link between the oppressiveness of the
life that Nick resists in the stories and the violent sketches, nor is it
the most important. In several stories the protagonist disengages
from encounters with others marked initially by belligerence and
then by gentility. Physical threat is only more apparent than decorous
threat. In nearly all the sketches there is a radical discord between
the violent content and the vacuous style, a style that like the style
of Mrs. Krebs and Bugs may seem to soothe, but in fact causes dis-
cord. The chapters are of the genre of partially overheard mono-
logues, fragments of conversations, and war correspondents' dis-
patches. In those that sound like remarks overheard in a bar, we are
especially conscious of the frivolous tone of narrators oblivious to the
horror of their own reports. Several times the rhetoric is that of the
English sporting gentleman, while the content is that of massacre.
"Chapter IV" especially achieves unintended grotesque effects in its
discrepancy between language and subject.

> It was a frightfully hot day. We'd jammed an absolutely per-
> fect barricade across the bridge. It was simply priceless. A big old
> wrought-iron grating from the front of a house. Too heavy to lift
> and you could shoot through it and they would have to climb over
> it. It was absolutely topping. They tried to get over it, and we pot-
> ted them from forty yards. They rushed it, and officers came out
> alone and worked on it. It was an absolutely perfect obstacle. Their
> officers were very fine. We were frightfully put out when we heard
> the flank had gone, and we had to fall back. (37)

In tone the sketches vary from the extreme impersonality of the anony-
mous correspondent's report, to the misplaced jocularity of a British
officer's having an "absolutely topping" time in combat. The imper-
sonal tone, which expresses no emotion, is clearly more appropriate
than the tone of boyish enthusiasm, which expresses a false and
cheapening emotion. But both kinds of language shield the speaker
from expressing and probably from feeling the horror. No one in *In*

Our Time can honestly deal with pain. The recurrent attitudes toward suffering are to avoid it or to disguise it. The battler, the men who demand thrilling war stories from Krebs, Dr. Adams—who, after the surgery in "Indian Camp," felt "exalted and talkative as football players in the dressing room after a game" (18)—find violent situations the occasion for boastful and assertive masculinity. Others, like the doctor's wife, Bugs, and Krebs's mother, deny the existence of cruelty, for to them difficulties can be overlooked or masked by piety or gentility.

Nick and other protagonists face only the language of violence (and its opposite, the language that denies violence) rather than the actual violence that dominates the sketches. Their governing emotion, fear, may seem more appropriate for the war episodes than for the tamer domestic ones. But the impulse to avoid the scenes of social confrontation is by logical extension a desire to avoid the violence of war and the occasional language of genteel athleticism with which it is described.

In "Chapter VI" Nick himself appears as a character in the war. He is far from the idyllic Michigan of his boyhood.

Nick sat against the wall of the church where they had dragged him to be clear of machine-gun fire in the street. Both legs stuck out awkwardly. He had been hit in the spine. His face was sweaty and dirty. The sun shone on his face. The day was very hot. Rinaldi, big backed, his equipment sprawling, lay face downward against the wall. Nick looked straight ahead brilliantly. The pink wall of the house opposite had fallen out from the roof, and an iron bedstead hung twisted toward the street. Two Austrian dead lay in the rubble in the shade of the house. Up the street were other dead. Things were getting forward in the town. It was going well. Stretcher bearers would be along any time now. Nick turned his head carefully and looked at Rinaldi. "Senta Rinaldi. Senta. You and me we've made a separate peace." Rinaldi lay still in the sun breathing with difficulty. "Not patriots," Nick turned his head carefully away smiling sweatily. Rinaldi was a disappointing audience. (63)

The events of the sketch follow the structure of several of the stories: the battle is ending and now, with the arrival of the stretcher-bearers, the tidying up will begin. Mrs. Adams, Bugs, and a few other characters are similar pacifying forces in their stories, tidying up unpleasant situations like stretcher-bearers removing the dead and the wounded.

In announcing his decision to withdraw from the war, Nick extends and essentially repeats the pattern of withdrawal from unwanted engagement that we see in the Michigan stories. The war is an extreme situation, but still a "scene" on the order of Nick's difficulties with Marjorie and Krebs's with his mother. The implicit point of Nick's comment, "Not patriots," is the irrelevance of patriotic cant to the situation of death and destruction in which Nick lies wounded. The only expressions vaguely patriotic in the war sketches are the enthusiastic commentaries of two Englishmen who seem to regard combat as a sporting event.

Krebs, as we have seen, dissociates the talk about war from war itself. He likes to read books that describe the battles in the dispassionate tone of the more objective sketches in *In Our Time*. To Krebs the war reminiscences that he hears are mostly lies, as presumably to Nick the patriotic talk that he hears is mostly lies. Such talk, of course, we can only surmise, using as limited evidence the tone of voice of certain combat participants and the inclination of many of the conversants toward boastfulness and smugness in violent situations. Dr. Adams in "Indian Camp" is more awed by his professional competence than disturbed by the screams of the Indian woman ("Her screams are not important. I don't hear them because they are not important" [16]). Nick's accusation that his girl friend, Marjorie, knows everything is certainly unwarranted by the scant events of "The End of Something," which demonstrate only Nick's anger toward her, but the explicit or implicit charge by Nick, Nick's father, and Krebs against a girl friend, a wife, and a mother is that they speak with unwarranted certitude. They "know everything"; the male protagonist, on the other hand, doesn't "know what to say" (34).

Hemingway, like Sherwood Anderson, consistently identifies speech with falsity, and encumbers his protagonists with a surround-

ing chorus of banal voices uttering slogans that urge sentiment, man liness, and responsibility. These voices, which convey a widespread and acceptable opinion, make clear the impoverishment of available language. "The Three Day Blow" is a somewhat humorous exposure of the corrupt nature of conversation. The story is mostly two boys' wandering, disconnected dialogue on subjects they know very little about—baseball and literature. As a sympathetic parody of those adult conversations in which people announce opinions based on the frailest knowledge, the story shows the two boys voicing a skepti cism of received opinion ("There's always more to it than we know about" [41]) or having "inside" information themselves (John McGraw "buys all the ones he wants. . . . Or he makes them discontented so they have to trade them to him" [41]). The boys know very little about anything, but utter sage comments like "Everything's got its compen sations" and believe that "they were conducting the conversation on a high plane" (44, 45). After a few pages of rambling dialogue on re mote subjects, we learn that the true purpose of the talk is to avoid mentioning the subject of Nick's break-up with Marjorie. When Bill ultimately introduces the subject, Nick quickly ceases to be fluent and responds to Bill's words of approval with near total silence: "'I guess so.' . . . Nick said nothing. . . . Nick said nothing. . . . 'Sure.' . . . 'Yes.' . . . Nick nodded. . . . Nick sat quiet. . . . Nick said nothing. . . . 'Let's have another drink'" (46–47).

The baseball and literary talk, though somewhat pompous, is in nocuous; but when the conversation reaches a significant issue, Nick ceases to talk. He perhaps feels embarrassed, uncomfortable, and even guilty and regretful, but there is no doubt that his thoughts are confused. As in "The End of Something," he doesn't know what to say. Like many Hemingway conversations, the discussion about Mar jorie concludes with an evasion of the issue, though the evasion origi nates in true confusion, not fear or disdain. Nick says, "I oughtn't to talk about it," and Bill adds, "You don't want to think about it" (48). As the story characteristically ends with the boys getting their guns and going off to hunt, Nick feels that "none of it was important now" (49). Certainly the therapy of curing a problem by evasion seems

clinically questionable, so that the reader here, as in a number of
stories dealing with the hero's seemingly too easy dismissal of diffi-
culties, may well question whether Nick has been relieved of his
guilt and anxiety. But there is little doubt that Nick cannot talk about
it, either with Marjorie or with Bill, and that the talk in which he
does engage is a youthful mimicking of the kind of adult talk we hear
from his father and mother.

In Hemingway the discomfort with talk and the sense of its futility,
impossibility, and meaninglessness is almost as pervasive as it is in
Anderson, but there is much less agony and isolated desperation.
Hemingway's characters can easily get along without talk, and mostly
want to. Their discomfort comes from being placed in situations in
which talk is expected and is judged to be important by the antag-
onist forcing it. But in these brief stories the discomfort is short-
lived, and the protagonists may walk off to the healing comfort of the
woods.

One hero who does not quickly walk off is the central character in
"A Very Short Story," who, in violation of the Nick Adams principle
of severe caution in relations with women, falls in love with a nurse
in a military hospital and is betrayed by her. In the hospital they love
idyllically and with a childlike playfulness, making a "joke about
friend or enema" after she prepares him for his operation (65). The
wounded soldier must restrain himself from "blab[bing] about any-
thing during the silly, talkative time" when he is under an anesthetic
(65). After their separation, the soldier for a long time hears nothing
from the girl, but eventually he receives fifteen letters from her in
one mail delivery, each telling "how much she loved him and how it
was impossible to get along without him" (65). It turns out that the
nurse has deceived the soldier through the jokes and the letters, since
she rejects him for another man, and writes that "theirs had been
only a boy and girl affair" (66). The soldier's fear of blabbing while
under the anesthetic points to an instinctive fear of speaking, a belief
that one's talk should always be guarded. The instinct is justified by
the eventual revelation of the nurse's hypocrisy throughout the affair.

At the time of their separation, they argue about the nurse's deci-

sion not to leave immediately with him for the States: "They kissed good-bye but were not finished with their quarrel. He felt sick about saying good-bye like that" (66). Better to be like Krebs and Nick— suspicious of sentiment. "The Revolutionist" points to the safer course, that of the detached narrator who tells the story of the fear- less, naïve revolutionist traveling about Italy with his confident belief in the imminence of world revolution. In reference to Italy, the revo- lutionist says, "It will be the starting point of everything." The nar- rator says, "I did not say anything" (81).

The implied nihilism of the Hemingway hero derives from no tragic experience or philosophical skepticism. It is mostly an emo- tional disposition to keep life at a distance out of a preference for comfort—what feels good—over discomfort—what makes you feel sick. D. H. Lawrence's early assessment of Nick Adams seems more accurate than those of critics who find Nick a tragic hero. To Law- rence, the Hemingway hero "wants just to lounge around and main- tain a healthy state of nothingness inside himself and an attitude of negation to everything outside himself."[13] It should be added, how- ever, that the hero's experiences have given him valid reason for re- jecting entanglements with others.

The stories and sketches of *In Our Time* begin during the war and continue after it. The postwar stories have little of the delight in life of the early Nick Adams stories, and even the later sketches, con- cerning bullfighting and crime rather than war, omit the narrative voice of the naïve enthusiast who regards war as a schoolboy sport. "Mr. and Mrs. Elliot" marks a drastic shift in tone, method, and sub- ject. The early stories are terse and dramatic—single episodes of char- acters whose histories are undetailed, related by a detached, sharp- eyed observer. "Mr. and Mrs. Elliot" is loose rather than tight in form, and satiric rather than objective in style. The story is not a momen- tary episode from a life, but the account of several years in the lives of the title characters—themselves enervated and languid, as well as probably impotent and sterile. Their ruling passions are aestheticism

13. D. H. Lawrence, "*In Our Time*: A Review," in Robert P. Weeks, (ed.), *Heming- way: A Collection of Critical Essays* (Englewood Cliffs, N.J., 1962), 94.

and puritanism. In method the story reflects the lives of the characters; it lacks the nervous tension of the earlier stories. The restlessness of the effete characters and loose, meandering narrative is not the restlessness of a Nick Adams eager to move on, but that of bored people leading boring lives.

"Mr. and Mrs. Elliot" introduces what might be called Hemingway's marriage group. "Cat in the Rain" and "Out of Season" are more like the early single episode stories in method, but they resemble "Mr. and Mrs. Elliot" in their representation of the married state as tedious, boring, and marked by unresolved antagonism. But unlike Mr. or Mrs. Eliott, the men and especially the women in these stories at least recognize that their marriages are traps. The stories themselves might be regarded as scenes that cannot be walked away from. In each story the wife does temporarily leave the domestic situation of boredom and pettiness, led by an attraction to something more appealing (a quiet, manly hotelkeeper, a cat in the rain) or by a recognition of a husband's inadequacy (his cowardly submission to a drunken, avaricious Italian guide who pressures him to fish out of season). As in "Mr. and Mrs. Elliot," tedium and boredom are the dominant feelings, and only the repressed anger of the women indicates energy in the married couples. In each story an argument has taken place before the story begins, and the deepening, unconcluded, and never defined hostility creates the tensions underlying the trivial situations in the stories. In "Out of Season," the disagreement is mentioned only once.

> "I'm sorry you feel so rotten, Tiny," he said. "I'm sorry I talked the way I did at lunch. We were both getting at the same thing from different angles."
> "It doesn't make any difference," she said. "None of it makes any difference." (99)

The man withdraws from the renewed confrontation, trying to smooth over a problem with an irrelevance (in the manner of Mr. and Mrs. Elliot). Drastically changing the distasteful subject, he asks his wife: "Are you cold? . . . I wish you'd worn another sweater" (99).

The unhappy and uncommunicating couples in the marriage group recall the doctor and the doctor's wife, as does the title "Mr. and Mrs. Elliot." But there are important differences. Not only is the husband in the later stories a weakling, making the wife's bitchiness appear warranted, but Hemingway has reevaluated cowardice by reconstituting the nature of the evasive act. In the earlier stories it is preferable for Dr. Adams to withdraw from his wife to hunt squirrels with Nick and for Krebs to leave the family home. But the women in "Cat in the Rain" and "Out of Season" are not spokesmen for doctrinaire pieties; rather they regret (or seem to regret) an unfulfilled sexuality. The men share with Nick, Dr. Adams, and Krebs only a disinclination to talk, though their reticence seems founded more on fear and shame than on a belief that an honest dialogue can only be futile and cause pain to the woman. In *In Our Time* marriage is defined as an extended unpleasant scene that cannot be walked away from, but only ignored or not talked about. Nick suspects as much in "The End of Something." But by the time of "Cross-Country Snow," his unwillingness to discuss his marriage can only be a temporary evasion, appropriately placing this story within the marriage group.

The marriage stories present interludes in marriages probably full of such interludes, episodes that characterize the life before and after the episode. In the earlier Nick Adams stories, however, the dramatized interludes are disturbances in a freedom that is presumably unmodified during the long periods of time that Hemingway does not distill into stories—the periods of reading, hunting, and fishing. The early stories are scenes surrounded by the implied evasion or absence of scenes—weeks and months of uneventful, untroubled, and undiscussed experience.

Like "Mr. and Mrs. Elliot," "My Old Man" deviates from the one-episode story to record a series of events over a long period of time. Reminiscent of the early Nick Adams, the narrator, the young son of a jockey, mostly evades the corrupt reality of adult experience, delighting in the physical and aesthetic pleasures of horses and racetracks. The story restates the familiar Hemingway dialectic of an adult world composed of death, deceit, and betrayal impinging upon a child's world of innocence, freedom, and joy. Like Dr. Adams, the

boy's father slides awkwardly between the two kinds of life, or in his case, between the commercial and the sporting aspects of horse racing. From the boy's narrative, we glimpse only enough of the corruption to know of its existence and the father's involvement in it; but until the end, in which the father and his horse are killed, the boy—through the unusually free circumstances of his life—is able to savor his pleasures without worry or interruption. His father, we deduce, can for a time evade bothersome scenes with gamblers and horse owners by moving about Europe and by sitting at the Café de la Paix drinking coffee or whiskey, but there must finally be an end to his illusion of limitless freedom. As he completes his story, the boy has not acquired an unwanted maturity through a painful recognition of the harsh conditions of life. Instead, he wistfully complains that people and life are not fair: "Seems like when they get started they don't leave a guy nothing" (129).

In various ways, the stories of In Our Time endorse an evasion of dramatic development. When we witness the engagements of individuals with social forces, the prevailing emotion is a regret that it has to be that way. The striking exception is the final two-part story, "Big Two-Hearted River," the only instance in the book of an extended, developed narrative. It is drama willingly initiated and maintained by the major participant rather than quickly evaded or submitted to reluctantly. There is but one character in the story, and the other participants in the action are the nonhuman constituents of a fishing trip—a camp, a tent, a river, grasshoppers, and trout. By implication Nick has been through the war (an experience described only in the single paragraph of "Chapter VI"), and his nerves have been badly strained, for a good part of his effort in "Big Two-Hearted River" is to put his past behind him and to avoid thinking. He avoids thinking of the past by concentrating intensely on the present. But if Nick's state of mind is unusual, his mode of remedying it befits perfectly the needs and desires of Nick in earlier stories. "Big Two-Hearted River" is an extended pursuit of those sensations that make Nick feel "happy" and "good." The difference is that now he makes a meticulous, conscious effort to reexperience what years ago were unconscious rhythms. The necessary condition for the pursuit is solitude, a total absence

of other people. The perfect resolution of the Hemingway dialectic is thus the abolition of one of its two components: society in all forms, including the forms explicitly oppressive in earlier stories— girl friend, mother, people who die, annoying conversations, and imposed duties—and in the intervening sketches, especially the chaotic violence of war.

The silence of the action is not insisted upon but is a steady fact of the two-day adventure. When Nick on a few occasions briefly speaks (he utters clowning rhetorical responses to a grasshopper and to his food), the effect is slightly startling: "Nick was hungry. He did not believe he had ever been hungrier. He opened and emptied a can of pork and beans and a can of spaghetti into the frying pan. 'I've got a right to eat this kind of stuff, if I'm willing to carry it,' Nick said. His voice sounded strange in the darkening woods. He did not speak again" (139). The river, Nick's beloved antagonist in the story, "made no sound" (137). Nick's silence collaborates with the silence of the setting. Thus the story strikingly contrasts with the other stories, which are dominated by evasive and falsifying dialogue, and even the sketches, which are full of screaming, hysterical people—mothers, soldiers, and bullfight spectators shouting in pain, anger, or derision. But it contrasts not primarily as tranquility contrasts with discord but as reality with unreality. Silence is the condition in which things, very simple things, can be clearly seen and the self may honestly relate to the external world—albeit a part of the world that is completely nonhuman and physical.

As an almost completely "satisfactory" climax to *In Our Time*, "Big Two-Hearted River" raises basic questions about the applicability of Hemingway's morality of escapism to a usable aesthetic of fiction—not the very short stories of easy withdrawal but longer narratives in which protagonist and author seem to assume at least the possibility of some benefit to be gained from social experience, which in itself must be looked upon as complex and full of surprises rather than as simply boring or entrapping.[14]

14. It should not be surprising that Jake Barnes, who relates Hemingway's next book and first novel, *The Sun Also Rises*, is not only a detached narrator, indifferent to most of the social events he reports and enthusiastic only about fishing and bullfighting, but a

As though to respond to this question, Hemingway makes of Nick's fishing expedition a narrative that does contain dramatic tension and variety. The nonhuman participants are actors in the drama, made relevant by the attention that Nick pays to them. More important, to Hemingway an engagement with those natural actors is far richer, more interesting, and more exciting than an engagement with girl friends or mothers, or even boy friends and fathers: "He stepped into the stream. It was a shock. His trousers clung tight to his knees. His shoes felt the gravel. The water was a rising cold shock. Rushing, the current sucked against his legs. Where he stepped in, the water was over his knees. He waded with the current. The gravel slid under his shoes. He looked down at the swirl of water below each leg and tipped up the bottle to get a grasshopper" (148). The nervously active sentences convey the detailed and complex dramatic interplay between Nick and the various natural forces. The relation of the man to the elements of nature has the rhythm of the conversation in a Henry James novel, wherein there is a constant parrying and thrusting, an offensive and defensive verbal exchange of conversationalists who seek their own advantages against the knowledge, powers, and skills of others.

In spite of the exclusively natural situation of camping and fishing, "Big Two-Hearted River" must seem an artificial experience because Nick has carefully predetermined the conditions of his engagement. As an outdoorsman, he leaves as little as possible to chance. The drama is largely directed by Nick and lacks the element of the arbitrary and the accidental that we may feel to be inescapable in real life, and the elements without which life is not very interesting. But as we must know by the end of *In Our Time*, "real life" to Hemingway is excessively governed by arbitrary, accidental, and irrational forces. The chaos of war is but an exaggeration of the violence of "Indian Camp" and "The Battler." In the outwardly tranquil stories, human tensions cannot be resolved through sensible compromises or the use of reason. There is some legitimacy to Nick Adams' artificial

detached character. Although an agony for him, his impotence prevents an intimacy with women and thus ensures the freedom that *In Our Time* shows to be an essential need for the Hemingway hero.

construction of his own drama—a drama that might be regarded as merely imitated or symbolic living to some, though certainly actual to the participant and to the author. Again, the unlikely parallel of Henry James is useful, for in the mostly civilized communities that James deals with, coherent codes of manners provide restraints and defenses against anarchy analogous to those that Nick looks for in the wilderness.

The fishing expedition offers Nick the opportunity to impose moral restraint on the urge of impulse. With a puritanical obsession with thrift, duty, and cleanliness, he delays and modifies his pleasures. Unlike his social experiences, his fishing experience can be controlled; it can be adjusted to his private principles of rationality and order. Although we mainly perceive the activity as an athletic and aesthetic one—the perfection of simple physical pleasures by the application of ideas of order—it is also, by the slightest extension, a moral one, based on the belief that no joy should be taken until it is earned, that indulgence should be tempered by restraint. Unlike the simple pleasure-seeking Nick of the early stories, the older Nick pursues his delights with an awareness of the importance of duty. Here only we see him as an adult. At the end of the story, he decides against fishing in the swamp, the place where fishing would be too difficult and the rules of order and control inappropriate. Hence to Nick, "in the swamp fishing was a tragic adventure" (155)—like life itself, a situation in which civilized conduct is irrelevant and futile.

Thus, even in the fishing expedition there can be no complete liberation from chaos. Likewise, the expedition is not wholly ritual drama, played according to coherent rules. It is also what it most superficially appears to be—an escape from life. This is nowhere more obvious than in the details of Nick's preparing his tent and crawling into it.

> Inside the tent the light came through the brown canvas. Already there was something mysterious and homelike. Nick was happy as he crawled inside the tent. He had not been unhappy all day. This was different though. Now things were done. There had been this

to do. Now it was done. It had been a hard trip. He was very tired.
That was done. He had made his camp. He was settled. Nothing
could touch him. It was a good place to camp. He was there, in the
good place. He was in his home where he had made it. (139)

Inside the tent, where "nothing could touch him," it is not certain
that Nick has found an ideal womb, but he has certainly found his
great good place, an actual rather than imagined refuge from pain and
discord that to Nick (unlike James's George Dane) becomes real and
deserved because he himself has carefully arranged it.

In the interlude between the two parts of "Big Two-Hearted River,"
during which Nick sleeps in "the good place," the reader confronts
"Chapter XV," the report of the hanging of Sam Cardinella. In a world
of such scenes, we sense that there is moral validity in the felt need
to escape into a snug tent, falling asleep in anticipation of a day of
fishing, in which the exertions and conflicts may be adequately or-
dered by the mind and the will.

THE DISCUSSION of Anderson and Hemingway has been restricted
to their first books not just because these works seem to be their
finest achievements, but because they are experiments in fiction that
point to a crisis in American realism. A case could be made that the
subsequent careers of Anderson and Hemingway demonstrate that
the novel itself was an inappropriate form to convey the kind of nega-
tiveness toward social experience that is the central emotion in both
Winesburg, Ohio and *In Our Time.* The American novel of the twen-
ties and thirties presents us with a great number of passive drifters
and failed heroes, to varying degrees idealistic, trying against all odds
to achieve some romantic goal in turbulent social situations. But if
we consider characters like George Willard, Seth Richmond, Nick
Adams, and Krebs as at all normative, it must seem that the careers
of such figures as Frederic Henry, Eugene Gant, Jay Gatsby, and Miss
Lonelyhearts must be misguided from the start. The early careers of
Anderson and Hemingway do not predict the greater accumulations
of incident and detail and complication of experience that we expect

to find in novels, but rather the greater intensifications of simple private experiences that we find in the climax stories—that is, "Sophistication" and "Big Two-Hearted River." In these speechless stories, George Willard and Nick Adams have obliterated their public and social identities. If the earlier stories in each volume represent the struggles to shrug off the harassments of both an impinging world and the conflicting desires of the ego, the concluding stories represent all the triumph that seems possible.

In "Sophistication" and "Big Two-Hearted River," the protagonists most fully attain a silence that in the earlier stories is threatened, assaulted, or attained with doubt and confusion. The pressures of society and self to pursue fulfillment in social relationships are indeed powerful, so that only the death of a mother and the experience of combat—that is, only the most severe kinds of initiation into pain—can convince the protagonist of the conditions in which the world may tolerably and validly be apprehended.

When we last see George Willard and Nick Adams they have achieved a sense of their own stable identities in relation to the universe. George at the deserted fairgrounds and Nick on the riverbank have gained a liberation from the urgent demands of accident, incident, sexuality, society, and time—of time as a succession of hurried ' moments rather than as stasis, at least the illusion of stasis. While it may well be that "Sophistication" and "Big Two-Hearted River" are stories that seal off all further fictional directions for the writers, especially the would-be novelists, the stories do provide a basis for other kinds of art. The kind of art that could expand the psychological, metaphysical, and spiritual intuitions of the climactic stories of Anderson and Hemingway would most likely veer toward the mystical and would not be so tolerant of temptations toward the usual forms of excitement and delight that recurrently disillusion George Willard and Nick Adams.

The silences with which *Winesburg, Ohio* and *In Our Time* conclude are the silences that are the necessary preliminary conditions for the important works of James Agee, Walker Evans, and Edward Hopper. The stance of the artist of silence is that of rather somber

but untroubled withdrawal from the turbulent world. The withdrawal allows the artist the perspective to observe the energies and essences of the world that must be concealed if the intelligence itself is absorbed in the frenzy of day-to-day life. In their confused ways, George Willard and Nick Adams ultimately come to possess the condition of silence, though it is less the attainment of the full capacities of silence than the struggle to escape the destructive din that accounts for the peculiar intensities of their stories.

Three

JAMES AGEE

I. *Let Us Now Praise Famous Men*
MEDITATIONS ON THE PORCH

THROUGHOUT his extensive film criticism, one of James Agee's most emphatic convictions is that there is too much talking in the movies. His article "Comedy's Greatest Era" seems a reactionary polemic against the talkies. To Agee silent comedy is funny not in spite of its silence, but largely because of it. Such comedians as Chaplin and Keaton, he writes, "learned to show emotion through [their medium], and comic psychology, more eloquently than most language has managed to, and they discovered beauties of comic motion which are hopelessly beyond reach of words." By contrast, Agee wryly notes, "the only thing wrong with screen comedy today is that it takes place on a screen which talks."

Agee's reactionary ideas about silence and speech—though he would not term them such—are not absolute.

A sound of silence on the startled
 ear
Which dreamy poets name "the
 music of the sphere."
Ours is a world of words: Quiet we
 call
"Silence"—which is the merest
 word of all.
All Nature speaks, and ev'n ideal
 things
Flap shadowy sounds from visionary
 wings—
But ah! not so when, thus, in realms
 on high
The eternal voice of God is passing
 by,
And the red winds are withering in
 the sky."
EDGAR ALLAN POE
"Al Aaraaf"

He resents the excessive talking of the talking pictures, "the American addiction to word-dominated films." To him the only film of the hundreds that he reviewed for *Nation* and *Time* that justly employs a good deal of speaking is Olivier's *Henry V*. Otherwise, films "have to know the value of pantomime, and they have to know when to shut up." What is the basis of Agee's belief? A good deal derives from his extreme visual responsiveness, his lifelong love of photography. Movies, to him, are primarily to be seen. They are literally "motion pictures," and the motion is less important than the picture. Of a wartime military documentary he writes, "There is frequent intelligent use of an excellent device which ought to be recognized as basic film grammar: the shot introduced and given its own pure power, for a few seconds—it ought often to be minutes—without sound, music, explanation, or comment."[1]

Agee's aesthetic of silence might be regarded as little more than an idiosyncratic taste, a preference of the visual to the auditory. If so, however, it is no shallow, sentimental, or perverse reaction to the routine films of the thirties and forties. Agee took all of his writing, even the most ephemeral, with extreme seriousness, and he was not given to thoughtlessly advance ideas, aesthetic or otherwise.

Agee's ideas about silence in films are less important for their own sake than for their vital relevance to the two books judged his finest works, *Let Us Now Praise Famous Men* and *A Death in the Family*. If one familiar with those two books should take the trouble to reread them, pencil in hand, looking for references to silence, he would be astounded. The very words *silence* and *silent* run through the works as an insistent theme, a positive control and unifying emphasis. Agee introduces us to the rural Alabama setting of *Famous Men* with a view of a tenant farmer's house encapsulated in silence: "There was no longer any sound of the setting or ticking of any part of the structure of the house. . . . There was no longer any sound of the sinking and settling . . . nor was there any longer the sense of any of these

1. James Agee, *Agee on Film* (2 vols.; New York, 1969), I, 3, 4, 40, 155, 79.

sounds, nor was there, even, the sound or the sense of breathing."[2] And four hundred pages later, at the end, Agee writes that "talk drained rather quickly off into silence" (428). *A Death in the Family* begins, so memorably, with a father and son going to a silent movie and walking silently home, and ends with the boy and his uncle walking "all the way home . . . in silence."[3]

Although Agee may seem willfully eccentric in the strange organization and stylistic shifts of some of his works, especially *Famous Men*, he is obviously a conscious artist and craftsman. Thus it can be argued that his persistent and obtrusive preoccupation with silence is neither an irrelevant accident nor a careless obsession; it is integral to his most fundamental purposes as a writer. It is a passion, but always controlled, always understood.

The reader may be forgiven for finding *Famous Men* an irritating book. It is not simply that it is eccentric in method, apparently formless, and admittedly unfinished; it is also a cranky work. Agee's regular confessions of his problems in writing it and his equally regular celebration of the importance of his effort are everywhere and intrusively present. Like a number of twentieth-century books, it has as a theme its own composition and existence. Agee insistently tries to tell us what he is trying to do, and just as insistently confesses his failure.

But when the reader carefully matches the numerous program notes (or guidelines to the reader) with the commentary on the lives of the tenant farmers, he may reach some understanding. It is in this respect that Agee's obsessive attention to silence is of key importance. The interpolated clues to the reader consistently refer to photography and music as useful analogies for his book. I should not say "his" book, as Agee makes emphatic his belief (an aesthetic principle and not an instance of modesty or humility) that the photographs of Walker Evans represent a contribution as important as his own. Evans' sixty-one photographs of farmers, landscapes, interiors of rooms, and

2. James Agee and Walker Evans, *Let Us Now Praise Famous Men* (New York, 1966), 19. Hereinafter cited parenthetically in the text.
3. James Agee, *A Death in the Family* (New York, 1957), 339.

other rural details are not, we are told, simply illustrative of the text. They are, to use a favorite Agee word, a counterpoint to the text. As the authors devise the formal structure, the photographs comprise Book One, the text Book Two. Evans' photographs are remarkably vivid and evocative. To Agee they suggest an ideal that his own writing cannot possibly achieve. In the first extended passage of Book Two, the first of many outrages against his own medium, he notes: "If I could do it, I'd do no writing at all here. It would be photographs; the rest would be fragments of cloth, bits of cotton, lumps of earth, records of speech, pieces of wood and iron, phials of odors, plates of food and of excrement. Booksellers would consider it quite a novelty; critics would murmur, yes, but is it art; and I could trust a majority of you to use it as you would a parlor game" (12). Agee regularly reminds us that he demands from his prose nothing less than absolute honesty and truth; it is an impossibility. Part of this conviction develops from his rather astounding view that "everything in Nature, every most casual thing, has an inevitability and perfection which art as such can only approach" (210). Thus the photograph is more effective than the word: "One reason I so deeply care for the camera is just this. So far as it goes (which is, in its own realm, as absolute anyhow as the traveling distance of words or sound), and handled cleanly and literally in its own terms, as an ice-cold, some ways limited, some ways more capable, eye, it is, like the phonograph record and like scientific instruments and unlike any leverage of art, incapable of recording anything but absolute, dry truth" (211). The photographer's medium is a direct access to what is Agee's highest ideal for all art— the truth: "The artist's task [in photography] is not to alter the world as the eye sees it into a world of esthetic reality, but to perceive the esthetic reality within the actual world, and to make an undisturbed and faithful record of the instant in which this moment of creativeness achieves its most expressive crystallization."[4]

Although not as much as photography, music also stands in Agee's

4. James Agee, *A Way of Seeing: Photographs of New York by Helen Levitt* (New York, 1965), 4.

mind as an aesthetic medium superior to writing. Music creates a direct emotional effect through its formal manipulation of pure sound. By contrast, language lacks the actuality of the photograph and the purity and direct emotional ordering of music. All language is more or less false to its subject, a distortion of nature and thus a blasphemy. Photography, which comes closest to duplicating a thing in itself, and music, which provides harmonic analogies to essential life rhythms, can avoid the debasement inherent in all language. Of course, some forms of language are more corrupt than others. Thus in *The Morning Watch* there is a running contrast between biblical rhetoric and the vulgarisms of the schoolboys. But in *The Morning Watch* the prayers that draw Richard's attention are often too abstract, formal, archaic, and demanding to do justice to his complex and contradictory feelings ("How can you say things when you only ought to mean them and don't really mean them at all?"[5]). Richard's striving for sanctity is frustrated through the prescribed language of sanctity.

Although Agee never quite says that language is an artifical construct, he insists that it inevitably interferes with a reader's apprehension of a subject; it is a translation of an experience rather than a rendering of it. Clearly then, one reason for Agee's celebration of silence is a severe awareness (based markedly on his own creative frustration) of the limitations of language. As a way of expressing feelings, words "are the most inevitably inaccurate of all mediums of record and communication" (213). In Agee's scheme, the opposite of silence is not primarily sound, but the spoken word.

In a section of *Famous Men* devoted to the education of farm children, Agee attacks "literacy" itself as a highly questionable value. As in his venomous attack on a writers' questionnaire sent by the *Partisan Review*, he contemptuously denounces the educated for being themselves illiterate ("Few doctors of philosophy are literate" [278]) and regards their intellectual and verbal sophistication as empty pretentiousness. To be educated and literate is to be deprived of the sense of immediate experience; literacy is a criminal perversion of

5. James Agee, *The Morning Watch* (New York, 1976), 47.

"consciousness," and "the discovery and use of consciousness, which has always been and is our deadliest enemy and deceiver, is also the source and guide of all hope and cure, and the only one" (279). The anti-intellectualism of the passage, though extreme and consistent with the sentiment of the entire book, is no simplistic primitivism. The peasants are "by virtue of their [verbal] limitations among the only 'honest' and 'beautiful' users of language" (279), and yet they are also severely crippled through their mental helplessness and their blindness to their own selves and relationships. But, in effect, the implicit ideal of a naïve and honest responsiveness in possession of consciousness is, and must be, unrealizable. In actuality the peasant experiences and communicates with an honesty that the literate intellectual cannot approximate. Given such a choice, wordlessness is preferable.

In the book's most extensive segment on fictional method, Agee criticizes the assumption by naturalists that an accumulation of data conveys reality. For all of his fidelity to fact, the naturalist cannot "communicate simultaneity with any immediacy" (213). Nevertheless, considerable portions of *Famous Men* constitute some of the most exhaustive, if not excessive, accumulations of sheer data on record. A seventy-page segment in the center of the book titled "Shelter: an Outline" describes in painstaking detail the objects that to Agee suggest fundamental qualities of the farmers' lives. In what may be regarded as an apologia for this section, in which Agee "spies" (his own recurrent word) on "a house of simple people which stands empty and silent," he states "that there can be more beauty and more deep wonder in the standings and spacings of mute furnishings on a bare floor . . . than in any music ever made" (121). With Vermeer-like precision, and indeed tenderness, he describes such static and "mute" details as shoes, overalls, contents of drawers, textures of wood, and kitchen utensils. Agee pushes language in the direction of photography, always stressing the stillness and motionlessness of the objects observed.

In his descriptions Agee confesses to "neglect[ing] function in favor of esthetics" (181). It is the look—and touch, smell, and sound-

lessness—of things that he describes and celebrates. The flimsy rooms and makeshift clothes to Agee are things of beauty; in a way the idea is analogous to his sense that the farmers' futile struggle with language is beautiful. "[The] partition wall of the Gudgers' front room *is* importantly, among other things, a great tragic poem" (182). The style of the descriptive segment is less ornate than that of the meditative parts, but the aesthetic evaluations are both elaborate and daring. It is Agee's achievement that they are not ridiculous or hyperbolic. In the four pages devoted to overalls, Agee uses an exacting, seemingly mathematical style to convey shape, color, and texture, but he also inserts extravagant metaphors to relate the lifeless overalls to the beautiful energies of life and art. Thus: "The edges of the thigh pockets become stretched and lie open, fluted, like the gills of a fish" (242). The texture and color of a worn overall achieve a "scale of blues, subtle, delicious, and deft beyond what I have ever seen elsewhere approached except in rare skies, the smoky light some days are filmed with, and some of the blues of Cézanne" (242). So too, the fabric of the overall suggests "the feather mantle of a Toltec prince"; the shoulders a "full net of sewn snowflakes"; and the wrinkles "old thin oilskin crumpled, and the skin of some aged person" (243).

The totally serious celebration of overalls reveals Agee's attraction to the nonorganic. He explicitly questions "whether there is anything more marvelous or valuable in the state of being we distinguish as 'life' than in the state of being of a stone" (204). In Evans' photographs people seem interchangeable with objects. Pictures of people, alone or in groups, are (or seem) arbitrarily placed next to pictures of shacks, shoes, beds, and wagons. The human figures have a rigidly posed look; even for photographs they are oddly frozen, statuelike— quite the opposite of the captured moment that some photographers try to achieve. There is very little drama in *Famous Men*. When Agee does present characters directly, he generally renders them as still and motionless. Often, as in the "Shelter" section, they are not the "active" dwellers in the house or the wearers of the clothes, but rather subordinate appendages to the objects. Their identity is felt only indi-

rectly. Thus the passive voice dominates, as in "The spectacles are worn only on Sunday" (236).

Agee's preoccupation with the inanimate is not to be interpreted as a belittling of the animate. To him the significant quality of things is a human quality; things derive their beauty from the humans who create and use them, and Agee himself responds to them with his humanness, especially his aesthetic sensitivity. But in approaching the quality of farm life from such an odd direction, he reveals a point of view that, to him, truly and profoundly evokes the essence of rural existence and all existence.

Agee's point of view is aesthetic, but it is also religious. To Agee aesthetics and religion are one. The chairs, beds, and rooms of the farmhouses are sacred objects. The language that represents them should ideally be the language of prayers, though always they must be "beyond designation of words" (92). Agee explicitly states his religious conviction, and though it is anything but dogmatic, he is quite literal in his intention to inquire "into certain normal predicaments of human divinity" (xiv). The divinity of the farmers and their otherwise worthless possessions is apprehended through exhaustive static description (or photographic representation). The intense observation of a still person or, more often, a still object begins to convey the transcendent quality of that person or object. But whatever transcendent clarity and truth may be recognized must dissipate when characters and objects are placed in motion. In all of Agee's works there is a fundamental incompatibility between essence and action, between the true identity of someone or something (its unique character, its divinity) and the merely superficial expression that is revealed in movement, or in speech.

For all of its diverse movements and styles, *Famous Men* is at its core meditative. The central framing portions are chapters entitled "On the Porch," one at the beginning, one in the center, one at the end. In each Agee describes himself as on the porch at night, lying sleeplessly on a pallet; his consciousness is acutely alert to soundlessness, though it is a sensation that he is only gradually to recog-

nize as a religious experience. In the first and briefest "On the Porch,"
he is absorbed in a sensation of the entire world at rest: "Fish halted
on the middle and serene of blind sea water sleeping lidless lensed;
their breathing, their sleeping subsistence, the effortless nursing of
ignorant plants; entirely silenced, sleepers, delicate planets, insects,
cherished in amber, mured in night, autumn of action, sorrow's short
winter, waterhole where gather the weak wild beasts; night; night:
sleep; sleep" (20). The vision, reminiscent of Whitman's "The Sleep-
ers," is a tentative association of the silent sleepers with the processes
of creation.

In the second "On the Porch," Agee again evokes Whitman, though
here he is more detailed in detecting the inner processes stimulated
in him by lying at night on the silent porch: "All the length of the
body and all its parts and functions were participating, and were be-
ing realized and rewarded, inseparable from the mind, identical with
it: and all, everything, that the mind touched, was actuality, and all,
everything, that the mind touched . . . turned immediately, yet with-
out in the least losing the quality of its total individuality, into joy
and truth, or rather, revealed, of its self, truth, which in its very nature
was joy, which must be the end of art, of investigation, and of all
anyhow human existence" (203). This sense of the fusion of mind and
body, of self and nonself, of the actuality of thought and feeling, and
of the achievement of "self, truth, and joy" should be familiar to read-
ers of Emerson, Thoreau, and Whitman. Agee celebrates a "sense of
wonder" (204). The private experience on the porch validates his dis-
affection with "consciousness," or intellectualism, just as it validates
his sense of the marvelous and his religious sensibility.

The final "On the Porch" is of quite a different order, and will be
treated in a somewhat different context. But as Agee writes in the
second "On the Porch," "the silence under darkness on this front
porch [is] a sort of fore-stage to which from time to time the action
may have to return" (219). If the action of the book (what little there
is) seldom returns to the literal porch, it often returns to the con-
templative mood and religious attitude of the porch sections. Agee
defines his religious attitude most explicitly (or less emotively and

hazily) in a section entitled "In the Front Bedroom: The Signal." Again he is lying still, now at dawn, awaiting the day. A little comically uncomfortable in his Emersonian stance as "bodyless eyeball" (168), Agee judges that "what is taking place here, and it happens daily in this silence, is intimately transacted between this home and eternal space" (168). That is to say, the Ageean "still point" is the apprehension of the mystical oneness of the cosmos and the unique individual self. Silence itself is implicitly the catalyst, the atmosphere in which the distinctness of the specific and the limitlessness of the whole are both grasped. This fusion seems the essence of Agee's religion.

If the silent art of photography provides an analogy to Agee's literary effort, the same is no less true of what may seem the precise opposite form of art—music. In a letter he stated, "I want to *write symphonies.* That is, characters introduced quietly (as are themes in a symphony, say) will recur in new lights, with new verbal orchestration, will work into counterpoint and get a sort of monstrous grinding beauty—and so on."[6] And in *Famous Men* he remarks, "The book as a whole will have a form and set of tones rather less like those of narrative than like those of music" (220).

It is not accidental that the form of *Famous Men* is superficially bizarre. It disdains chronology, narrative order in any conventional sense, and arrangement of material in chapters. Agee clearly seeks an organic (self-creating) form, whose models are to be found not in literature, but in nature and music. The theory derived from music stresses balances and contrasts, harmonies and counterpoints. The model from nature is most richly elaborated in an account of the life of rivers.

> As by benefit of that sped-up use of the moving camera through which it is possible to see the act of growth continuous from seed through the falling of the flower, so we may see in five minutes' time the branchings and searchings and innumerable growth of a river system, like a vine feeling out and finding its footholds on a wall, or like those subtlest of all chances which out of the very

6. James Agee, *Letters of James Agee to Father Flye* (New York, 1962), 47.

compasture of an acorn ordain upon the growing action of branches in unresisting air certain shapes and not others: this eternal, lithe, fingering, chiseling, searching out the tender groin of the land that the water in a river system is carrying on in ten million parts of a face of earth at once. . . . There is no need to personify a river: it is much too literally alive in its own way." (227)

By implication Agee's book, like a river, will find its own inevitable form: "an organic, mutually sustaining and dependent, and as it were musical form" (10).

The counterpoint of sound and silence is only one component of the complex musical and organic structure of *Famous Men*. Far from simple, the contrast is perhaps the key to the form and content of the entire book.[7] It is certainly the dominant musical device and is itself both a literal manipulation of sound and soundlessness and a literary equivalent of a principle of musical composition. In a movie review Agee noted that "Gluck, and Beethoven, in some of their finest music, were acutely aware of silence."[8] The various silences in *Famous Men* exist in contexts of sounds—of animals, work, cooking, storms, talking, and even the voice of the writer. Thus the contrast of Evans (the picture) and Agee (the word), introduced through the two-part form of the book, is a musical motif, parallel to, yet distinct from, numerous other variations on the silence-sound counterpoint.

The values of silence have already been considered. If silence is related to religious vision, sound is usually (though, significantly, not quite always) a disruptive intrusion—a suggestion of chaos rather than order, of "consciousness" rather than naïve intuition, of violent disturbance rather than passive reverence.[9]

7. The liturgical form of the book, indicated by the titles of some sections, is by comparison mechanical and superficial.

8. Agee, *Agee on Film*, I, 304.

9. The opening scene of *The African Queen*, for which Agee wrote the screenplay, gains most of its dramatic force from a contrapuntal sound pattern similar to that which recurs in Agee's books. As the camera moves slowly from the surrounding jungle to the missionary settlement, the sounds change from the silence of the jungle, to the harmonious animal sounds of the jungle, to the hymn being sung in the shelter, to the organ and the voices of the white missionaries. Abruptly the piercing whistle of the boat, *The African Queen*, obliterates all silence and sound. In the course of the film the episodes

The pattern of silence, then silence disturbed by sound, and ultimately silence restored is introduced in several anecdotal episodes at the beginning of the book. Three brief dramatic episodes immediately follow "On the Porch:1." In the first, called "Late Sunday Morning," Agee describes his introduction by a foreman to a group of blacks. The blacks, fearful and embarrassed, "hovered quietly and respectfully in silence" (27). Then they are prodded by the foreman to sing, to entertain the visiting journalists: "After a constricted exchange of glances among themselves . . . they sang. It was . . . jagged, tortured, stony, full of nearly paralyzing vitality and iteration of rhythm, the harmonies constantly splitting the nerves" (28). Agee further stresses the harshness of the sounds: "the screeching young tenor, the baritone, stridulent in the height of his register" (29). But suddenly, as before the singing, "they were abruptly silent, totally wooden" (29). When commanded they sing again, and the pattern is repeated. To Agee the episode reveals the degradation of the blacks, forced to be amiable entertainers of the northern white guests. Blacks figure very slightly in *Famous Men*, but the identification of intrusion with violent sound, so apparent in this episode, recurs frequently.

Thus the next brief section, "At the Forks," relates another intrusion into privacy: Agee and Evans ask directions of a group of people on the front porch of their farmhouse. These people, suspicious, even hateful (justifiably Agee feels), seem to be still photographs, sitting "as if formally, or as if sculptured, one in wood and one in metal," constantly watching the stranger (32). Like the blacks in the previous scene, they "communicat[ed] thoroughly with each other by no outward sign of word or glance or turning, but by emanation" (32). As Agee requests directions, quite suddenly "the older man" of the group has a violent fit, and like the song of the blacks it is described so as to make it appear exaggeratedly raucous and hideously discordant. The man "came up suddenly behind me, jamming my elbow with his concave chest and saying fiercely *Awnk, Awnk*." He continues "this blasting of *Awnk, Awnk*." He "nod[s] violently in time to his voice

of intense recognition—of love, of the coming into the lake—occur in periods of extended silence.

and root[s] over and over this loud vociferation of a frog." A woman, seeking to pacify him, gives him a piece of bread: "He took [it] in both hands and stuck his face into it like the blow of a hatchet, grappling with his jaws and slowly cradling his head like a piece of heavy machinery, while grinding, passionate noises ran in his throat." As Agee leaves the scene, the man continues "honking" and "coughing like a gorilla" (34). It is a hideous verbal portrait, almost totally in terms of sounds. Yet, suggestive as it is of a Nathanael West creation, it is not a savage caricature. In the six-page episode, it is Agee's failure to be other than patronizing, his own unintentionally cruel intrusion, that is hideous. To his mind he callously "causes" the agonizing coughing. A calm is restored only when he leaves the house, in effect because he leaves it.

The farm people in *Famous Men* are helplessly innocent; they are fragile, docile, gentle, easily victimized. The quietness of their lives is carelessly devastated, often by machines. When a simple farm girl named Emma is forced to marry a much older man, the symbol of the cruelty is the harsh sound of the truck that carries her away forever. Like the automobile of Jay Follet in *A Death in the Family*, the truck is a monster of terrible noises, and these are described in extreme detail: "The engine snaps and coughs and catches and levels on a hot white moistureless and thin metal roar, and with a dreadful rending noise that brings up the mild heads of cattle a quarter of a mile away the truck rips itself loose from the flesh of the planed road" (64).[10] The violence of Emma's leaving is a moment of noise in a vast placidity that precedes and succeeds it. The murderous moment in time is finally absorbed by the timeless. Thus the Emma passage, in a section called "A Country Letter," is introduced by one of the most elaborate celebrations of silence in the book. The night before Emma's departure, Agee responds to the religious quality of the stillness.

10. In *The Night of the Hunter*, for which Agee wrote the screenplay, the sounds of the cranking of a Model T Ford evoke a horror similar to that caused by the engine sounds in *Famous Men* and *A Death in the Family*. As the viewer watches the sleeping children in an upstairs room, he hears the loud, raucous, and prolonged noise of their stepfather's automobile outside the house. As the viewer shortly learns, the car contains the dead body of the children's mother, whom the stepfather has murdered.

"The light in this room is of a lamp. Its flame in the glass is of the dry, silent and famished delicateness of the latest lateness of the night, and of such ultimate, such holiness of silence and peace that all on earth and within extremest remembrance seems suspended upon it in perfection as upon reflective water: and I feel that if I can by utter quietness succeed in not disturbing this silence, in not so much as touching this plain of water, I can tell you anything within realm of God" (49).

The evocation of silence extends for seven pages. Then it is morning and Emma departs in the grinding truck. Afterwards the family sits about the house: "The talking is sporadic, and sinks into long unembarrassed silences" (68). And the silences gradually control the house and the mood as the night falls and the people go to bed.

The lives of the tenant farmers in *Famous Men* are ruled by the simple pattern of work and rest, and the dominant rhythm of silence alternating with sound steadily suggests that pattern. The sounds of work are nearly always extremely harsh, even tortuous. When a saw cuts down a tree, "the air is one rich reeking shriek" (88). A "whistle is cut off like a murder" (88). A cotton gin "is working in the deafening appetites of its metals" (312). What these hideous noises suggest to Agee is nothing less than "the savageness of the world," just as "the unconscious, offhand, and deliberated cruelty" of the farmers toward animals and blacks reflects an intrinsic "sadism in the South" (98, 194).

The cruelty of rural life is based on intrusion and exploitation, on a denial of personal dignity. Thus Agee is always sensitive to his own intrusive, inevitably exploitive role. Banal excerpts from tattered newspapers and calendar ads similarly disrupt the calm. The otherwise irrelevant response to the *Partisan Review* questionnaire, in which Agee's tone is unfamiliarly angry, shatters the usual stillness of the book. Also blatantly "noisy" is the purely gratuitous insertion of a newspaper interview with the fashionable photographer Margaret Bourke-White, which clashes stridently not only with the philosophy of photography implied in the Walker Evans photographs but with the solemn and ritualistic concluding sections.

Certainly the last pages of *Famous Men* are the most solemn and ritualistic, as well as the most poetic and philosophical. In the final fifty pages Agee also achieves a kind of synthesis between silence and sound, heretofore irreconcilable opposites. He describes an especially violent summer storm, focusing on a frightened family huddled together in its shack. As is usual, the description of the storm is primarily and hyperbolically in terms of its sounds.

> The wind has suddenly sunken as if cut, the dry storm being over, the orchestra arrested of its bullying *tutti*, and among the quivering flocculence of vegetation, which knows well to expect another blow, no sound as such at all, yet a quality of withdrawal, of tension, which is part smell, part temperature, part sound, a motion of withdrawal as of wide hands armed with cymbals: the exhausting odor that breeds of dynamos, a searching change to coldness, a sound from all the air as of a sizzling fuse, a blind blattering of thunder and brightness, silence again, so steep, and down it, water like trays that bursts four inches wide in a slapping of hands. (358)

The family remains silent during and after the storm, but afterward a real sense of change has been effected. At the same time that "there is everywhere such a running and rustling, gurgling sound of water," there is a profound stillness within the house (365). Agee experiences an extreme delicacy of closeness to the strangers he is sitting with: "I felt as of a new level, a new world" (363). He finds "the music of what is happening" during and after the storm understandable only through the analogy of the visual arts: "What began as 'Rembrandt,' deeplighted in gold, . . . has become a photograph" (367). Fear has evolved into love. What is unique in the episode is the ambiguity of violence. The storm is not simply an agent of terror; it is also mysteriously an agent of comfort.

A similar fusion is found in the final "On the Porch" section, which concludes the book. "On the Porch: 2," two hundred pages earlier, ends with the rather baffling sentence, "From these [woods] a good way out along the hill there now came a sound that was new to us" (229). "On the Porch: 3" returns to the same episode and is mostly an

inquiry into the new sound. Like the storm, "this sound immediately stiffened us into much more intense silence" (421). It is an animal cry, rather the cries of two animals, speculatively identified as foxes. After his minutely detailed description, Agee comes to regard the cry as "a work of great, private and unambitious art which was irrelevant to audience. . . . as perfect a piece of dramatic or musical structure as I know of . . . [that] carried with it an excitement beyond what is possible to bear" (424). Agee's total reaction is very complex, involving laughter, pain, "a kind of fear and deep gentleness," sexual love, and religious ecstasy (424). "In the sound of these foxes, if they were foxes, there was nearly as much joy, and less grief. There was the frightening joy of hearing the world talk to itself, and the grief of incommunicability" (426).

Agee's extensive account of "what seemed [the] infallible art" of the fox call might be regarded as his own "Ode to a Nightingale" (427); it is also his "Out of the Cradle Endlessly Rocking." As he bewilderingly remarks in a footnote, he has experienced "the explosion or incandescence resulting from the incontrovertible perception of the incredible" (426). Silence is transcended by a sublime music that partakes of the silence and completes it.

Such an effect is apparently Agee's intention, but nowhere is the book less satisfactory than in the conclusion. Indeed Agee seems betrayed by his failure to adhere to his own conviction that language cannot convey the sacred. The effort to transcribe the cry of foxes is a legitimate effort—and a successful one—and the association of the cry, less symbolically than psychologically, with transcendence is in a tradition of romantic literature. The parallels to Keats and the nightingale, Whitman and the mockingbird, and Thoreau and the loon may be intentional. But the overall effect is a failure and calls attention to the unfinished and tentative nature of the book as a whole. Throughout most of *Famous Men* silence and sound essentially register the "actuality" of rural life in Alabama. The final poetic "harmony," surely meant to be something like a revelation, if not an apotheosis, is solely a private vision. As deeply felt as it is, the cry of the foxes is less a resolution than an appendage. A finality is achieved

through a peaking of emotional intensity, not through a poetic logic. But even so, Agee remains honest to his private vision. Finally, *Famous Men*, in spite of Agee's wish to be as objective as a camera, is a very personal reaction—mainly aesthetic and religious—to a world in which he must always be alien. The rhythms of silence and sound to which he is ever alert gain their force and significance from the author's responding imagination.

II. *A Death in the Family*
BEYOND WORDS

As a novel about death *A Death in the Family* is a compassionate, tender rendering of the responses of the surviving family. The major characters—Jay Follet, the suddenly killed thirty-seven-year-old father, his wife and two small children, and their close relatives—are seen mainly through their relation to each other, through their existence in a family. The book is rich in their shared histories, their Knoxville and rural Tennessee roots, the simple and suddenly horrible details of their day-to-day being. Agee reveals the strain created by the extraordinary on the ordinary—of unexpected death as it affects characters with rather secure and prosaic lives. As Agee turns his focus in what seems a random fashion on the thoughts, feelings, and doings of the Follets—mainly the boy, Rufus, and his mother, Mary—his close attention to detail creates a sense of deep caring for these people; he subordinates whatever religious, philosophical, and even aesthetic concerns he may have to an unyielding conviction that the Follets in themselves matter preeminently.

In each of his major works Agee risks an overly solemn and reverential estimation of his subjects. The Maundy Thursday vigil at a prep school in *The Morning Watch* is for Agee less an instance of a boy's anguished embarrassment at a failed religious experience (something on the order of *A Portrait of the Artist as a Young Man*) than it is an unironic empathizing with the boy's limited achievements in vicariously experiencing the sufferings of Christ. As Agee describes and praises the lives and possessions of the sharecroppers of *Let Us* .

Now Praise Famous Men, his tone is solemn and his style lyrical. He represents himself as a person only fitfully capable of the humility and religious awe that should be the responses of one reporting the "actuality" of three tenant families in rural Alabama. Like the boy Richard in *The Morning Watch*, the narrator of *Famous Men* strives for both absolute humility and absolute exaltation, never questioning the justness of such responses and the inadequacy of anything less. Of *A Death in the Family*, Dwight McDonald mildly complains that "the book has its *longueurs*, and very long *longueurs* they are sometimes."[11] These seem to derive from Agee's belief that whatever the Folletts do (eat breakfast, idly talk, get lost on the road) is important. (The practice accords with Agee's aesthetic of the camera: the camera responds to every slight detail within its view.)

Thus there is little comedy in Agee's books, and what satire there is focuses on those incapable of appreciating the worth of ordinary people, such as New York journalists or writers of children's textbooks. Agee's fits of satire are invariably angry. To him, the pompous self-righteousness of a Father Jackson and the platitudinous civic-mindedness of the textbook writers are nothing less than blasphemous. They are outrages against the sanctity of life. Agee's letters to Father Flye support the impression given by his formal publications of a man not only deeply religious but deeply Christian, though in instinct (what he called his "shapeless personal religious sense"[12]) rather than in formal affiliation. Agee's Christianity influences his books almost solely in his incarnational sense of life—or, as Robert Fitzgerald puts it, his "profound and sacramental sense of the natural world."[13]

Agee's efforts to attain a delicate solemnity are apparent in his incorporation of liturgical rhetoric into his own styles and structures. In *The Morning Watch* the language of the New Testament fuses with Richard's personal meditations. The structure of *Famous Men* is

11. Dwight McDonald, "Jim Agee: A Memoir," in David Madden (ed.), *Remembering James Agee* (Baton Rouge, 1974), 132.

12. Agee, *Letters of James Agee to Father Flye*, 184.

13. Robert Fitzgerald, "A Memoir," in Madden (ed.), *Remembering James Agee*, 90.

explicitly paralleled to that of the Mass. Christian prayers for the
dead, never abbreviated but always fully reported, have an important
place in *A Death in the Family*. In each work the poetic language of
Christianity, in its mystical more than its theological significance,
encourages us to view the human experiences from an incarnational
point of view. What Agee says of *Famous Men* is also true of his two
novels: "This is an independent inquiry into certain normal predica-
ments of human divinity."[14] In Christian terms a belief in "human
divinity" is no more outrageous than Hopkins' celebration of the "im-
mortal diamond" that is man precisely because of Christ's becoming
man. Christianity is also important to Agee because it offers a view
of life as solemn ritual, though there are views of life achieving the
same effect that Agee sometimes offers himself.

Agee's sense of religious reverence toward his material directly re-
lates to his passion for still photography. For in addition to its star-
tling lucidity, photography (that of Brady, Atget, and Evans) has the
merit of achieving a total apprehension of the subject. With custom-
ary excess Agee says of *Let Us Now Praise Famous Men*, "It is in-
tended that this record and analysis be exhaustive, with no detail,
however trivial it may seem, left untouched." In embracing a pho-
tographic aesthetic that excludes selectivity and hierarchy, Agee im-
plicitly acknowledges a kind of absolute undifferentiated love for
everything. Also, the camera, in its precision, is the instrument of art
that can best reveal the uniqueness of everything. What Agee ad-
mired in photography was its capacity to convey both finely detailed
individuality and a transcendence of the ordinary. In his writing Agee
seeks to emulate the camera not just in "the subtlety, importance,
and almost intangibility of the insights or revelations or oblique sug-
gestions," but even in achieving "a firm quality of the superhuman."
As Wright Morris has suggested, there is in certain photographic
portraits, especially nineteenth-century daguerreotypes, an iconlike
quality, a magisterial precision and stillness that is a transcendence of

14. Agee and Evans, *Let Us Now Praise Famous Men*, xiv.

ephemeral existence.[15] The photographic portrait therefore is the most obvious way of representing the "human divinity" of "single, irreparable, unrepeatable existences."[16] Agee's opinions represent extreme exaltations of both art and the subjects of art. Implicitly also they explain the reason for art, which is essentially to convey the religious character of life.

If there is a religious dimension in Agee's work, one evidence is that social relationships count for little. Thus the experiencing of grief in *A Death in the Family* may seem remarkably selfish. The child Rufus is never seen to be mourning or even missing his dead father; he looks for ways in which to transfer the loss into a personal gain—for example, by boasting to his schoolmates that his father is dead. Even the wife Mary dwells mostly on the sudden drastic rearrangement in her own sense of who she is and how she will live. Richard in *The Morning Watch* rarely thinks of his family, and has the thinnest affection for his schoolmates, whom he (like Rufus) regards more as competitors than as friends. The family members in *Famous Men* are only incidentally associated with each other.

The most important relationships in the books tend to be cosmic and existential. Agee's characters are most fully revealed when alone, when the environments that engage them are nonhuman ones, like night, silence, a house, or a sky. In *Famous Men* the leading character (if not, indeed, the only character) is Agee himself, and the curious logic of that book consists in Agee's conveyed sense that he most accurately reports the lives of the farm people when he is alone "on the porch" meditating on the closeness of his place in time to absolute being, or when he finely describes the houses and possessions of the people, who are themselves not present. In *A Death in the Family* the special occasions of insight are not the conversations of the family but meditative moments like "Knoxville: Summer, 1915" or Rufus and his father sitting silently on a rock at night.

15. Wright Morris, "In Our Image," in Vicki Goldberg (ed.), *Photography in Print: Writings from 1816 to the Present* (New York, 1981), 537.
16. Agee and Evans, *Let Us Now Praise Famous Men*, 9.

It is an undisguised fact that Agee's three extended prose works are autobiographical. He presents himself as a child in *A Death in the Family*, as a young adolescent in *The Morning Watch*, and as an adult in *Famous Men*. In each case he is fundamentally isolated, a rather aloof person, so introspective as to seem solipsistic. Although each book marks a progress toward objectivity, toward a lessening of the identification of author and central character, clearly Agee is always most comfortable when he directly relates his own emotions. This is not to say that he lacks control. But it seems that one of his efforts as a writer is to find means of making coherent the bonds between his inner life and the outer world. That he is only secondarily a dramatic writer—one engaged with personal relationships—by no means compels us to regard him as a self-indulgent romantic poet employing the superficial form of the novel or the documentary. Yet it remains true that Agee's most important character is himself and that among the principal realities that engage his imagination are the nonhuman.

The stance that Agee favors in both his fictional and nonfictional writings is the perspective of the camera. Although he lacks what is perhaps the essential faith of the novelist—a faith in the capacity of action and speech to advance the understanding of the truth of human life—he is to the core a believer in realism. Agee's passion for photography is a passion for the truth of surfaces. He seems never to tire of reiterating his confidence in the ability of the physical world to manifest its secrets to both the "unassisted and weaponless consciousness" and the camera: "in the immediate world, everything is to be discerned, for him who can discern it, and centrally and simply, without either dissection into science, or digestion into art, but with the whole of consciousness, seeking to perceive it as it stands . . . and all of consciousness is shifted from the imagined, the revisive, to the effort to perceive simply the cruel radiance of what is."[17]

In Agee's fiction the moments of static discernment are always in opposition to the lengthier periods of conversation. When a character

17. *Ibid.*, 11.

responds to "the cruel radiance of what is," the superiority of his vision to all the "knowledge" conveyed by speech is vividly clear. In *A Death in the Family*, the major instance of the superiority of photographic intelligence to any other kind is the scene in which Rufus simply "sees" the dead body of his father and thereby absorbs the meaning of death to a degree that all the well-intended instructions by the adults cannot begin to approach. Agee accentuates the opposition between visual and verbal knowledge by making nearly all of the adult discourse obviously distorting and insincere. As a way of communicating, language in the novel is always clumsy and fraudulent; it is dishonest even when it is meant to be truthful.

A Death in the Family is Agee's only work that fully presents characters in conversational situations, and their speech is almost always strained. At the beginning of the book, after Jay is summoned by a late night telephone call to see his father, who is believed to be dying, he and Mary communicate their concern for each other only through mute gestures, such as making breakfast and turning over a blanket to keep a bed warm. Speech is oddly impossible. "Because of the strangeness of the hour, and the abrupt disruption of sleep, the necessity for action and its interruptive minutiae, the gravity of his errand, and a kind of weary exhilaration, both of them found it peculiarly hard to talk, though both particularly wanted to."[18] The strain of inarticulateness continues after a few awkward words about eating breakfast, and Agee remarks that "they had nothing to say. They were not disturbed by this, but both felt almost the shyness of courtship" (35). This scene is marked by deep feeling and gestures of love, but it also suggests some defect in the marriage by the inability of husband and wife to speak to each other.

Similar awkwardness abounds in the book, and problems of verbal communication are given an uncommon emphasis. Four of the twenty chapters begin with telephone calls, of which the first three are dramatically and emotionally significant. The call from Jay's

18. Agee, *A Death in the Family*, 34. Hereinafter cited parenthetically in the text.

brother, Ralph, summoning him to their father's bedside is particu-
larly incoherent because Ralph is drunk and the hour is late. Nothing
is ever quite understood.

> "Yeah?" [Jay] said, forbiddingly. "Hello."
> "Is this the residence of, uh . . ."
> "Hello, who is it?"
> "Is this the residence of Jay Follet?"
> Another voice said, "That's him, Central, let me talk to um,
> that's . . ." It was Ralph.
> "Hello," he said. "Ralph?"
> "One moment please, your party is not connec . . ."
> "Hello, Jay?"
> "Ralph? Yeah. Hello. What's trouble?" For there was something
> wrong with his voice. Drunk, I reckon, he thought.
> "Jay, can you hear me all right? I said, 'Can you hear me all
> right,' Jay?" (23–24)

The second call, the report of Jay's automobile accident, is nearly as
discordant and disjointed as the first. Later the news of Jay's death
must be reported to relatives in the country, and once more Agee spe-
cifies the mechanical problems and necessary inadequacy of telephone
communication. The telephone, like Mary's mother's ear trumpet,
regularly figures in the novel as an ironic symbol of an inhibiting
means of communication. The unsophisticated characters of *A Death
in the Family* are repeatedly uncomfortable with the telephone be-
cause it is an impersonal machine that denies them the visual con-
tact that is always more important to them than speech. For speech
nearly always fails. Mary waits with her aunt Hannah for news of
whether Jay is dead or alive, and the two women experience an awk-
wardness together much like the earlier one between Mary and Jay:
"Mary did not speak, and Hannah could not think of a word to say. It
was absurd, she realized, but along with everything else, she felt al-
most a kind of social embarrassment about her speechlessness" (131).
Later, after the long family gathering following the news of Jay's
death, Hannah and Mary are again alone together, as awkward as be-

fore in embarrassed uncommunicativeness: "There was an odd kind of shyness or constraint between them, which neither could understand. They stood still again, just inside the living room; the silence was somewhat painful for both of them, each on the other's account" (203).

A Death in the Family contains a number of incidental touches bearing on the problem of verbal communication. The phrases "beyond utterance" and "beyond words" are stock responses of Mary and her mother to aspects of Jay's sudden death. Rufus is at an age when the reality of words and the reality of experience are imperfectly related to each other, and many of his confusions stem from his failures to resolve these differences. Rufus learns words before he knows their meanings, and invests them with a special value if they are obscure or difficult. He boasts to Walter Starr:

> "I can say some ever so big words. . . . Want to hear? The Dominant Primordrial Beast."
>
> .
>
> "Now what does the word 'primordrial' mean?"
> "I dunno, but it's nice and scary." (301)

Words recurrent in adult accounts of Jay's accident, like "embankment" and "concussion," are meaningless to Rufus, but for that reason mysteriously significant to him.

If Mary is linguistically evasive in telling Rufus that his father is dead (as she is in preparing him for the birth of his sister), Rufus himself receives the information matter-of-factly. "Is Daddy *dead?*" he asks his mother. Then a bit later, "He said to himself: *dead, dead*" (252). Seeing his father's corpse, "he thought over and over: 'Dead. He's dead. That's what he is; he's dead' . . . he . . . said to himself, over and over: Dead, Dead" (316). Rufus has learned the meaning of the word. As the words *dead* and *death* are evaded by his mother, whose own softening analogies seek to shield Rufus from anguish but only confuse him, so he ever exists in a world in which language is a betrayal, both through conscious (if often well-meaning) deceitfulness and the inherent inaccuracies and ambiguities of words. Rufus, who

has been taught that to "have an accident" means to wet one's bed, can only be perplexed when told that his father was "put to sleep" by God because "he had an accident. . . . He knew it could not be that, not with his father, a grown man, besides, God wouldn't put you to sleep for *that*, and it didn't hurt anyhow" (258).

Excessive politeness, which always frustrates communication among the adults, is the underlying principle of their constant, if incidental, instructions to the children. The children, naïve enough to require an elementary logic and consistency from the adults who would educate them in the matters of life and death, expose the fraudulence of a communications system grounded in euphemism. Thus Mary's desperate efforts to find solace in religion are undercut by Rufus' common sense curiosity.

"Grandpa is getting old, and when you get old, you can be sick and not get well again. And if you can't get well again, then God lets you go to sleep and you can't see people any more."

"Don't you ever wake up again?"

"You wake up right away, in heaven, but people on earth can't see you any more, and you can't see them."

"Oh."

"*Eat*," their mother whispered, making a big, nodding mouth and chewing vigorously on air. They ate.

"Mama," Rufus said, "when Oliver went to sleep did he wake up in heaven too?"

"I don't know. I imagine he woke up in a part of heaven God keeps specially for cats."

"Did the rabbits wake up?"

"I'm sure they did if Oliver did."

"All bloody like they were?"

"No, Rufus, that was only their poor little bodies. God wouldn't let them wake up all hurt and bloody, poor things."

"Why did God let the dogs get in?"

"We don't know Rufus, but it must be a part of His plan we will understand someday."

"What good would it do *Him*?"
"Children, don't dawdle. It's almost school time." (56)

The breakfast scene, an entire chapter, gives a good insight into the dynamics of the Follet family. The mother, who resists the child's pleas for coherence through sentimental evasions, is herself exposed as sentimental and evasive, and her clear discomfort leads her to assume the more comfortable role of one who gives commands. Most of the commands are on the order of keeping quiet (children—and husbands as well—dutifully eating breakfast cannot talk).

On the only occasion that Mary fully expresses her grief she does so not through words, but through gross physical motions quite inconsistent with the decorum she regularly demands of her children and herself. The episode begins with her insistence that the children be quiet when looking at their father's body. As is common, her euphemism for death betrays her.

"It will be just as if he were asleep, so you must both be just as quiet as if he were asleep and you didn't want to wake him. Quieter."
"But I do," said Catherine.
"But Catherine, you can't dear, you mustn't even think of trying. Because Daddy is dead now, and when you are dead that means you go to sleep and you never wake up—until God wakes you."
"Well when *will* he?"
"We don't know, Rufus, but probably a long, long time from now. Long after we are all dead."
Rufus wondered what was the good of that, then, but he was sure he should not ask. (286)

The imposed quiet is interrupted by Mary's struggle to repress hysteria: "Suddenly she pressed her lips tightly together and they trembled violently. She clenched her cheekbone against her left shoulder, squeezing their hands with her trembling hands, and tears slipped from her tightly shut eyes" (287). Mary is overwhelmed by anguish,

but not to the point of making noise. Soon recomposed, she tells her children, "Be very quiet and good" (287).

Mary's mother, Catherine, has an oddly comic function. She is kind and gentle, but almost totally deaf. At the long family vigil she regularly asks others to speak louder and repeat themselves, while thrusting her useless ear trumpet in the direction of whoever is speaking. Further, she speaks with exaggerated formality and has considerable respect for the importance of verbal clarity. When the conversation moves to the epigraph Mary chooses for Jay's gravestone—"In His Strength"—Catherine is concerned. She wonders "whether people will quite—*understand* it . . . I've always supposed it was the business of *words*—to *communicate—clearly*" (176). Her concern is doubly ironic: for deaf Catherine, words seldom communicate anything, and they seldom communicate clearly for anyone. The conversations of *A Death in the Family* are strained silences, pious euphemisms, garbled telephone exchanges, and improvised prayers (once Rufus thinks his mother is praying when she speaks to him, and almost says "amen" when she finishes). The only kind of conversation in which family members can engage effectively is the exchange of factual information. Thus in the long chapters immediately following the report of Jay's death, most of the discourse has to do with the concrete details of how he died. Andrew's minutely explicit account, interspersed with questions and repetitions, provides a way for all of the group to avoid their deepest feelings of grief and terror. The question of why Jay died and the fact that he is dead are more comfortably dealt with by focusing on the question of how he died.

Failure of speech derives in part from the various divisions that actually separate the family members, who would evade the differences through their feeling that affection for each other should transcend them (Mary feels guilt for disliking Jay's father). Crucially the love of Mary and Jay is deeply modified by their religious differences: Mary is an especially devout Anglican and Jay an unbeliever. Mary's father, a skeptic in religion, believes that "it was the whole stinking morass of churchiness that really separated them" (143). Also Jay's drinking habits create a distance between the two. There are impor-

tant barriers of age within the family, though the importance of age is exaggerated by Mary, who is as patronizing toward her parents as she is toward her children. The extended family of in-laws, uncles, aunts, and grandparents in its own way is an artificial community, as is the neighborhood. Aunt Hannah is uncomfortable in Mary's house, never fully sure that Mary really wishes her to stay; the friendly neighbor, Walter Starr, feels awkward when involved in another family's death and being the recipient of its perfunctory graciousness. Agee stresses these matters; he dramatizes the distances between seemingly intimate people. Also he emphasizes geographical separateness, the emotional consequences of people living in different houses and different communities. Mary is for a long time unaware of whether her husband is dead or alive.

Jay's death is itself primarily an extension of the isolation that is the true condition of everyone. The curiously solemn irony of the novel stems partly from Agee's representation of death as the final estrangement among persons always basically estranged from each other. Agee plays regularly on what is to him the terrible ambiguity of the word *home*. To go home is to go to the comfort of family, but that is never so satisfying as to go home to one's inner self, or, as in the song that Jay sings to Rufus, to die: "Swing low, sweet chariot, coming for to carry me home." Returning home from a movie, Jay dawdles, preferring to sit silently in a vacant lot. A few hours later he is inwardly pleased at the opportunity to leave home after being summoned to his father's bedside, to the country, which is also his home. "Home" in the sense of one's immediate family is always a kind of fiction; to go to the home of domestic warmth is to leave the home of one's private being.

The problems of speech encountered by the characters in *A Death in the Family* thus point to the deeper problem of some primal estrangement. The principal characters—Jay, Mary, and Rufus— are estranged because they identify themselves with their love for others and that identification is too fragile to sustain them (though in each case the love is real) and because they are ignorant of the meanings of life and death (though there is a felt social pressure to assume under-

standing) and the ignorance is too difficult to endure and acknowl-
edge. At the conclusion of the prefatory "Knoxville: Summer, 1915,"
the speaker, Agee-Rufus, says, "*After a little I am taken in and put
to bed. Sleep, soft smiling, draws me unto her; and those receive me,
who quietly treat me, as one familiar and well-beloved in that home:
but will not, oh, will not, not now, not ever; but will not ever tell me
who I am*" (8). The very end of the novel focuses on Rufus' bewilder-
ment in the face of adult contradictions (how can Andrew love Mary
when he hates her religion?). Such contradictions form the world in
which Rufus is placed and thus render insoluble his problem of learn-
ing who he is. Rufus differs from the adults in that he directly feels
his bewilderment and can, if fitfully, wonder what his place in the
world is and doubt that whatever it is can anchor his being. But Agee
involves the reader in his characters' uncertainty even if the charac-
ters are themselves unaware of their condition; the various failures of
speech create that effect.

Failures of speech reflect an interior discord, but there are other
sounds quite literally discordant. Two especially—the recurrent ring-
ing of a telephone and the elaborately onomatopoeic rendering of a
car engine—are dramatic, symbolic, and melodic disruptions in a
rather quiet novel. Dramatically, the telephone rings prefigure devas-
tating news; the starting of the car prefigures terrible death. Sym-
bolically these mechanized sounds, like those of the farm machinery
in *Famous Men*, suggest the element of unfeeling brutality that may
at any time destroy the tender and the gentle. Melodically they
counterbalance the literal quietness (and sometimes silence) that
mainly governs the sound pattern of the book. Through animated
metaphor, Agee stresses the grotesqueness of the ringing telephone:
it prods like "some persistent insect, . . . shrill[s], forlorn as an aban-
doned baby," and, when the receiver is lifted, gives forth a "death
rattle" (23). Even more grotesque, the automobile motor sounds "like
a hideous, horribly constipated great brute of a beast; like a lunatic
sobbing, like a mouse being tortured" (40).

THE IDEA of silence is central in all of Agee's works. The explicitly
religious meditative silence in *The Morning Watch* is matched by the

long and frequent contemplative silences of *Famous Men*, especially in the "On the Porch" sections. The first chapter of *A Death in the Family* begins with a father and his son attending a silent movie, walking home past an asylum for the deaf and dumb, and finally sitting silently on a rock before going home: "Sometimes on these evenings his father would hum a little and the humming would break open into a word or two, but he never finished even a part of a tune, for silence was even more pleasurable, and sometimes he would say a few words, of very little consequence, but would never seek to say much, or to finish what he was saying, or to listen for a reply, for silence again was even more pleasurable" (21). In *Famous Men* and *A Death in the Family*, silence is symbolically the opposite of sound, with all its suggestions of discord and intrusion; silence is the condition of contemplation; it induces or accompanies a religious feeling of oneness of the self with the eternal, of a pleasure nearly sublime. The feeling of Agee and some of his characters in the presence of silence is like the explicitly mystical feeling of Dostoevski's Alyosha Karamazov.

> His soul was overflowing with emotion and he felt he needed lots of room to move freely. Over his head was the vast vault of the sky, studded with shining, silent stars. The still-dim Milky Way was split in two from the zenith to the horizon. A cool, completely still night enfolded the earth. . . . The silence of the earth seemed to merge with the silence of the sky and the mystery of the earth was one with the mystery of the stars . . . Alyosha stood and gazed for a while; then, like a blade of grass cut by a scythe, he fell to the ground. . . . It was as if the threads of all those innumerable worlds of God had met in his soul and his soul was vibrating from its contact with "different worlds."[19]

Silence is often embarrassing to the characters in *A Death in the Family*, but it can also provide immense comfort. Rufus is sternly commanded to be quiet and thus finds silence a strain, but he can

19. Fyodor Dostoevski, *The Brothers Karamazov*, trans. Andrew R. MacAndrew (New York, 1980), 438–39.

also relish a "silent, invisible energy [that] was everywhere" (265). Jay is uncomfortable when unable to converse easily with Mary but nearly luxuriates in the "exquisite silence" of his predawn drive in the country (48).

Clearly silence may be the occasion or the necessary condition for a kind of transcendental experience. It is problematical whether the "contentment" felt by Rufus in the first chapter is a transcendental experience, though the entire episode, in which father and son tarry on the way home from a movie and sit silently for a while in a vacant lot, creates in Rufus a sense of the cosmic and the timeless similar to the more frequent and more extended contemplative passages in *Famous Men*. Rufus cannot understand the "particular kind of contentment, unlike any other that he knew." He feels a closeness to his father, and yet he also senses his father's deep loneliness, though he believes that his father "felt on good terms with the loneliness." The boy's private feelings toward his father fuse with his sense of the quiet night scene, of the "feeling of the place they paused at . . . on a rock under a stray tree . . . and above them, the trembling lanterns of the universe, seeming so near, so intimate, that when air stirred the leaves and their hair, it seemed to be the breathing, the whispering of the stars" (20).

A similar and more conscious sense of a vast peace in the late night is felt by Rufus' uncle Andrew as he walks home with his parents after the long harrowing session in the Follet house. Agee's prose, cameralike, follows the course of Andrew's awareness from the presence of his parents, to the neighboring houses, to the sky beyond and above.

Andrew could hear only their footsteps; his father and mother, he realized, could hear nothing even of that. How still we see thee lie. Yes, and between the treetops, the pale scrolls and porches and dark windows of the homes drifting past their slow walking, and not a light in any home, and so for miles, in every street of home and of business; above thy deep and dreamless sleep, the silent stars go by. . . . Upon their faces the air was so marvelously pure, aloof and tender; and the silence of the late night in the city, and

the stars, were secret and majestic beyond the wonder of the deep-
est country. (206)

The lines from the Christmas carol recur in Andrew's mind as an odd
peace and contentment overcome him. Such moments as these are by
no means frequent in *A Death in the Family*. The characters are too
immediately involved in the drama of Jay's death for idle contem-
plations of the cosmos; nor are they easily given to meditations on
nature. For these reasons such occasional moments are especially im-
portant, just as it is important that our final glimpse into Jay's mind
is of his joyful feeling after crossing the ferry, a feeling induced by the
stillness of the night.

 Throughout the novel, nonverbal stimuli lead to the keenest per-
ceptions, though these perceptions are seldom translatable into any-
thing but the vaguest of feelings, such as peacefulness and well-being.
As if to stress this notion, Agee sometimes contrasts instances of
wordless communication with strident or chaotic speech. Thus, when
Andrew relates the details of Jay's funeral to Rufus, he tells of his
intuition of Jay's immortality through the vision of a butterfly's as-
cending from the grave, to Andrew a phenomenon "surely miracu-
lous" and markedly in contrast to the legalistic officiating of Father
Jackson ("*that* son of a bitch") at the burial service (335, 336). Earlier,
in another "mystical" scene, the members of the family acutely sense
the invisible presence of the dead Jay, a sudden and awesome intru-
sion into their late-night discussion in the Follet's kitchen. Mary is
keenly aware of the inappropriateness—to her, blasphemy—of the
group's inevitably trivial talk.

> She began to think with astonishment and disgust of the way they
> had all been talking—herself most of all. How can we bear to
> chatter along in normal tones of voice! She thought; how can we
> ever use ordinary words, or say words at all! And now, picking his
> poor troubled soul to pieces, like so many hens squabbling over—
> she thought of a worm, and covered her face in sickness. . . . Oh, I
> do wish they'd leave him in peace, she said to herself. A thing so
> wonderful. Such a *proof*! Why can't we keep a reverent silence!
> (189)

At this point Mary gives direct expression to the aesthetic of silence implicit throughout the novel.

> "Oh, Andrew!" Mary cried. "Andrew! *Please* let's don't *talk* about it any more! Do you mind? . . . It just—means so much more than anything we can *say* about it or even think about it. I'd give anything just to sit quiet and think about it a little while! Don't you see? It's as if we were driving him away when he wants so much to be here among us, with us, and can't."
> "I'm *awfully* sorry, Mary. Just *awfully* sorry. Yes, of *course* I *do* see. It's a kind of sacrilege."
> So they sat quietly and in the silence they began to listen again. (190)

Except Jay, all the adults must strain to achieve a silence that they feel appropriate, and even when quiet they are uncomfortable. Rufus, however, has a natural and easy response to certain moments of silence—not to the periods when he is nervously told by adults to hold his tongue, but to the stillness he feels on the hill with his father or the strange quietness of the house on the morning after his father's death. Chapter 16 is a kind of orchestral movement counterpointing the contented silence of Rufus and the harsh noises of others. After his breakfast Rufus

> felt deeply idle and empty and at the same time gravely exhilarated, as if this were the morning of his birthday, except that this day seemed even more particularly his own day. There was nothing in the way it looked which was not ordinary, but it was filled with a noiseless and invisible kind of energy. He could see his mother's face while she told him about it and hear her voice, over and over, and silently, over and over, while he looked around the sitting room and through the window into the street, words repeated themselves. He's dead. (263)

Rufus' exhilaration no doubt has something to do with an unconscious association of his father's death with his own liberation (his "birthday"), but Agee relates the joy to an atmospheric silence. As

Rufus walked outdoors, "he felt even more listless and powerful; he was alone, and the silent invisible energy was everywhere" (265). One of the curiosities of the ensuing scene is that Agee makes explicit what is implicit—that a vacant street is silent. When some school-boys appear in the distance, they are too far away from Rufus to be heard, but Agee emphasizes the silence; it is a silence that is a pro-jection of Rufus' new sense of self-possession: "They came silently nearer. Waiting, in silence, during those many seconds before the first of them came really near him, he felt that it was . . . long to wait, and be watched so closely and silently. . . . the nearer they came but were yet at a distance, the more the gray, sober air was charged with the great energy and with a sense of glory and of danger, and the deeper and more exciting the silence became, and the more tall, proud, shy and exposed he felt" (264). Far from showing Rufus the new respect that he expects, the boys taunt him, telling him that his father was probably drunk when he died. Then another sound, the school bell, intrudes. Rufus' precious silence, and his sense of power in silence, are totally obliterated as he returns to his house and is met by the outraged Aunt Hannah. Her reprimand—"Rufus Follet, where on earth have you been!" (275)—is a ferocious vocal energy that drives away whatever is left of "the silent invisible energy" that he had ear-lier felt: "His stomach quailed, for her voice was so angry it was as if it were cracking with sparks" (275). Rufus himself becomes absorbed in the spirit of his aunt's fury and almost immediately picks a fight with his sister. He screams at her as his aunt had screamed at him and thus is rebuked again by Hannah. As the chapter ends, Rufus is again quiet and alone, but now full of shame. He cautiously walks to his father's chair and runs his finger through the ashtray on the table beside it. "He looked at his finger for a moment and licked it; his tongue tasted of darkness" (281). Rufus' emotional movement is con-veyed through a pattern of sounds—the silence of joyful pride, the increasingly harsher words of the schoolboys, his aunt, his sister, and himself, and the final silence accompanying his sense of guilt and his father's being dead.

Agee's musical conception of literature and of the human experi-

ences that literature contains is only partially a focusing on speech and silence and the rhythms created by their interchange. Agee makes his reader unusually conscious of such sounds as the ringing of a telephone and the starting of a car, but he also calls attention to the sound of speech—for example, Jay's mountain dialect. Rufus is young enough to have an immediate sensitivity to the sound of words, so that human utterance to him is often primarily musical and secondarily semantic. The word *dead*, which he feels compelled to repeat to himself frequently, has an affective quality conveyed through its sound that only the sight of his father's corpse can give precise definition to. Rufus' education is largely a matter of acquiring a vocabulary, but it is mainly the broad connotations of words rather than their denotations that he understands. *Orphan* is an obscure concept but certainly a desirable state; *nigger* is mysteriously very bad, as is *bragging*: "What was bragging? [Rufus wondered.] It was bad" (15).

Rufus gives his own private meaning to the words in the songs that his father and mother sing to him at bedtime, and his perception is based on the mysterious syllables and the recurrent melodies: "*He did not know what 'she's worth the saving' meant, and it was one of the things he took care not to ask, because although it sounded so gentle he was also sure that somewhere inside it there was something terrible to be afraid of exactly because it sounded so gentle*" (97). To Rufus the songs convey such a sense of comfort (of some ultimately secure "home") that he is afraid to learn exactly what they mean for fear that the comfort will dissolve. His apprehension is almost purely musical, a grasping of sense through sound, not of sense accompanied by sound. He is acutely, even scientifically, alert to the differences between his father's and his mother's styles in singing "Swing Low, Sweet Chariot."

Rufus is constantly responsive to the tones of people's voices, especially to evidence of anger or hypocrisy. In a scene that is something of a *tour de force* for Agee, Rufus and his sister eavesdrop on the conversation of Mary, Hannah, and Father Jackson. The varied emotions and attitudes of the overheard group are fully grasped through tones, cadences, and changes in volume: "They could hear no words,

only the tilt and shape of voices; their mother's, still so curiously shrouded, so submissive, so gentle. . . . The man's voice was subdued and gentle but rang very strongly with the knowledge that it was right and that no other voice could be quite as right" (294). In this passage, extended for two pages, Rufus' sharp attention to the sounds of words is similar to one of Agee's basic descriptive techniques. To an unusual degree Agee evokes moods by describing sounds. In the episode dealing with Rufus' nightmare, the opening visual description (of the window, the curtain, and the street light) is followed by an auditory description. Rufus *"heard the summer night,"* sounds of the air, locusts, trains, hooves, walkers, a porch swing, a cricket, and other common elements of a summer evening (81). Next the actual sounds dissolve into the imagined *"voice"* of darkness, to Rufus a terrifying revelation of *"nothingness"* that compels him to scream for his father (85). To Rufus the episode is entirely auditory, and Agee presents it in fine detail. Jay's coming into the room is not seen but heard: a *"deep breath . . . a long snort of annoyance,"* a chair creaking, *"quick, small, attendant noises"* by the relatives in the living room, a few *"annoyed"* words by Jay, and then *"his mastering, tired approach"* (87).

The prefatory "Knoxville: Summer, 1915" is a symphony of the sounds of a summer evening (the piece has been rendered as a musical composition by Samuel Barber). In its close attention to the evening sounds, the passage resembles those detailing the nightmare and the walk home from the movies, but it is more elaborate, and the parallels to orchestral music are more explicit. The middle three pages of the five-page preface concentrate on the *"contemporaneous atmosphere"* created by the sounds of garden hoses (especially), locusts, crickets, horses, autos, and streetcars. The description of the hose sounds is characteristically detailed and technical: *"the water whishing out a long loose and low-curved cone, and so gentle a sound. First an insane noise of violence in the nozzle, then the still irregular sound of adjustment, then the smoothing into steadiness and a pitch as accurately tuned to the size and style of stream as any violin. So many qualities of sound out of one hose: so many choral*

differences out of those several hoses that were in earshot" (4–5).

"Knoxville: Summer, 1915" has the liturgical and sacramental quality of certain Emily Dickinson poems, like "A Certain Slant of Light" and "Farther in Summer than the Birds." In a less concentrated way, *A Death in the Family* as a whole evokes the same sense of some ultimate rhythm in things (as does the cry of foxes at the conclusion of *Famous Men*). This rhythm, if inscrutable, is nevertheless detectable, just at the edge of human activities and human comprehension. Music, and particularly a music based on silences and slow movements, communicates to Agee a rich elemental harmony. Yet the harmony is constantly at odds with blasts and discords—the ringing of telephones, the taunting of schoolboys, the grinding of engines. Whether the interaction of silence-laden melodies and contrapuntal disruption creates some larger harmony is far from clear. Actually the conclusion of the novel, which focuses on Rufus' confusion, suggests otherwise, though the fact that the novel is unfinished makes the issue at best problematical. What is clear is that the nonverbal elements in the book produce its major themes and interior structures (that is, the patterns of chapters and episodes). There is an ever-felt spiritual harmony shadowed by the overt motions and talkings of Agee's characters. (It would seem to be symbolized by a puzzling event close to the end of the book: deaf Catherine runs her fingers over a piano keyboard, as if playing, but she doesn't touch the keys.) The harmony may be intuited only indirectly. Words can no more grasp it than the words of the Follets can account for Jay's death. Agee's discontent with words derives partly from a sense that rational interpretation must cheapen our sense of harmony. The presence of Father Jackson is the presence of a fraudulent liturgy, a blasphemous outrage against the watering of lawns, the singing of songs to a terrified child, the silent stars going by, and the living and dying of human beings.

Four

WALKER EVANS

I. *American Photographs*

AMERICAN RELICS

AMERICAN *PHOTOGRAPHS* was published in 1938, two years before *Let Us Now Praise Famous Men*. Although *American Photographs* contains several pictures of the rural South, a few of which also appear in *Let Us Now Praise Famous Men*, it is far more encompassing, with pictures from New York, Pennsylvania, New Orleans, and even one from Havana, and creates a distinctly different effect. Like those in *Famous Men*, the photographs record a definite time and place, though in *American Photographs* the record is of the general American scene with its most significant and symbolic characters, artifacts, and situations rather than of the more parochial cotton-based culture of the lower South. Like *U.S.A.* and *In Our Time*, the title *American Photographs* announces broad inclusiveness and general topicality.

Although the word *Photographs*

Photography . . . doesn't really interest me. I do know that I want to do something with it though. . . . I thought [photography] was a substitute for something else—well, for writing, for one thing. I wanted to write.

WALKER EVANS
"Interview"

in the title may not in itself suggest that the artist's medium is also his subject, the topic of photography is blatantly (and comically) displayed in the first segment of the book: a photograph of a garish, seedy photography shop specializing in photographs for automobile licenses and then a photograph of more than a hundred miniature snapshots of faces in the window of another such shop. These pictures of photographs and photographic activity are extreme instances of Evans' insistent reminders in all of his books that his pictures be regarded as photographs and not as reality or as art. They are formally and conventionally centered; they are posed for; they exist to tell us what someone or something looks like.

Evans' forthright display of medium is a little like that of Dos Passos in *U.S.A.* or Whitman in *Leaves of Grass*, whose works are both language experiments wherein typography itself immodestly intrudes and calls attention to itself. Also similar is Agee's literary contribution to *Let Us Now Praise Famous Men*. For all of the complaints by Agee about the inadequacies of language, his own writing peculiarities and unorthodox structuring devices publicize themselves in ways broadly suggestive of Cummings, Dos Passos, Faulkner, and especially Joyce. He employs such avant-garde processes as the listing of several hundred consecutive nouns, long prose sections introduced by the word *colon*, the interpolation of an entire newspaper article, a list of aphorisms from William Blake, a response to a *Partisan Review* questionnaire, and interruptions in the text called "Notes" and "Intermission—Conversation in the Lobby." The collage, a commonplace medium in the poetry and painting of the 1930s, is an effect gained by many of Evans' individual photographs and Agee's unusual combinations of different literary and subliterary genres and typographic styles.

Agee's self-proclaiming literary techniques are extremely stylized, as are Evans' photographic techniques, albeit that the style of the latter is ordinary and conventional. The title *American Photographs*, the apparent simple technique, the opening pictures of a shabby photography shop and an array of miniature snapshots in a store window all seem to announce that this is a book of rather ordinary pictures of

American life, and that photography itself has a significant place in American life. Like Anderson, Hemingway, and Hopper (but not like Agee), Evans embraces the usual primitive implications of American realism; also as with Anderson, Hemingway, and Hopper, his stylization results from a simplification forced beyond naturalness, indifferent to contradicting the appearance of spontaneity (for spontaneity encourages thinness and waste). When he mentions "the Puritanical eye of Walker Evans," Lincoln Kirstein may suggest that Evans' simplifications are not easily found and casually photographed but are achieved with difficulty.[1]

In structure *American Photographs* has nothing like the obvious organizational frame of the farm families and the town that constitutes the major divisions of *Famous Men*. Nor is there any external prose commentary or obvious situational or topical system of arrangement beyond that of "American." To turn the pages of the book is to receive the suggestion (much encouraged by the alternate blank pages) that we are seeing a very few rigorously selected details that in their accumulation and mutual relationships add up to a synthesis or epitome of "the American scene." *American Photographs* is thus a book of significant fragmentary images, disparate silent impressions interrupting the static unifying silence of the blank pages between the images. As *The Waste Land* and *As I Lay Dying* are collages of voices, *American Photographs* is a collage of perceptions. The structure is neither narrative nor musical (except in a metaphorical sense even looser than Agee's) because it is totally achronological—not atemporal, for the subjects of the photographs are significant aspects of a historical age. In no important sense do the photographs in the book "follow" one another, though there are multiple relations among them that are thematic. Modes of synthesis of individual photographs are suggested by similar subjects and obvious contrasts.[2]

1. Lincoln Kirstein, "Photographs of America: Walker Evans," in Walker Evans, *American Photographs* (New York, 1938), 193.
2. Dorothea Lange described her own principle of photographic relationship, which seems the same as Evans': "I find that it has become instinctive, habitual, *necessary* to group photographs. . . . I used to think in terms of single photographs. . . . A photographic statement is more what I now reach for. Therefore these pairs, like a sentence of

The bleakness and wretchedness of the photographs in *Famous Men* are heightened and made tragic by the dominance of human portraits, especially those of children, and the surviving coherence of families. The impersonal commercial and technological debris of the fourth segment bears only a tangential relation to the lives of the rural poor. The persons in *American Photographs* are never seen as members of families, and the many houses in the book are seen without people living in them or as boardinghouses for anonymous itinerants. Most of the persons—and relatively few dominate individual photographs—wear accustomed but uncomfortable masks of aggression or resignation. Whatever may remain of a natural innocence and a capacity for spontaneous expression has been concealed or disguised; more likely, innocence and spontaneity have died or been destroyed. If Evans' intention in the Farm Security Administration photographs was "to demonstrate the value of the people photographed," his intention in *American Photographs* may not be the opposite, but it is clearly different.[3]

American Photographs presents (but does not celebrate) many views of aggressive industrial society, unyielding before depression sluggishness. Evans provides us in abundance with automobiles, factories, conspicuous clothing, houses both drably identical and ostentatiously unique, and omnipresent advertising signs. These images are the cultural artifacts of the urban, small town, and rural America that Evans considers important. In this "contemporary" America there is a Hopper-like absence of people that makes the settings seem of a remote past. The suggestions are of a civilization that is a failed community and of dwellings that have been abandoned as homes. In *Famous Men* the susceptibility of structures to almost immediate deterioration is mostly responsible for the "waste land" effect. Certainly *American Photographs* contains a large share of pictures of quickly constructed shacks that, like the automobiles, seem to pass

two words . . . express the relationships, equivalents, progressions, contradictions, positives and negatives, etc." (Quoted in Milton Meltzer, *Dorothea Lange: A Photographer's Life* [New York, 1978], 353).

3. Susan Sontag, *On Photography* (New York, 1978), 62.

immediately from brand-new to falling apart and worn out, but many of the buildings in *American Photographs* are new and seem durable; they are lifeless because they stand alone (or bunched together) without people, built on land that seems more suitable for something else or entrapped by utility wires, billboards, and the general congestion of the city. The "modern" and "fashionable" houses resemble those in the photographs in real estate sections of newspapers. In Evans' photographs of houses, it is the clarity and precision of the representation, plus the distinct ornateness of the specimen, that make them different. But in their unnatural severance from environment and the presence of people, Evans' pictures of houses do suggest those of houses for sale.

As what seems a casual gathering of photographs recording the details of a nation blighted, fatigued, and incapable of spontaneity, *American Photographs* regularly forces a comparison of an actual sadness and apathy with the hollow gestures of a "forward looking" mass culture that essentially has nothing to do with the scenes on which its products and manifestos are superimposed. The products are mainly automobiles and their necessary adjuncts, the gas stations; the manifestos are the advertising signs. Neither automobile nor advertisement survives the universal impetus of all organic and inorganic phenomena in Evans' America to become discarded, wrecked, or ignored. The persistent satire of *American Photographs* stresses the destructive relationship between technology and life, between the public symbols of material power and a waning private vitality.

There are a few pictures of smiling independent purveyors of goods— like the one of two boys holding watermelons and posing between baskets of fruit (1). But typically the boys are dwarfed by the mammoth and all-encompassing advertising signs covering and surmounting the roadside store behind them, at the center of which is a gigantic painted fish, much larger and more precisely defined than either of the boys. In its compositional ironies, the photograph of the roadside stand emphasizes the uncomfortable and discordant relation of the organic—fish, melons, boys—to the inorganic that is characteristic of nearly all of the pictures that present the animate in contexts of the

1. *Roadside Stand Near Birmingham*, 1936

2. *South Street, New York*, 1932

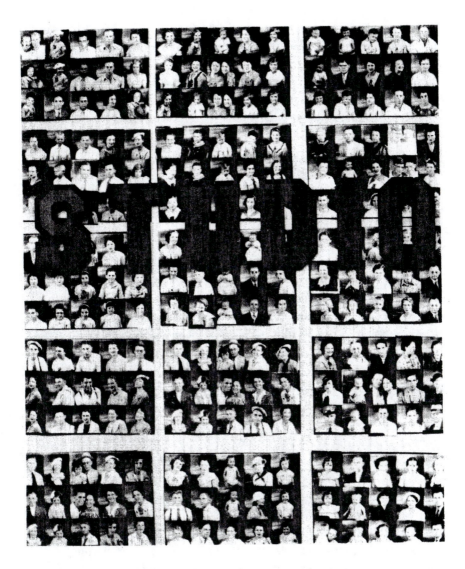

3. *Penny Picture Display, Savannah*, 1936

inanimate. The roadside stand photograph is a complex assemblage of symmetries—of squares, rectangles, and triangles. We notice these in the formal designs of signs, windows, doors, and arranged fruit, in the unintentional alignments formed by the boys, and in the x-centered structure of the picture itself. It is a picture that strains to achieve formal rigor; its effort is to convert roundness to angularity, the effect produced when watermelons are arranged to form triangles. The boys themselves are seen as trying to blend with the linearity of the verticals within the store facade, to force their fluid bodies and the oval melons into the prevailing pattern of enclosing straight lines. The painted fish is tightly squeezed into a narrow rectangle of lettering and architecture. The standing men within the store unintentionally duplicate the inanimate arrangement of white sign and dark wall that stands directly before and beside them.

A photograph of three men lounging before the door of a copper company (2) also expresses the domination of the living by inanimate structure. Not only does the distance of the camera from the men require that they be dominated by the building exterior, which absorbs the entirety of the photograph and extends far beyond it, but their postures duplicate the symmetry of the structure that supports them: the vertical lines of the pillars and the horizontal line of the doorstep. In a more obvious way the large introductory collage of miniature snapshots (3) shows the human form subordinated to geometrical arrangement.

Photographs of organic life submitting to the authority of impersonal geometry indicate a major theme of *American Photographs*, especially Part One. Most of the pictures reveal the process whereby some form of human energy unconsciously concedes to the irresistible domination of some lifeless thing. The numerous photographs of advertising posters, for example, suggest many ways in which human beings disappear from the artificial images that human beings have constructed. We might pay some attention to several photographs that emphasize advertisements and note the sardonic ironies that Evans conveys through them.

In *Interior Detail, West Virginia Coal Miner's House* (4), two lu-

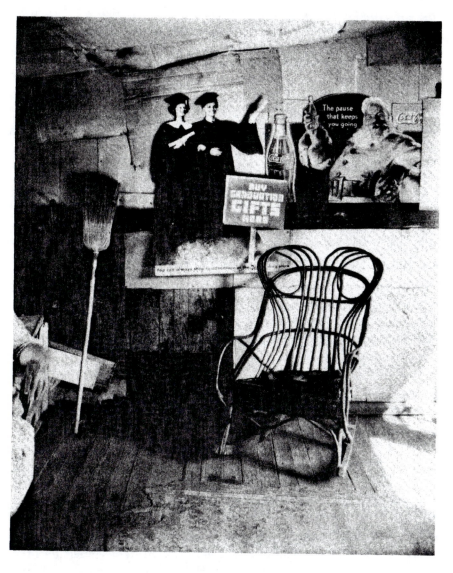

4. *Interior Detail, West Virginia Coal Miner's House*

dicrously inappropriate advertising posters—one of a young couple in caps and gowns and the other of a Santa Claus holding a bottle of Coca Cola—adorn the patched wall of a crude room. In front of the posters stand a broom and a rocking chair. The images on the posters seem especially unreal stylizations of the human form (and of human festive occasions) in this discordant context of crude poverty. The alignments of the picture draw together the broom with the poster of the graduates (on the left side) and the chair with that of the Santa Claus (on the right); also the broom, like the graduates, is tall and vertical; the chair, like the Santa Claus, oval and fat. But because of the ambiguity of emphasis in the picture, the posters do not quite dominate the room. On one hand, the graduates and the Santa Claus stand above and superior to the broom and the chair that are aligned with them, but on the other hand, they stand behind these household objects as background tableaux. The uncertain relation between the posters and the broom and chair—the suggestion of only potential domination by the posters—directs attention to the absence of people from the room. Not only do the unused broom and chair compel a consciousness of this absence, but so do the texts of the posters, which address an absent "you." The picture suggests a tentative dispossession or displacement of the living but absent inhabitants of the room, weakly represented by the broom and chair, by the banal figures on the posters. Likewise the photograph addresses us with its silence. Not only does the absence of the people who should be in the room produce a sense of silence, but so does the failure of the smiling cardboard images to transcend the deadness of their substance and the artificiality of their form. The picture represents an all-but-achieved annihilation of human presence through both its stylistic falsification of the human form and its displacement of the absent by fraudulent imitations of the living.

The same general effect is achieved in the military sequence in the middle of Part One, in which statues, rather than advertising posters, vulgarize the human form. The first two photographs are of statues of soldiers. In the first the background of a deserted and oblivious small town street makes the statue seem especially artificial and inappro-

priate; it simply does not belong there. In the second the exaggerated gesturing of a Confederate general before his almost as theatrical horse illustrates the comic effect often achieved by statuary intended to represent movement. Following these two photographs of soldiers, who seem especially lifeless because of the failure of art to give them life, are three photographs of uniformed figures. The preliminary context of military statues emphasizes what is apparent in the individual pictures: the strain within each person both to adjust to the identity required by the uniform (in effect the identity of a statue) and to subvert whatever is individual and human (5).

Following the military sequence—or perhaps concluding it—is a photograph of a black coal miner (6), an old man whose worn face, deep solemn eyes, and posture of defenselessness stand as a force of resistance against the vacuous authoritarianism of the American Legionnaire in the previous photograph. Yet the miner himself bears his shovels on his shoulder in the military manner. If his portrait reveals a human quality, an innocence, that successfully resists submission to a patterned identity, that resistance is manifest only as an irreducible interiority of being, for all else that we see of the miner is a docile acquiescence in his function as worker.

The portrait of the miner leads immediately to a different kind of photograph of blacks in America. Most obviously the photograph of a deteriorating poster of ludicrously cavorting minstrel characters (7) reiterates the theme of the degradation of blacks apparent in the previous picture. Yet in its attention not just to the poster but to the brick wall on which the torn poster is pasted, *Minstrel Showbill* induces a reaction that surpasses bemusement at the absurd or outrage at the racial stereotyping. The main effect of the photograph is a surprising horror caused by the atrocities that the deterioration is accidentally creating. The photograph simultaneously represents the *then* of the poster—what it was originally meant to be—and the *now* of the poster—its process of deterioration that converts the silliness of the original into a spectacle of grotesque agony and violence. The two stages of the poster are two kinds of nonrealism: cartoon and surrealism, a demeaning caricature of pain and a nightmare vision of pain.

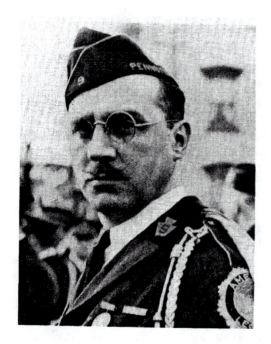

5. *American Legion-*
naire, 1936

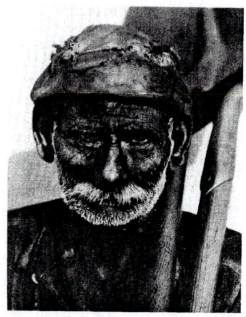

6. *Coal Dock Worker*, 1932

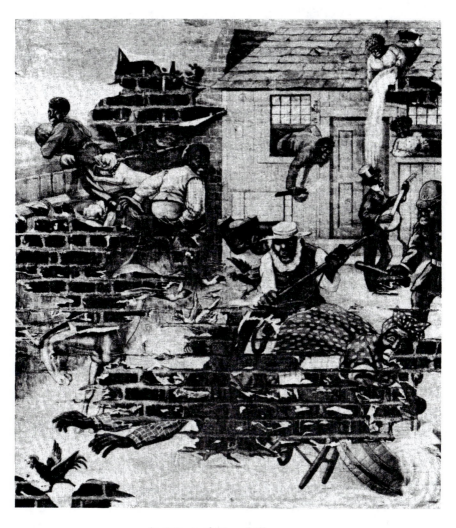

7. *Minstrel Showbill*

In its tattered form, for example, we observe disembodied hands grasping for a chicken, and the half-obliterated face of a frenzied woman; the stupid befuddlement of the woman in the original version converts to an expression of terror. Throughout the whole of the crowded painting the original effect of childlike foolishness changes before our eyes into a scene of panic in the presence of imminent annihilation. The figures in the forefront of the poster express a horror at the advancing vacancy of the poster itself, which has already consumed all but the hands and forearms of the man at the lower left and half of the body of the woman at the lower right. The two boys at the upper left look now at the widening gap, not at the barnyard escapade that may have alarmed them when the poster was new but now exists only in tatters. Likewise what may once have been an innocent farcical situation in the upper right corner is now a situation of ironic obliviousness to the approaching catastrophe. This photograph represents the destruction of a particular kind of an illusion and the indestructibility of the plain materiality—the brick wall—that the illusion had once completely masked. If we accept the illusion as true, the merging wall is a nothingness. When we acknowledge the nothingness to be in fact a wall, the process of annihilation assumes another dimension.

Although in multiple ways the comic vitality of the minstrel scene is an illusion, it is only in such tawdry paintings as this that *American Photographs* reveals any kind of human vitality. The persons in the book who strongly express some positive emotion—joy, love, and celebration—are to be found only in advertising posters. What we mostly see of actual human beings is the adoption of the costumes and the gestures of patriotism, intimacy, and pleasure; but the faces of these people are sullen or despondent. Most often human beings are surprisingly absent, as if they have abandoned their authority to the fabricated human beings of advertisement posters or to their houses, streets, and cities. Hence as *Minstrel Showbill* transforms cartoon caricature into the stubbornly inanimate, it displays a process frequently suggested in *American Photographs*. The minstrel

photograph is a depiction of a dead imitation of vitality becoming simply death and of an illusion of frantic noise becoming silence.

Unlike nearly all of Evans' other photographs of advertisements, *Minstrel Showbill* reveals nothing of an actual environment beyond the poster. Here the "real" environment—the wall—is behind and inside the poster; there is nothing beyond the wall. The wall, in its illusory process of obliterating the images on the poster, is thus the eventual totality of the picture. Nothing modifies the absolute silence toward which the images are regressing.

Unlike most other American documentary photographers, from Lewis Hine to Gary Winograd, Evans takes very few pictures of people at work or at play. There is no working or playing in *American Photographs*, and when humans, including a number of "workers," are seen, they are fixed in postures of idleness, not the strained posings of *Famous Men*, but what seem habitual postures of either angry immobility or resigned apathy: from the extreme of a militaristic American Legionnaire to that of a derelict sleeping in a doorway. A sociology-minded analyst would probably find in these pictures a record of a society out of work in large numbers, generally discontent, regimented by factories and row houses, full of junked and cluttering automobiles that symbolize the failure of mass technology, and swamped by tattered advertising posters, the failure of whose promise of "entertainment" by Hollywood and "refreshment" by Coca-Cola is evident in the tawdriness and abandonment of the signs. Such a sociological appraisal is valid, and not entirely superficial. But Evans' synthesis of American life in the 1930s reflects a fatigue and an anxiety brought about more by cultural than by economic failure.[4] The images of opu-

4. The observations of two major critics of the American scene compellingly anticipate the moral, emotional, and cultural judgments implied by *American Photographs*. In *The American Scene* (New York, 1946), Henry James, passing through North Carolina, reflected on the view from a train window: "My view of the melancholy of [the scene] had been conveniently expressed, from hour to hour, by the fond reflection, through the dreary land, that nobody cared—cared really for *it* or for anything. . . . The social scene, shabby and sordid, . . . affected me above all, and almost each time, I seem to remember, as speaking of the number of things not cared for. There were some presumably, though not at all discernibly, that *were*—enough to beget the loose human

lence are not merely contrasted to the images of destitution, thereby becoming simple evidences of inequality. The well-dressed and well-fed, like the pretentious Victorian-style houses, are mostly foolish and pathetic in themselves. (There seems a failure of taste and certainly of subtlety in Evans' determination to represent all prosperous people and expensive houses as aesthetic monstrosities.)

The inherent nature of any book of photographs compels an effect of fragmentation, and this effect increases when there is no apparent relationship between one photograph and another, as there is in *Famous Men*. The persons and the places in *American Photographs* are seen only once; no one apparently knows anyone else and the settings have no relation to the characters. *American Photographs* indeed insists on disconnectedness—of person and person, person and house, person and work. This emphasis rules both the book as a whole and individual photographs. Most of the few group photographs show individuals detached from each other, self-preoccupied, or gazing at something beyond the picture. Such disjointedness results in photographs noticeably absent of the complexity created when individuals interact with their environments or with one another. In *Famous Men* there is always at least the implied association of the farm people with their rooms and their beds, but such is not the case in *American Photographs*, where the bedrooms are those of boardinghouses and the most common setting for individual portraits is a public street. Instead of complexity, a suggestion of drama, a merging of person and place, and a revelation of personal identity amid a flourishing, or at least neutral, arrangement of buildings and streets, there is a general flatness, apparent not just in the collage of disconnected fragmentary images, but in the usual absence of gradation, shadow, and subtlety of arrangement in the individual photographs.

As the initial photographs blatantly announce, the subject of Part

cohesion, the scant consistency of parts and pieces" (397). In *Character and Opinion in the United States* (New York, 1961), George Santayana remarked: "Consider now the great emptiness of America; not merely the primitive physical emptiness, surviving in some regions, and the continuing spacing of the chief natural features, but also the moral emptiness of a settlement where men and even houses are easily moved about, and no one, almost, lives where he was born or believes what he has been taught" (106).

One of *American Photographs* is "faces." The first four photographs—
the photographic shop (containing the word *photos* six times), the
130 miniature snapshots in formal regimented collage beneath the
word *studio* in the window of a photographer's shop, the two workers
(entitled *Faces*), and the view into a window containing a retouched
photograph of Herbert Hoover—suggest what happens to faces in a
mass society, wherein portraits become cheaply reproduced as minia-
ture badges of identity, faces become equated with persons, and presi-
dents are misrepresented as figures of glamor, like the movie stars
seen on torn posters in a number of other photographs in the book.
Appropriately, yet wittily, the faces segment is followed by pictures of
two notably delapidated barber shops—the exterior of one in New
Orleans and the interior of another in Atlanta. These wretched and
garish shops promise in their signs to make a person beautiful by
trimming, bobbing, and restoring hair. In Evans' America the beau-
tiful is invariably promoted by the ugliest and crudest of advertising
displays.

The photographs continue to be organized in thematic clusters. In
Part One the major concerns are the loss or fragility of private iden-
tity, the dominance of persons by inanimate structures, transience,
mobility, and decoration. Hence the subjects are mostly automobiles
and boardinghouses, overly embellished living rooms (of the middle
class and the poor), and billboards. Human beings assume four domi-
nant attitudes: defeat (as in the black coal miner and the skid row
idlers); frail, vulnerable innocence (as in the sharecropper child and
wife); stern militarism (as in the American Legionnaire, the police-
man, and the heroic statues of soldiers); and pretension to elegance
and beauty (as in the two heavily made-up New York women in furs
and the couples at Coney Island and in the Bronx Park). Interwoven
with these characters are enough photographs of urban and rural de-
cay to make clear that poverty—abetted by widespread aesthetic im-
poverishment and the absence of a vital tradition, a living past—at
least indirectly underlies all human expressions.

An examination of a few of the photographs organized themati-
cally will suggest ways in which Evans' different emphases interfuse

with each other, making *American Photographs* something more
than a propagandistic attack on America. One series of photographs
constitutes what might be called "the automobile": *Joe's Auto Grave-
yard, Pennsylvania; Roadside Gas Sign; Lunch Wagon Detail, New
York* (dominated by a crude painting of a young man and woman eat-
ing sandwiches in a parked convertible); *Parked Car, Small Town
Main Street.* For all of the dozens of automobile photographs in the
book, not one car is seen in isolation; each is in a revealing relation-
ship of some sort. Thus in the early cluster of four photographs, the
automobiles are associated with collapse and death, advertising, and
sex. The opening panoramic auto graveyard scene, now a cliché, an-
nounces its subject as an incoherent heap of discarded junk (parallel
to the introduction of photography itself as a tawdry commercial
operation, supplying snapshots for automobile licenses). From the
jumbled collage of wrecked cars, a visual echo of the snapshot col-
lage, we turn to the surrealistic detail from the layered posters and
hand lettering of the gasoline sign. Because it is seen in detail (thus as
more restricted and more concentrated than the eye would naturally
see it), the collage first appears as an unintelligible abstraction. A
hastily hand-scrawled "gas" beside a large printed "A" are superim-
posed upon torn and displaced advertisements. The quick consump-
tion of cars indicated by the auto graveyard is associated with the
sloppy improvisation of the incoherent sign advertising gas. The gaso-
line sign is followed immediately by another advertisement, a picture
on a roadside lunch wagon, whose presumed message is that fash-
ionable young people driving in fashionable new convertibles stop
here for a bite to eat, continuing to have a marvelous time as they
comfortably chat against the background of a scenic lake. The in-
tended glamor of the painting is made pathetic and ridiculous not
just by the proximity of more directly functional signs ("HAMBURGER
STEAK and onions 35" and "BELL SYSTEM") but by the extreme crude-
ness of the art work. One of the themes of *American Photographs*
must be that as much as Americans pursue beauty and pleasure, very
little of either is to be found. In the next photograph, life uninten-
tionally imitates art, as we see a "real" young man and young woman

in an actual parked convertible; but these two are scowling, possibly because of the intrusion of the photographer. The real couple in a convertible are unconscious imitators of the pair in the advertisement, as are the policeman and the legionnaire of the military statues, and rather less delighted than the couple on the poster. The wit of this combination of pictures is characteristic of Evans' often cruel humor.

Evans very seldom presents cars in their intended primary function, as vehicles for transporting people. Thus they are usually parked and empty. That is the case in another automobile sequence, pictures of parked cars on streets. A car before a woefully deteriorated barber shop (yet another one) and three loitering black men appears immediately before a car parked in front of Cherokee Parts Store, a building with more than a dozen tires and wheels hanging from or leaning against it in a bizarre display. Again we see Evans' ironic wit in these related pictures of idle cars before shops wherein humans and automobiles are repaired. Next come two panoramic views of downtown streets, each lined with diagonally parked cars: the first (8) may seem to report the busy prosperity of a southern county seat, but the photograph is actually dominated by the empty width of street between the rows of still cars; the second (9), clearly a paralleling picture, is taken during a winter rainfall, and the long lines of parked cars are arranged beneath bare, spindly trees. The overwhelming effect is of bleakness. The broad sidewalk in the foreground is empty; the houses are barely detectable. The cars sit closely packed together as lifeless identical black shapes in a setting of death.

Most of the photographs in the book fall into thematic units, though some are interrupted and some overlap into other units. It is tempting to read the militaristic sequence as the key to the entire book, but that tendency may exist only because the military figures are such strident exceptions to the otherwise prevalent atmosphere of inertia and defeat. The military unit appears in the middle of Part One and arrays the postures and uniforms of war in a temporal sequence that begins with two statues—a World War I soldier on a pedestal in an empty Pennsylvania town and a preposterously exultant Confed-

erate general extending his sword before his rearing horse—and leads
into three contemporary "living" militaristic figures or groups in
peacetime: a pudgy policeman (seen very much as a snapshot), three
awkward-looking and somewhat irreverent "sons of legionnaires" in
uniform, and an absurdly imperious adult legionnaire with glasses,
a jaunty Germanic mustache, a full array of medals and insignia, and
an expression of intended belligerence (5). Since they are placed in
the context of dozens of photographs of hopeless poverty and desper-
ate displays of beauty (interior decor, movie posters), power (the auto-
mobile), and bare survival (shacks, cheap food), the military figures
may be assumed to be some indication of the way things are headed
in the America of 1938. But it is difficult to feel either awed or threat-
ened by these monuments of a militaristic past and rather foolish
contemporary uniformed men. Apprehensions of fascism are more
profoundly and more subtly conveyed in the many photographs stress-
ing conformity—especially in the multitude of identical automobiles
and the rows of identical houses that occupy much of Part Two, in
addition to the uncertain and desperate efforts to manifest individu-
ality and self-importance that are stressed in most of the portraits.
For example, some of the individuals rather awkwardly try to present
themselves theatrically. Evans seems drawn toward subjects whose
sullenness of expression negates the glamor of their attire and thus
achieves the effect of a disconnection between person and clothing. It
has been said of Bressai's subjects (in *Paris de Nuit*) that they "were
self-prepossessing and had a sense of their own style that was, if any-
thing, overdeveloped."[5] Unlike the persons in Bressai's photographs
of Paris night life, Evans' well-dressed urbanites are fixed in rigid and
uncomfortable postures against vague backgrounds. One woman
seems frozen and hostile, another simply weary and confused.

Most of the emphasized single portraits in Part One appear before
blurred and confused backgrounds, usually of urban crowds. That
photographic effect, usually considered a technical defect, distances
and distinguishes the solitary or paired individuals in the forefront

5. Colin L. Westerbeck, Jr., "Night Light: Bressai and Weegee," in Vicki Goldberg
(ed.), *Photography in Print: Writings from 1816 to the Present* (New York, 1981), 414.

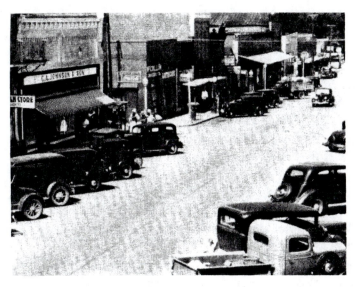

8. *Main Street of County Seat, Alabama,* 1936

9. *Main Street,*
 Saratoga Springs,
 New York, 1931

and sets them apart from incoherent social situations. Because the background is dense yet blurred, the figure in the forefront seems oddly isolated; the congestion is too vague and undifferentiated to compel any sense of its containing or even relating to the foreground figure. These pictures of individuals isolated amid crowds (or rather before crowds) exploit the "unrealism" of photography. The unfocused backgrounds in effect silence the backgrounds and annihilate the assumed and expected dynamism of the busy street. Individuals in larger groupings in Part One—like figures on distant sidewalks or on the porch of a gas station—are dim, concealed, and so minute as to seem only shadowy forms merging into one another. Or else they so much blend into objects and portions of buildings that it is hard to find them at all, as is notably the case in *Garage in Southern City Outskirts.*

In many of the photographs of Part One, human figures are absent altogether, and the lack of human presence is the governing situation in Part Two. In only three of the thirty-seven photographs in Part Two do human beings appear, and in these cases they are accidental, irrelevant, and minute. The subjects of Part Two are towns, factories, and houses. Thus the silence of these photographs is a condition inherent in all stationary inorganic entities, and the fact that they are all man-made indicates a duration (even in the flimsiest of shacks) exceeding that of human beings. These are pictures not only of works constructed by man, but of works that seem abandoned by man. A ghostly note, for example, is struck in the photograph of a factory street lined with apartment and factory buildings and emptied not only of persons but even of automobiles, an absence emphasized by the traffic marker ("SLOW KEEP RIGHT") in the forefront of the picture.

Also, Part Two contains a simpler and more apparent thematic structure than Part One, owing in part to the nonhuman and largely nonsouthern content. Industrialism is clearly the pervasive motif. Evans' major insight into the character of a society dominated by industrial process is the deadening effect of impersonal mechanical duplication. The segment is introduced and concluded by two nearly identical photographs, entitled *Stamped Tin Relic* and *Tin Relic*, pic-

tures of two rather indefinable pieces of crumpled embellished metal, no doubt some decoration, now discarded. The first piece of junked tin contains a miniature duplication of a Corinthian column, bent and twisted and the only recognizable form amid the chaos of other debris; in the second piece a metallic flower is seen within a piece of battered coiled metal. These iconographic photographs emphasize a theme considered in subtler photographs: throughout *American Photographs* Evans seems to look for scenes and situations that represent the triumph of the mechanical over the organic. Thus the second relic—the crumpled tin flower—both duplicates and exaggerates the implied subject of the roadside stand photograph (1), though the effect is blatant rather than subtle. Also, with the tin relics as the frame of Part Two, we are presumably invited to regard the entire section as the gathered images of the less apparent discarded artifacts of some society. If this is the case in any literal sense, Evans is indeed using photography as an inherently elegiac medium, as well as observing the buildings of America in the 1930s as the assorted remains of a dead society. But if these buildings are to be thought of as discarded remains, very few can be considered ruins. However, the absence of human life reinforces the impression of lifelessness, as does the lingering effect of many of the photographs of Part One, which suggest the inevitable and rapid deterioration of American automobiles and buildings.

But there is little apparent deterioration in Part Two. Nearly all of the scenes are of thriving towns and sturdy buildings. Even the rural gas station (also used in *Famous Men*) is moderately clean and well-constructed, and the only striking evidence of decay is in the wall enclosing a tomb in a graveyard. It seems as though Evans, through the framing tin relics and the absence of persons, wishes us to view ironically those images of American life that are frequently publicized by spokesmen for industry and progress. Hence the book is generally arranged according to the following scheme: group one—factories, factory towns, workers' houses; group two—churches; group three—workers' houses; group four—the houses of the wealthy. While there are overlappings and interruptions, the scheme generally

prevails and is quite obvious. The implicit points that Evans makes are equally apparent. These points are often made in single photographs, but they become glaringly obvious in series of parallel photographs (so as to raise the question of whether Evans has exaggerated). It is especially obvious that workers' houses, regardless of how well-made and well-kept, are uniformly identical and subordinate appendages to the mills and factories that dominate them like medieval cathedrals in small villages. Repetition and uniformity are noted as well in rows of telephone poles and steel mill blast furnaces. As the section progresses, the housing sequence ironically registers the admired American pattern of "upward mobility"—from plain uniform house, to embellished uniform house, to foolishly embellished single house. There is almost nothing in this book like a house with the plain dignity of the primitive shacks of *Famous Men*, nothing other than the impersonal duplicated houses of workers and the highly decorated suburban houses buried beneath their elaborate gingerbread facades. There are a few possible alternatives to anonymity and ostentation: a brick store in Selma, Alabama, with a notably simple classical design and a typical New Orleans French Quarter house with relatively unobtrusive porch embellishment.[6]

The four religious edifices close to the center of Part Two—three crude southern rural churches and a pompous imitation Greek temple in Vicksburg, Mississippi—show the forlorn and mostly irrelevant state of religion, and by extension the failure of society to give intelligent architectural form to any noncommercial institution or cult (we recall the nearly hilarious war monuments). The three simple wooden churches are survivals of a primitive frontier aesthetic. According to Agee, they should be considered as examples of a native American classicism, and thus have a validity that sharply contrasts with the anachronistic artificiality of the Vicksburg temple. The frame churches, like the more durable Selma store, suggest an archi-

6. For Evans, porches and their roofs seem the crucial detail in American domestic and commercial urban architecture; whether they be decorated by posters in southern stores or weighted with elaborate embellishment in suburban residences, porch roofs are always mainly for decoration and usually represented as absurd.

tectural authenticity that is probably doomed. For the churches are
falling apart, and the store is making concessions to the universal
demand that all commercial buildings become repositories of adver-
tising signs. Even the recently built and floridly embellished houses
of modern design seem headed for extinction, even if no signs of dete-
rioration are evident. The heavy latticework seems to weigh down
the structures (as do the Coca-Cola signs on southern shacks). And
there is an ominous sign attached to the first of these houses: a FOR
SALE notice is attached to the central column supporting a pair of
cathedral arches of this wooden gothic house in Massachusetts.

American Photographs, Part One, stresses the silence of impover-
ished, fearful, and isolated people and their mournful surroundings;
at the same time it stresses the dying of all that is organic and the
triumphant survival of the inorganic. The silence of Part Two is per-
haps an inevitable consequence (or, possibly, cause) of this human
deadness. The automobiles, houses, posters, towns, and churches
that are the existing or imminent relics of American culture also an-
nounce death. Hence the observer of these photographs is like an
archeologist of the present, an unwelcome witness of a silent aban-
doned world, whose images of power, beauty, and opulence are per-
manently lifeless.

Perhaps the key photograph of Part Two is that of an unkempt
graveyard with its crumbling stones in the forefront of congested row
houses and a cluster of awkward telephone poles (10). Typically, the
scene, though extensive, is without people. The camera angle makes
the houses on the right side of the street seem compressed, even
crumpled together, denied the space they need. The graveyard, with
its uncut grass and tumbling stones, presents simply a more familiar
evidence of death, ruin, and abandonment than the sloping row of
narrow houses on the opposite side of the street. The two main com-
ponents of the picture—the graveyard and the row of houses—may
seem to have no relation to each other, for they seem indifferent to
each other, but the apparent discord can only be an illusion.

By denying the benefits of the ease, luxury, efficiency, and democ-
racy promoted by American culture and by identifying the manifesta-

tions of these qualities with death, Evans in *American Photographs* surely reveals himself as a pessimist of an extreme order, not simply hostile to America, but morbidly skeptical about the modern world and its future. One must turn to the hard-won affirmations of *Let Us Now Praise Famous Men* to modify this judgment and gain a better understanding of Evans' complexity. The Evans who gathers relics and sees the world as a graveyard is also the Evans who praises famous men.

II. *Let Us Now Praise Famous Men*
''PLEASE BE QUITE''

James Agee insisted that Walker Evans' photographs were much more than illustrations for the text of *Let Us Now Praise Famous Men*. "The photographs are not illustrative. They, and the text, are coequal, mutually independent, and fully collaborative."[7] Perhaps Agee used the photographs of Evans as Utrillo used the photographs of Atget, or as Agee used the actual subjects that Evans photographed. The photograph provided the author with a subject that was unphased by time or change of any sort, or even the obligations of courtesy that normally impede prolonged intense concentration, especially on a human subject other than someone posing for an artist. The photograph both releases the writer from dependence on memory and stimulates memory.

Much more importantly, the photographs enable the observer/reader of the book to participate in and even collaborate with the author's efforts to comprehend the persons and experiences that are the subjects of both photographs and text.[8] As one whose writing is nearly

7. James Agee and Walker Evans, *Let Us Now Praise Famous Men* (New York, 1966), xv.
8. Necessarily the relation of the text to the photographs is ambiguous: the photographs may "illustrate" the text, but the text "explains" the photographs. The latter relationship is actually more suggested by the arrangement of the book, as by Agee's extreme homage to photography in his text. Also it may be that the relation of any text to the photographs associated with it must be a subordinate one. As Roland Barthes writes, "It is not the image which comes to elucidate or 'realize' the text, but the latter

10. *Street and Graveyard in Bethlehem, Pennsylvania, 1936*

simultaneously descriptive, meditative, and analytical, Agee takes the position of someone looking at photographs, at images timeless and still—a straightforward dwelling upon fixed people, places, and objects. Thus Evans' photographs are not just complementary or reflecting parallels to the text but are, almost literally, the original text themselves. Certainly they are (often in historical fact as well as ontologically) distinguishable from the text, though in the collaborated volume inseparable from it. The relationship of picture to text is not exactly that of eye to mind, appearance to reality, or experience to art, but, rather more, that of gesture to speech and visual art to poetic art.

If we extend upon Agee's instructions to the reader in the preface, we may conclude that the ideal way to "read" *Famous Men* is somehow to read ("aloud" and "continuously") the text while simultaneously absorbing the photographs.[9] Always impatient with the restrictions of the conventional art forms and with the assumed absoluteness of the distinctions among them (as well as with passive submission to words written on a page), Agee was a writer who wanted nothing less than for his reader to possess simultaneously the raw materials of his work, precise and sensitive photographs of these materials, and the verbal commentary. Evans said of his pictures that "unless I feel that the product is a *transcendence* of the thing, of the moment in reality, then I haven't done anything, and I throw it away."[10] The same attitude was Agee's: the greatest possible realism remaining itself while transforming itself into art. The photographs obviously introduce the book with hard visible actuality, but, according to both "authors," they, as well as the text, are transcendent. There is no mistaking the poetic quality of Agee's language, but to the collaborators the photography is poetic as well.

It is probably inaccurate but nevertheless tempting to argue that Walker Evans instructed Agee how to see and how to understand *by*

which comes to sublimate, patheticize, or rationalize the image" ("The Photographic Image," in Goldberg [ed.], *Photography in Print*, 529).

9. Agee and Evans, *Let Us Now Praise Famous Men*, xv.

10. Leslie Katz, "An Interview with Walker Evans," *Art in America*, LIX (March–April, 1971), 85.

seeing the sharecroppers in Alabama. Both acknowledged that they saw the people, the houses, and the rooms in the same way. "My work happened to be the style and matter for his eye," Evans said.[11] Agee's writing in *Famous Men* is descriptive to the point of being scientifically analytic and nearly mystically meditative. On the other hand, there is little in the writing that is dramatic or even narrative and virtually nothing of characterization; the distinctly nonchronological arrangement of materials seems so loose as to be random, though, following Agee's explicit and implicit indications, we recognize that it is musical. Curiously Agee rejects the very literary methods that are impossible attainments for the still photographer—narration, chronology, dialogue, historical exposition. His eye shall be the photographer's eye, his intelligence that of the photographer and the observer of photographs. Like the editor of a volume of photographs, he shall arrange his materials according to patterns other than those of time or plot.

Agee not only abolishes from his writing those techniques impossible or uncongenial to photography, but he seems to wish that writing itself could be photography. He is unhappy not just with the unavoidable filtering effect of language but with the unavoidable linearity of language: the impossibility of freezing a scene as a camera does. Sentences occupy time, both the time of the experience recorded and the time the reader must take to progress from letter to letter and from word to word. Even such a sentence as "All over Alabama, the lamps are out" is a temporal unit. The writer cannot achieve stasis (few have tried so mightily as Agee). The literary Agee found Evans the ideal photographer because his photographs, like those of Matthew Brady and Eugene Atget, were "monumentally static." Furthermore: "the static [photographic] work is generally the richest in meditativeness, in mentality, in attentiveness to the wonder of material and of objects, and in complex multiplicity of attitudes of perception, whereas the volatile work [like Cartier-Bresson's or Helen Levitt's] is richest in emotion; . . . though both kinds, at their best,

11. *Ibid.*, 83.

are poetic in a very high degree, the static work has a kind of Homeric or Tolstoyan nobility, as in Brady's photographs, or a kind of Joycean denseness, insight, and complexity resolved in its bitter purity, as in the work of Evans."[12]

Probably few people would regard Evans' photographs as particularly meditative, poetically attentive to wonder, complexly multiple in attitudes of perception (hundreds of similar frontal pictures of buildings and rooms) or, especially, Joycean (is there a simpler photographer than Evans?). Ansel Adams probably spoke for a generation or more of deliberately "aesthetic" photographers when he labeled Evans, Dorothea Lange, and other photographers working for the Farm Security Administration as "a bunch of sociologists with cameras."[13]

The most obvious element of Evans' pictures—though hardly a distinguishing one, for it is common in photography, especially illustrative photography—is that each of his pictures is usually concerned with a single object directly seen in the center of the picture. A mule, a pair of shoes, a church, or a store may be seen in direct, simple, unflattering obviousness. Little attention is paid to backgrounds. Most of Evans' subjects may seem quite ordinary in themselves; at the opposite extreme from Cecil Beaton, he seems the completely democratic photographer, albeit one who equates the poor and the obscure with reality and the wealthy and the famous with illusion and theatricalism. Nevertheless several of the photographs are characterized by unique intensity of subject, for example such poetic portraits as those of a small boy in *Famous Men* and a black mine worker in *American Photographs*. Here indeed are faces that may fairly be described as poignant. Sometimes in Evans' work the Emersonian uncommon common man is vividly apparent in the sad faces of the extremely poor. Likewise Evans is sometimes inclined to rather crowded pictures, of cluttered rooms and downtown streets full of

12. James Agee, *A Way of Seeing: Photographs of New York by Helen Levitt* (New York, 1965), 4–5.
13. Roy Stryker, "The FSA Collection of Photographs," in *In This Proud Land* (New York, 1973), 8.

autos and stores, even of entire factory towns. But that there is a naturalistic, if not sociological, motive behind this accumulation of stark identifying images is difficult, and unnecessary, to deny. The pictures are factual data, pieces of information, and ideological observations on rural and industrial working and living conditions as well as the marketing, advertising, and recreational practices of a particular area at a particular time.

But Ansel Adams' dismissal of Evans' work is valid only if one regards the proper subject of serious photography to be the picturesque (conventional or otherwise) or the obviously "aesthetic," or if he responds only to the informational content of Evans' works. Evans' pictures do have their documentary uses and, if they are artistic, the beauty resides neither in the beauty of the subject nor in the manipulative intrusion of the photographer. Two points need to be made, and the first must be judgmental: that the constant primary subject of Evans' photography is man and not his circumstances, powerful as these are shown to be, and that the individual photographs gain depth and reverberation when considered in the contexts—that is, in the books—in which he has arranged them. "I think all artists are collectors of images," Evans stated, and he made no distinction between literary and visual artists. According to Evans, the individual images and the fusion of the separate images into books or portions of books resemble the units and flow of a novel, especially a novel by Flaubert: "I know now that Flaubert's esthetic is absolutely mine. . . . his realism and naturalism both, and his objectivity of treatment; the non appearance of author, the non subjectivity."[14] By being on successive pages of a book, images of persons, places, and things explicitly relate to each other as do the paragraphs of *Madame Bovary.*

In *Let Us Now Praise Famous Men*, Evans and Agee seem to take for granted the dictum of Susan Sontag that "to photograph is to confer importance."[15] The men and women who stand before Evans' camera in Book One of *Famous Men* are of the decision and knowl-

14. Katz, "An Interview with Walker Evans," 85, 84.
15. Sontag, *On Photography*, 28.

edge that their images will become photographs achieving fame. The viewer/reader validates the assumption. The photographs arrest while revealing the process of rapid deterioration affecting everyone and everything photographed. The embarrassed stances and expressions of the adult subjects manifest their sense that to be photographed is to be made special, and the fact of the presence of the photographs before our eyes makes their anxiety not foolish but appropriate. Evans has praised these people; he has conferred fame upon them.

We cannot evade the social situation of portrait photography. Whether it be an informal snapshot or a formal studio portrait, the photograph of a person is intended by both photographer and subject to acknowledge some kind of eminence, distinction, or importance. Since being photographed can be anyone's easy way of gaining fame and importance, the fame and importance are usually considered trivial. Ordinary portrait photography seeks to emphasize a person's beauty and well-being (in the form of prosperity, good looks, and expressed happiness). Evans' photographs redefine what it means to become famous by being photographed; they reveal not distinction but obscurity, not happiness but pain, and not prosperity but poverty. The major paradox is that the unyielding privacy of Evans' subjects resists the automatic function of the camera to confer upon its subject a public identity. Yet the obscure achieve a fame differently than the subjects of ennobling or otherwise superficially distinguishing portraits. Because Evans redefines fame, we see how illusionary the conventionally famous actually are.

The photographs of Book One are organized in four units: the three families and the town. Each sequence develops both cinematically and in accordance with the simple formulaic pattern of the family photograph album. The progression from photograph to photograph is a cinematic technique that Agee praised in his movie reviews—the progression of single images, lingered on for periods varying from seconds to minutes and gaining their effect through accumulation and counterpoint. The apparent family album arrangement may seem a cynical and snobbish abuse of the humanity of the farm families; the paupers and their worthless belongings may appear

to be ridiculed when their pictures are organized in accordance with the dignified hierarchical scheme of the commemorating and aggrandizing leather-bound volumes that were much valued in the 1930s by middle- and upper-class families. The effect, however, is neither cynical nor ridiculing. The message of the groups of photographs is not that these are parodies of families (such a middle-class bias would be conveyed only if the characters were cartoon figures or subhuman grotesques), but that they are families. The propriety and formality conferred by the photographer's tact and skill and the editor's respect and logic are not inappropriate for people as innocent, profound, and complex as these. If there is a parodic intention in putting a vulgar conventional practice to original use, the target of the parodist is not the people but the conventional practice.[16]

The order of the photographs in the first sequence is characteristic of each of the three family gatherings, but especially emphatic in its hierarchical design and logical bondings of persons and places. There are fifteen photographs in this first sequence: husband; wife; double bed in bedroom; house—front view; child; child; child; table before fireplace and wall; kitchen table; covered child on floor; corner of room; shed; pair of shoes; child picking cotton; house—rear view. The other family sequences are similar, though the latter two contain more portraits. The dominant impression is of poverty; rather it is of

16. Especially in *American Photographs*, as I have suggested, Evans often indulges in parody, especially by seeking out photographic subjects that are self-parodies, like the fancy roof over a pump. Also an observation should be made about the genre of the album as it applies to a number of the works considered in this book. The formal arrangement of the photograph album, with its inevitable effect of commemorating and memorializing, is somewhat similar to the less formal arrangements of *Winesburg, Ohio* and *In Our Time*, which are also collections of revealing sketches—verbal snapshots, so to speak—that sum up the various eccentrics of Winesburg and the significant stages in the growth of Nick Adams. Although they ironically subvert the stereotype, these works of fiction nevertheless explicitly seek to achieve what is automatic in photography: the distancing of the subject from the present and yet the rendering of the subject with vivid realism. In a sense, the "pictures" in all these "albums" are both accessible and inaccessible; they are immediately present but of an irrecoverable past. The album arrangement emphasizes the elegiac quality of photographs, and the similarities of *Winesburg, Ohio* and *In Our Time* to albums approximate it. The stories of Anderson and Hemingway, like the photographs of Evans, are the silent specimens of lost years.

human beings enduring amid poverty. The characters do not transcend their wretched clothes and shacks; they live in conditions that create misery. What is important, however, is that the misery is manifest not as degradation but as an absence of happiness. While it is probably impossible for any sensitive observer not to imagine the horror of people living with so few possessions, this kind of pathos is actually not conveyed or even implied by the pictures. Just as Agee avoids pity and other expected responses to human deprivation, so does Evans' clinical concentration make us so intent on what is before us that we pay little attention to what is missing. The broom, the pair of shoes, the child's grave are strikingly positive and actual. We are made to give to these simplicities the same kind of respect as do the people who own so little. In the photographs of simple objects, the reality and conferred importance of the thing contradict whatever pathos the observer may feel obligated to impose upon the image. The pain of the photographs is almost wholly caused by the subtleties of unhappiness seen in the faces of the poor.

Thus Evans only partially achieved what his employers in the Farm Security Administration sought: "a new candidness in recording fleeting expressions of despair, determination, sorrow, endurance, bitterness, and pride—showing faces that even in the depth of poverty revealed a flickering hope."[17] Certainly his photographs suggest none of the sentimentality that would seem inevitable in his employer's purposes, but they possess immense reality, intensity, and subtlety. Somehow Evans managed to achieve portraits of extremely natural and delicate facial expression, though most of his figures are consciously and obviously posing. They reveal unconcealable, distinct, complex feeling behind composed masks, either embarrassed or at strained attention before the photographer.

The pictures of rooms without people are in their own ways subtly and movingly humanized. In the third photograph of the first sequence, the bed is positioned at an angle in the corner of an empty bedroom with bare clapboard walls and wood floor. The crudeness of

17. Hiag Akmaksian, Preface to *The Years of Bitterness and Pride: Farm Security Administration Photographs, 1935–1943* (New York, 1975), 3.

the room is not disguised but transformed by the simple attempt at personal arrangement, by the cleanliness and orderliness that prevail in spite of the soiled sheet on the bed. In the photographs of the kitchen table and of the corner of a room, the most conspicuous details are carefully hung towels in the centers; the broom, unquestionably used to tidy all the interior scenes, leans against a door frame as the dominant subject of the latter photograph. A puritanical concern for cleanliness definitely rules this household. Furthermore, the color white is most emphasized in this section, mainly the white cloth of towel, sheet, clothing, coverlet, and table covering.

In the photograph of a small table covered with a white cloth set before a fireplace against a wall, the top of the fireplace and the wall are adorned with assorted decorations with an advertising calendar at the center. Given the flattening effect of the black and white photograph, the image seems a decorative arrangement of uncertain function and identity. In the domestic context it is an altar: the aesthetic center of the house, the place of formal reserve and special occasion.[18]

It is important that for the most part the people and the physical settings of the first family sequence are carefully segregated. The backgrounds for the portraits are plain walls or open spaces; in two instances members of the family are seen before panoramic views of the front and rear of the house, but here the individuals are small and clearly subordinate. By keeping his figures and his settings separate (a method opposite that of Cartier-Bresson) Evans calls attention to his aesthetic of simplicity, of the plain, uncompromised image. One unexpected effect is that the photographs humanize the objects rather than dehumanize the people. Furthermore, the people, posing, are uncharacteristically inactive and detached from things, not even idly sitting on the chairs or bed that we see in separate pictures. Isolated as they are, Evans' subjects are liberated from the circumstances that otherwise abnormally confine them. They appear to exist absolutely in themselves, as ontologically independent, as simple and separate persons.

18. Agee calls this "one ornamental wall" and mantel and fireplace frame "the altar" (Agee and Evans, *Let Us Now Praise Famous Men*, 147).

The second family group in *Famous Men* is markedly dirty and unkempt, in sharp contrast to the cleanliness of the faces, clothes, and rooms of the first family. Here is a wretchedly poor family, its house far smaller and thus more cramped than that of the first. The husband is unshaven, the clothes of each person little more than rags, the small space around the stove cluttered, neglected, and containing a chair without a seat. The family portrait is one of especial wretchedness, and seems an unbearable caricature of the formal group arrangements favored by professional photographers. Along with the filth, the obvious abandonment by the family of all efforts toward order, dignity, and even such "art" as is seen in the fireplace tableau in the first group, here there is a wanton confusion of place and person. Unlike the first segment, in which persons are seen separately and wholly, in a number of the pictures in the second segment there is an absence of discrimination of person and environment, a disarray chaotically including family members and their belongings. The ruthless but careless domination by environment is an extreme form of naturalism, and a minor note in Evans' work, though an important one. It is the dominant note in the photographs of the second family.

Evans has arranged on facing pages the group picture of the family (11) and the picture of a vacant stove-centered room (12). Since these are horizontal photographs, the reader must turn the book so as to see the family arrangement mounted above the room disarrangement. Anything more than a casual glance will show the formal similarities of the two photographs, the room mirroring the family. The inverted washtub hung above the seatless chair is an abstract surreal reflection of the seated mother's head, and the chair beneath the washtub geometrically suggests her lap and bent leg and the leg of the bed on which she sits; the baby she holds becomes the vacancy in the chair that was once a seat. Likewise, in a cruelly demeaning reflection, the standing daughter is balanced by the abstract inverted V formed by two pine boards bolstering the wall; even the blackened lower wall corresponds to the soiled lower portion of her dress and her dirty and perhaps bruised legs. The rigidly posing seated father firmly clutching the shouting child trying to break away has the cylinder-upon-

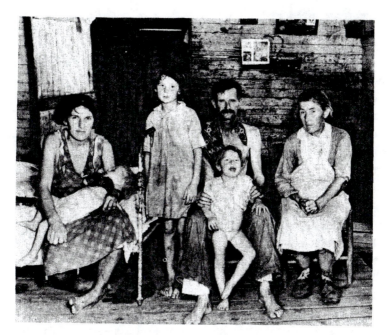

11. Family grouping

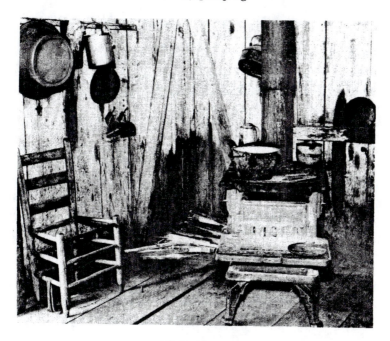

12. Kitchen

square shape of the stove and its pipe. The open mouth of the child—
the sole animated detail in the abject, despondent assembly—seems
balanced by the elliptical interior of the pot on the stove, which
obtrudes in its purity of white and symmetry of rounded form. The
seated woman on the far right is (most vaguely of all) adumbrated by
the murky arrangement of table, discolored wall, and hung kettles
that bears a cubistic resemblance (with white and black reversed as in
a photographic negative) to her chair, her lower body, her head, and
the oval formed by her folded arms and the crease of her apron. These
remarkable correspondences in design between the family and the
room reinforce the effect of a virtual interchangeability between per-
sons and things. Indeed, in a ghostly way, the persons in the first
picture have metamorphosed into the things of the second picture,
which perhaps in its surrealistic representation gives the truth of
their identities.

As opposed to the freedom implicit in the autonomy of each mem-
ber of the first family, each person given a separate, full revealing
photograph independent of environment, here is a photographic
representation of domination and enslavement. The portrait of the
father of the first segment (13) might be compared with the corre-
sponding portrait of the father introducing the second (14). The first is
soft and subdued, relaxed in posture; he seems a deeply internal and
reserved man. The mustachioed and sunken-eyed second father peers
through his black slitted eyes directly at us. He is a figure of comic
imperiousness, with eyebrows and mustache masquerading as eyes
and mouth, his neck a wooden pedestal or a wrinkled overly large
collar. There may be signs of determination in defeat in the man's
face, but the determination is more ineffectual obstinateness than in-
domitableness grounded in power, will, or spirit. Although in this
first as well as other pictures, the man asserts authority, he is seen in
all the photographs to be a victim of the domination of demeaning
poverty, as the other members of the family are seen to be victims of
both the husband and economic deprivation. The ruling father ap-
pears in five of the ten photographs (truly hogging the camera). In two
(on the same page) he seems playful and nearly smiling, but his vul-

nerably exposed bare torso (a pallid white beneath his nearly black sunburnt neck) seems pinned between the metal tubing of the front and rear frames of the bed on which he sits. He seems not to know that he is a captive, but his child, on the opposite page (15) mocks the posture of the prisoner behind bars: like a convict in a cell, the child grasps the upper horizontal bar, hangs her legs over the lower one, and peers between the vertical bars of the bedstead. The rags of her clothes fuse indistinguishably with the rags of a blanket behind her that can be seen beneath her stretching arms as forlorn crumpled wings.

The father is next, and finally, seen as a cartoon figure or a parody (16). His full body revealed, he stands with hands on hips and cotton-gathering bag slung over his shoulder, gazing fearlessly into the camera, the conqueror and leader of the cotton bushes behind him that he literally dwarfs. In terms of the title of the book and its insistence on redefining *fame*, this farmer proclaims his praiseworthiness; in posing so haughtily he accepts "fame" as his privilege. The photograph is merciless: there is no dignity or pathos, no direction of the irony toward the circumstances that have caused the ludicrous posture of aggrandizement. The shapeless baggy pants, the shirt open at the waist, even the taunting car in the background, and perhaps especially the accidental rhythmic grace of the cotton-gathering bag in contrast to the graceless pants—these so devastate the Sutpenesque hauteur that we mostly feel for the man an overwhelming shame.

This photograph, resembling the traditional sculpture of the statesman or the general, appears on a page opposite a photograph resembling a different traditional model, that of a madonna and child (17). While a madonna is no less susceptible to parody or cartoon than a statesman or general, this image is not a corruption of the archetype. While there may be futility and final defenselessness in the mother's efforts to both comfort and imprison the child (by making her arm into a bar and her hand into a clamp), there is an honesty of feeling in the shared, though distinctly different, miseries of the mother and child. The prison motif of the second photographic section culminates in a picture of a broad horizontal expanse of field

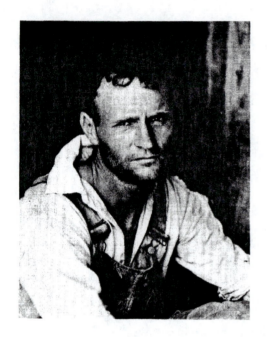

13. First father

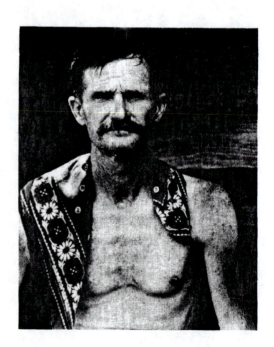

14. Second father

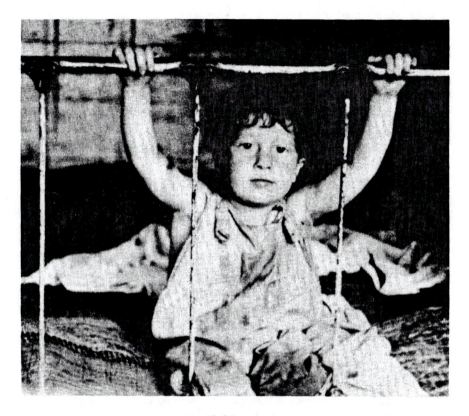

15. Child on bed

with a network of fences in the foreground—probably to mark off a small vegetable patch from the extensive acres of cotton, but looking like a delapidated stockade—and dark menacing clouds above.

The third family sequence is quite different in theme and tone from the other two. Here the suggestion is of parents neither sublime or even dignified in their stoicism as in the first couple, nor warped and shackled in their oppression as in the second, but of a man and a woman who are before anything else, and perhaps rather than anything else, a father and a mother. If a father dominates the previous segment, children dominate this one. In the rather formal—by now, it seems, obligatory—introductory photographs of father and mother each looks downward in timidity or embarrassment with arms held awkwardly to their sides so that the clean (maybe new) overalls of the father and the loose, dirty dress of the mother are given an unwanted prominence. The heavy eyelids and mustache of the man, unlike those of the second father, do not become his total countenance. His significant expression is richly reflected in his firmly staring but soft eyes, the creases of his cheek, and even the complex curvings of his lip, chin, and beard stubble. Unlike the uncomfortable rigidity of the man, the woman's posture is one of an uncomfortable attempt to be relaxed. Of the three couples in the photographs, this is the one that most obviously reveals the fragility, shyness, and discomfort among strangers that Agee stresses in his treatment of each of the farm families.

The two portraits of the adults are succeeded by two of the house, and once again the pair of horizontally facing photographs are complementary, as opposed to the ironically contrasting pairs in the previous segment. In these two pictures the boards of the house dominate; they are crudely and simply functional—on one side as exterior walls (the husband's domain), on the other as interior ones (the wife's domain), whereupon the simplest and sparsest of eating utensils and odd kitchen implements are hung. The primitive aesthetic of the small clapboard house is a puritan one, oddly clear, clean, and spacious. We see what Agee calls "the bare essences of structure." There

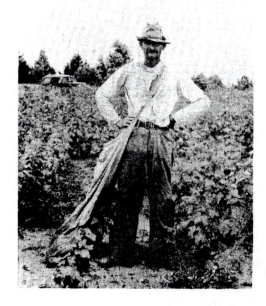

16. Man with cotton gath-
ering bag

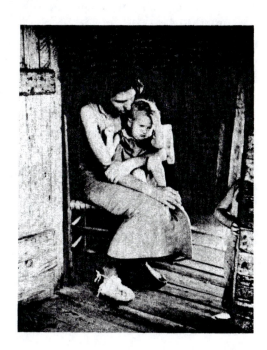

17. Woman with child

is no open window in this rear view of the house—rather what appears to be a boarded one—but we sense in its absence not a deprivation but a completeness and honesty of form with "not any one inch of lumber being wasted on embellishment, or on trim, or on any form of relief."[19] Likewise, in the interior view the mostly uninterrupted alignment of raw pine boards reveals crippling poverty to be sure, but it mainly manifests a will to austere survival and growth: the centered knives, spoons, and forks are secure and freely available, ready to be used.

In this cluster of photographs we have thus far seen a man and a woman whose minds are more occupied with something other than the intruding photographer before them; we have seen the inside and outside of their shelter; next we see in extravagant abundance what it is that occupies the man and his wife, those whom they are sheltering. Eight photographs of children, six of them of a child alone, indicate the entire subject of this group of pictures and certainly the subject that gives to the family its defining identity. The main effect is a strong sense of unique individuality in each child. Yet we also note in each child a curious and inappropriate assumption of maturity, so that even the boy with the dog on his lap (18) is unrelaxed, partly reluctant to act as a boy at play. Also he is "dressed up" a bit, wearing what we will see to be the family hat, but his inexperience in and distrust of such studied playfulness may be seen in his failed smile and tense posture. That the boy is more sure of himself as man than as boy may be judged by observing his large sturdy feet and dark worn ankles.

The hat worn by the boy (made of cornshucks, according to Agee) is worn by an older sister in the opposite photograph. For her, the hat, as well as the beads around her neck, seems the least natural of embellishments, as her wide concealed eyes and wide thin-lipped mouth are tensely apprehensive. The children in solitude or, in one instance, in a pair, are not just serious and solemn, but they seem not children at all. In these portraits, however, what Henry James calls "the death

19. *Ibid.*, 131, 130.

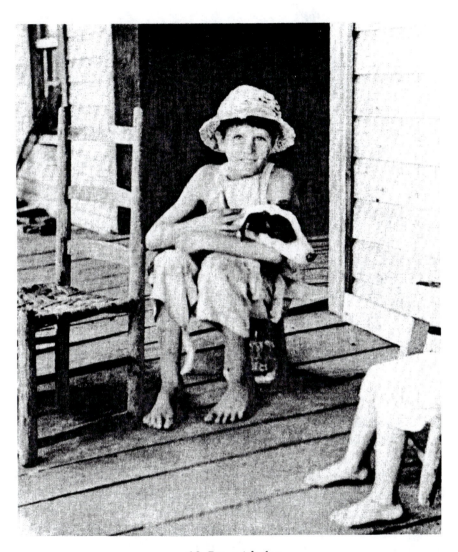

18. Boy with dog

of . . . childhood"[20] is not a loss of innocence, but a loss of playful-
ness and joy, a terribly premature, troubled, and forced adjustment to
adult obligations. Yet while each child individually projects both war-
iness and profundity, there remains in each an innocence. However
there is less innocence than solemnity in their faces in the group
assemblage of seven ragged children with their mother, whose own
look of abjectness and torment seems compelled by a need to repress
her undisguisable youth and vibrant eyes. In crowding the children
together, the group picture mainly abolishes the independence of the
individual portraits.

The theme of a parental attention to children that far surpasses
duty is to be seen in the five remaining photographs devoted to this
family: the mother about to serve a meal on the kitchen table; the
fireplace (useless because of a hole in the wall behind it) overhung by
the family hat and a crayoned admonition ("PLEASE BE QUITE"); the
amazing clutter of calendars and advertisements hung over another
fireplace and thus a locus of information and "culture"; two nailed
snapshots that may epitomize the family's history; and finally the
turned back of the father, wearing the communal hat, driving his pair
of mules into the empty road before him. All that we see of the par-
ents and the house in these final photographs is instances of their
serving the family, that is, the children. Aside from their initial por-
traits, in which they seem uncooperative photographic subjects, the
father and mother are either absent or at work, and (with one excep-
tion—a child in the first section picking cotton) they are the only
persons seen at work in all the photographs in the book.

The general inactivity of Evans' subjects makes their silence seem
strained. The enforced stillness becomes progressively more apparent
as one follows the succession of photographs through each of the
three families. The members of the first family appear habitually
quiet, those of the second appear subdued by the domination of the
male head, and those of the third mostly seem hushed only for the
moment that the picture is being taken.

20. Henry James, *The Art of the Novel: Critical Prefaces*, ed. Richard P. Blackmur
(New York, 1934), 146.

Evans is the exact opposite of "process" photographers like Cartier-Bresson and Weegee, who pursue the sudden and surprising apprehension of a moment of revealing action. Quite the contrary, Evans exploits his subjects' awareness that he is taking their pictures, and he gains unique effects from photographing them when they are still. The pictures do not freeze an action but absorb or retain a self-consciousness and in most cases a stillness that are both uncharacteristic and revealing of personality. Even when obviously unnaturally stiff from embarrassment, the subject's real identity is evident in a feature of face or gesture of body unmodified by the consciously posing self that is to be photographed. In all of the portraits of the third family, for example, we detect both a submission to photography and a resistance to it.

At the same time, the momentary accession to the photographer's request releases the subject from normal activity. A formal photograph can be as revealing as a candid one. Unlike Richard Avedon, Evans works with subjects extremely ill at ease before the camera; but the practice is far from a limitation, though it is no doubt a problem, just as photographing the relaxed celebrity must be a different kind of problem. Evans in effect tells his subjects: do nothing, be still. The farmer of the second group finds it impossible to be anything other than a model—that is, to pose—but the subjects of the third group find it impossible to be models only. Also the camera—imposing unaccustomed stillness, self-awareness, concentration, even an unfamiliar feeling of victimization—compels one simply to be and to do nothing. The mask adopted for the camera requires the removal of the various masks adopted unconsciously in ordinary life, especially those facial expressions that are the natural accompaniments of some habitual labor. As William Stott puts it, Evans "records people when they are most themselves, most in command, as they impose their will on the environment."[21] It is fundamental to Evans' aesthetic of photography that when a subject is revealed in isolated stillness, he shows himself ideally or truly. If each adult and

21. William Stott, *Documentary Expression and Thirties America* (New York, 1973), 269.

child in the third section expresses some kind of fright, we know that the fright is not solely caused by the camera. The faces reveal a failed effort to disguise fear, but the expressed fear has deeper and more enduring sources than the intruding camera. When we look at some of the children in Evans' photographs, especially the one of the brother and sister together, we can imagine that this boy and girl gaze directly at death itself.

In *Famous Men* Agee writes much about his own responsiveness to the silence of rural Alabama at night and about the quietness of the families in their rare and ritual periods of inactivity, especially the time between dinner and sleep; but the silence of Evans' photographs is of a different, though complementary, order. Agee favors the actual silence of night, Evans the mostly artificial (owing to photography) silence of day. But mainly the silence of the photographs is the silence inherent in a person's or a thing's taking existence in a photograph. Much of the dramatic intensity and aesthetic richness of candid action photographs derives from their magical annihilation of time, their instant freezing of motion so as to make visible what would be impossible to see clearly without the intervention of the camera. In posed photographs the subject wills to be immobile, and is so whether or not a picture is taken. In this sense the photograph of a still object or person is more accurate than the photograph of motion, in which the motion must be implied from the appearance of literally static figures.

The power of Evans' photographs, particularly his portraits, is not primarily an effect of accuracy alone, though extreme precision and clarity of detail are certainly essential to the effect. Evans has used the term *transcendent* to define the quality he seeks to achieve. As nebulous as the term is, the transcendent in a photograph can be thought of as the quality achieved through an intense, undisguised, and unmodified representation of a subject to such a degree that the particular documentary circumstances are transformed. The poetic of photography is an absolute poetic of realism: an acknowledgment of the presence and visibility of depth in surface. As Susan Sontag writes, "In the normal rhetoric of the photographic portrait, facing the camera signifies solemnity, frankness, the disclosure of the substance's

essence."[22] The same kind of high regard for the capacity of the camera is expressed by Garry Badger: "The straight photographic aesthetic demands above all else respect for the primacy of the object and, in terms of artistic expression, an allowance for transcendent experience through the objective signification of the thing itself."[23]

There are several senses in which Evans' photographs, especially his portraits, can be regarded as silent. We are conscious, first, of the silent stance assumed by the original subject of the photograph, and, second, of the silence of the reproduced image before our eyes. But the transcendence that the photograph is intended to achieve must also be an attainment of a silence—a silence of total removal from temporal motion and sound, from the usual environment of the subject that the photograph may omit but in fact suggests as something that has been omitted. The silence of the photograph that is also a work of art is thus the silence of other works of art, especially engravings and icons, paradoxically forms of art that are not notably realistic. Certainly the black-and-white appearance of the photograph has much to do with the similarity of photography to forms of art that give a strong effect of omitting the inessential, for in photography color can appear as the superficial, the merely decorative, and the absence of color—even in a photograph of complex detail—may appear as an achievement only of the essential.

A further kind of silence is achieved by Evans because of the extreme transience of most of his subjects—for example, of children who are forced prematurely to become adults and already show strong signs of being worn down by the hard conditions of their lives. The paradox and dialectic of these photographs is the simultaneous and emphatic presence of time and timelessness. As William Stott writes, "If [Evans'] vision is timeless, what it sees is not. Indeed, its stability and imitation of eternity only further emphasize how instable, how rotted with time its subjects are."[24]

22. Susan Sontag, "America, Seen Through Photographs, Darkly," in Goldberg (ed.), *Photography in Print*, 513.
23. Garry Badger, "American Painting 1908–1935 at the Hayward Gallery, London," in *ibid.*, 462.
24. Stott, *Documentary Expression and Thirties America*, 288.

"Photography is an elegiac art," according to Susan Sontag; "photographs are themselves instant antiques."[25] In making their subjects immediately old, all photographs are about the past in a way that paintings do not have to be and indeed seldom are. Paintings of historical events are intended to make them seem contemporaneous. Photographs work in exactly the opposite way: they convert the present into history. Except for some aesthetic photographs, like those of Edward Weston, all photographs must be historical documents. Evans is an artist who embraces the memorializing (perhaps even deadening) effect of photography instead of resisting it. He encourages the illusion of lifeless immobility, of helpless stasis, of permanent silence. He does not try to transcend or disguise what some may regard as the restrictions of the photographic medium—its stillness and necessary realism that emphasizes transience.

In Book One of *Famous Men* and in other works, especially *American Photographs*, Evans includes occasional photographs of photographs. One effect is to make us conscious that society uses photographs as historical records and prized images, such as the snapshots of an old woman and a child nailed to the wall in the house of the third farm family. A photograph of a photograph makes the observer doubly removed from the reality of the original photographic subject and intensifies the sense of pastness, for the photographed image was of the past when the inclosing photographed scene was of the present. As a single page in one of Evans' books, such a photograph further annihilates the illusion of immediate reality. We are not allowed to evade the knowledge that we are looking not at people but at pictures of people, who are as still as the rooms and houses that share the pages with them, who are not now alive as they are seen in the photographs but are of a past that existed only for a moment.

The fourth segment of the photographs in *Famous Men* shifts from the farm families and their shelters to the characteristic buildings of nearby towns. In these photographs we mostly see a different kind of crudeness, delapidation, and primitivism. The sharecroppers'

25. Sontag, *On Photography*, 80, 15.

houses at least have a human function. Chairs, beds, porches, and walls, like shoes and hats, have essential human uses. Furthermore, of the forty-three photographs of rural life, twenty-seven are essentially portraits; in only one of the eighteen photographs in the town section are persons the major subject. The exception is a picture of two men animatedly conversing in chairs on a sidewalk before a storefront containing a handpainted notice of a "free dance." These men belong to another world from that of the farm families. They are well-dressed in the formal southern country mode of white suits, straw hats, and black shoes and socks. One wears a white coat, a black bow tie, a watch chain, and a badge of some kind on his lapel. These relaxed conversationalists are so worldly and so busy chatting that they take no notice of the photographer.

The ethos of the town is very different from that of the farm; indeed most of the photographs in this segment bear a more obvious resemblance to those of *American Photographs*, a book much concerned with urban life and industrialism. These are exceptionally static photographs, principally because of the near total absence of people on streets, or before a mayor's office, a school, or a church. Here are aspects of towns that may once have been human communities. Although they lack the orderliness of Edward Hopper's deserted neighborhoods, like Hopper's locations they seem to have been abandoned some time ago. Thus they are both eerie and forlorn, mostly fragile relics of an extinguished life.[26]

But there are exceptions, there are some signs of energy: not just the two sprightly gentlemen in their friendly conversation, but the prosperous main street of an Alabama county seat, lined with new black Fords parked before a row of apparently busy and well-cared-for stores (8). The photograph of the main street introduces the town sequence, and whatever impression it may give of well-ordered and dynamic prosperity is instantly challenged by the photograph on the

26. Since he used a cumbersome unconcealable camera, it was pragmatically useful and sometimes necessary for Evans to photograph buildings when few people were present. But this fact does not rule out the opinion that Evans wanted effects of desertion. It is one of numerous ways in which Evans' technique and sensibility benefit each other.

opposite page—a photograph whose dominant diagonal line balances it in form and whose representation of a group of village stores balances it in content. But no automobiles stand before the second grouping of stores, nor are these well-made or well-cared-for, for the tin roof over the sidewalk is crumpled and swaying, uneasily supported by frail, uneven, and unpainted boards. In another photograph Evans intertwines his themes of the prosperity of the automobile age, the elegance of "city" clothing styles, and decay. A less than brand-new automobile is parked before a barber shop in a state of nearly unimaginable decay. Three black men lounge before the shop, one in suit, vest, tie, and felt hat, the others less nattily dressed but informally well-clothed nevertheless.

The farm houses in Evans' photographs are marked not by deterioration but by crudeness. Certainly the rural shacks do not suggest much permanence, but in their boxlike primitive simplicity and clean angularity, they seem unsusceptible to the kind of rot and delapidation that is to be seen in the village stores. These flimsy shanties are literally collapsing beneath their advertising signs, their mostly ornamental sidewalk shelters, and their congested facades.

As we have seen, Evans likes to exploit the potential ironies and reverberations of two photographs facing each other in the open book, especially when the pictures are set horizontally, requiring that one be seen above the other. The first diptych of the town sequence (of the prosperous orderly stores with new cars in front and of neglected stores with collapsing roofs) is portentous in its irony—a *memento mori* to the bright new world. The second diptych is simply and rather crudely funny: the two white-clad men in their gingerly dialogue are matched by the heads of a pair of mules, one white, one whitish, both nattily attired in facial harnesses and blinders. The succeeding contrasts are mostly architectural, and in different ways contrast past and present. A coldly functional, recently completed block stone building labeled "MAYOR'S OFFICE" stands blankly before some large puddles (one reflecting "MAYOR'S OFFICE") on a stretch of unpaved dirt; this photograph appears opposite one of another single building, a much older store with the usual overhanging roof, almost completely cov-

ered with beverage and circus posters. The final ironic pairings are of a crude schoolhouse and a railway station (paralleling lines of pine boards leading into paralleling railroad tracks) and of a gasoline station–post office, its porch cluttered with bunched and unidentifiable people posing for the photograph, and a rude new grave on a bare field. In the second pairing the opposition of present and past explicitly assumes allegorical meaning: the icon of contemporary life— manifesting the age of the automobile, of quick communication, even of photography (the men posing for the picture)—is balanced by the timeless icon of death—the plain grave in the open field.

The composite town that Evans represents is a patchwork of disparate fragments—a few irrelevant people; omnipresent Coca-Cola signs; the stubborn ruins of an antebellum plantation society; the hasty constructions of a contemporary society supported by the train, the automobile, and trade; the ruined shacks of a recent and ignored past; and the intended and unintended emblems of death. The final photograph is of a towering homemade birdhouse—gourds with carved openings fragilely mounted to a long pole against a background of blank sky. The birdhouse looks like a primitive symbol of some sort, and in the context of the pictures that precede it, it would seem to symbolize an aspiration to ascend, to fly from the soil—the soil that dominates the photograph of the grave that comes immediately before.

The town sequence suggests a return to the pessimism and cynicism of *American Photographs*, for it is full of images of conventional "progress" that convey a sense of despair and futility. Such photographs as these may be said to express a negative aspect of silence—the silence of inevitable death, meaninglessness, the irrelevance of time before eternity. The positive aspect of silence dominates the three farm sequences in *Famous Men*. For through Evans' photographs, the family members and their goods attain what seems an eternal existence of their own. They achieve an ultimate fame.

Five

EDWARD HOPPER

I. Drama and Vacancy

IN HIS 1963 interview with Brian O'Doherty, Edward Hopper happened to mention a few poems that he liked, and on the basis of the interview as a whole we can surmise that these enthusiasms are probably important, for Hopper was not easily given to categorical approvals of many things. But he did acknowledge to O'Doherty that "there's a beautiful thing of Verlaine's on evening," and that he admired Frost's "Stopping by Woods on a Snowy Evening" and "Come In," and also Goethe's "Wanderer's Night Song." It is not surprising that a painter preoccupied with the light effects produced at different times of day and night would have such tastes in poetry. In the Goethe poem the silence of the described scene especially affects Hopper, for as in many of his paintings, the silence of the scene is an aspect of the time in which it is observed. Hopper translated "Wanderer's Night Song" as follows:

. . . the magic power which trans-
forms the negative into being.
G.W.F. HEGEL
The Phenomenology of Mind

168

> Over all the hills is quiet
> Over all the dells you can hardly hear a sound.
> All the birds are quiet in the woods.
> Soon you will rest, too.

After speaking the words to O'Doherty, Hopper observed, "It's an extraordinary visual picture."[1] If it is a visual picture, the subject of the picture is silence, and silence is also the subject of many of Hopper's most important paintings.

Hopper's paintings are uniquely silent, conveying a sense of unnatural stillness. The silence is more active than passive, mainly because it suggests little of the calmness, tranquility, or placidity commonly associated with it. Hopper's silences are tense—hushed decorums maintained with terrific strain. In most of his works noise would be a welcome relaxing of tension. But what does it mean to say that a painting is silent, and particularly a Hopper painting? Since canvases covered with paint produce no sounds, obviously all paintings are silent. In this crude sense, of course, novels are also silent. But a painting may immediately evoke sound by representing a source of it (for example, Toulouse-Lautrec's *Moulin Rouge*). Some paintings subordinate the auditory content by distracting us from the implied, possible, or even inevitable sounds that would be audible were the artificial representation an actual perception (for instance, Seurat's *La Grande Jatte*). Still lifes and most landscapes, unlike paintings of musicians playing or people laughing, imply no sound. But in the vast majority of such works the auditory sense is simply irrelevant. The nonexistence of imagined sound—and imagined nonsound as well—is beside the point, as is the nonexistence of imagined sight in response to most music. By contrast, the silence of Hopper's most characteristic paintings is a silence so emphasized, so dramatized, that it is essentially a subject and theme of the work.

Quite obviously Hopper chooses subjects that are in themselves silent, especially buildings and rooms. Further, in a representative Hopper work, one becomes conscious of silence because the chosen

1. Brian O'Doherty, *American Masters: The Voice and the Myth* (New York, 1973), 47.

subject (say a railroad station) though inherently silent in itself is, in the memory and associations of the viewer, related to some kind of noise (say that of trains and loudspeakers). But Hopper repeatedly paints deserted streets, empty houses, motionless trains, unpopulated segments of cities and towns, and idle factories. He defamiliarizes the commonplace by, among other things, requiring us to observe the most banal features of a society at a time or in a situation when they are rarely observed; hence they become unfamiliar, as they also become curiously quiet. The subject matter of many of Hopper's paintings is the *mise en scène* of much naturalistic fiction, that of Dreiser and Dos Passos for example, but in Hopper it is mute and motionless, and the energies are exclusively latent if they exist at all.

Stillness, owing largely to the emphasis given formidable stationary buildings, enhances silence. Hopper likes massive lighthouses, exceptionally large houses, and the thick masonry of turn-of-the-century doorways, walls, and window frames. Also the formality and extreme bareness of the buildings, both basic to Hopper's style in rendering architecture, intensify the stillness. For example, *Approaching a City* is presumably a view from a moving train as it approaches a tunnel before a row of factory and office buildings. But there is no sense of motion, for there is absolutely no life in the vision. Nor is there any disarray. Judged by any criterion of verisimilitude, the scene is improbably desolate; the silence is strongly felt because it is the wrong atmosphere for the situation. Hopper's street scenes are the neighborhoods of deserted cities. The city in *Approaching a City* is one without people.

Observing a usually busy scene when it is still is only one of the ways in which Hopper compels a new perception of a subject. A more startling method is to employ a nonhuman perspective. That is, the positions from which a number of the situations or settings are observed could not be occupied by actual human beings. Viewers of some Hopper paintings, especially those of interiors, are uncomfortably located in space. In one painting the viewer feels suspended a few feet outside an upper apartment window glimpsing the partially concealed backside of an oblivious woman; in another he is made to

hover above the street looking sharply downward at a nun pushing a baby carriage; and in another he is positioned near the ceiling of a high-walled office building at night, staring at a seated man and his standing secretary. Hopper's seeming voyeurism is routinely observed by his critics, and it cannot be denied that some of Hopper's work seems calculated to titillate. But titillation or adolescent pornographic excitement is not the significant effect gained by the viewer's unconscious feeling that he has no business being where he is. He is indeed prying into other people's secret lives, sometimes even into the secret lives of buildings and rooms. James Agee in *Let Us Now Praise Famous Men* regarded himself as a "spy," intruding not only into the delicate privacy of the three farm families he lived with but also into their houses. His regular shame, embarrassment, and self-contempt is perhaps something like the feeling of a viewer standing before Hopper's *Office at Night* or *Hotel Room*. The subjective reaction heightens the sense of silence, since the observer of the quiet scene automatically feels that he himself should be very quiet, so as not to disturb or, more important, be found out. He is looking at scenes that he is not intended to see. The self-absorbed figures do not know of his presence; otherwise they would be embarrassed, startled, or otherwise uncomfortable. Even the inanimate buildings and deserted streets have a privacy that observation somehow violates.[2]

Frequently in Hopper's works the attitude toward buildings or other inanimate structures is much the same as the attitude toward people. Like his naked women alone in their bedrooms, his deserted drug stores and office buildings are also naked when seen in solitude and silence; and also as with the women, Hopper pitilessly exposes them. Most of Hopper's buildings are public buildings, made for impersonal community service. When seen at night or—as in *Early Sunday Morning*—at dawn, they are caught off guard, detected in their private selfness. They are like the women without clothes who

2. In this respect, Hopper's portraits of nudes are the opposite of those of Degas, who, as Edward Snow points out, places the viewer at a respectful distance from his subjects (*A Study of Vermeer* [Berkeley, 1979], 26). Hopper pulls the viewer in against his will, creating a sense of helpless, unwanted observation.

only think they are alone. Most of Hopper's buildings are elaborately decorated and inappropriately ornate; they are given to posturing with bravura and self-dramatization. Only when seen in desolation is the absurd pretentiousness of such self-display truly obvious. The self-dramatization of the gasoline pumps in *Gas* (26) is identical with that of the stripper in *Girlie Show*—both strident posturers in the midst of vacancy. The stripper and the gas pumps exist mainly to be seen, but not as uncompromisingly as Hopper makes us see them. The urban scene that Hopper paints is of a time when Victorian decorativeness merges with twentieth-century tawdriness, and the paintings reinforce the complaint made by Henry James in *The American Scene* of "the interference . . . of the immense amount of vulgar, of barbaric, decoration."[3] Hopper's paintings reveal the vulgarity of the vulgar not by exaggeration but by intense concentration, the elimination of all that might modify the effect of the singleness and simplicity of the image. Saying that these images are silent means not just that they are still but that the stillness is an aspect of concentration, as both its cause and effect. Thus the silence is intrinsic, a part of the identity of a scene, not an accident or a secondary attribute.

Hopper seems to give his buildings and frozen situations an unmerited importance—far beyond the achieved realism of the representation, beyond the democratic inclusiveness of the subjects, beyond, if not contrary to, lyrical reverence and humble respect for the commonplace. Many of the paintings, especially the later ones, seem artificial, not natural, and often quite theatrical. *High Noon* and *Rooms by the Sea*, for example, are somewhat stilted scenes, captured not randomly or casually but at times when lights and figures compose in formal arrangements.

Silent and still as they are, many of Hopper's works suggest dramatic situations. The drama is partly an aspect of the often noted intensity of his works, achieved by sharp color contrasts, vivid light or absolute darkness, surprising angles of vision, abrupt croppings, and obtrusive geometry. Directness and obviousness certainly make

3. Henry James, *The American Scene* (New York, 1946), 361.

Hopper's works seem simple, but also oddly contribute to their baffling subtlety and mysteriousness. Hopper has been likened to Chirico and Magritte in his use of windows, stark skies, and prominent shadows to create sinister effects.[4] In only a strained sense is Hopper a surrealist, but like the surrealists, he claims to paint "with the intellect as master" so as to challenge the intellect of the observer.[5]

Hopper makes us curious, the curiosity arising from dramatic tension and dramatic anxiety (What is happening? What has just happened? What will happen next? What am I seeing?). Hopper paints motionlessness to the point of exaggeration, but perhaps as an inevitable result, time is usually an element of his work. He paints and preserves captured moments, but the time of day or night in which the moments occur strengthens our sense of a "before" or "after." A favorite Hopper subject is the hotel lobby, wherein people enter and leave, but more often simply wait. There is a tension in moments—seemingly minutes, not seconds—of rare stillness, certain to be disturbed. In *Sun on Prospect Street* (19) the strong shadows will soon lengthen, a person could at any time appear on the deserted street, the two cars will not remain parked, the houses may be entered or departed from. Unseen people live on Prospect Street, and we wonder about them. The drama depends on external or relatively incidental conditions. The rooms, buildings, and streets cannot move, but the light does and the absent figures may appear and the motionless ones may move.

In their boldness, directness, and blatant obviousness Hopper's paintings seem to attack us. Over the many decades of his career Hopper worked for increasing clarity of line and sharpness of distinction. One might contrast the earlier and later versions of *Sun on Prospect Street* to remark the total elimination of impressionistic blurring of edges in the more recent painting. Also, Hopper's working practice was to eliminate human figures or other details often present in the preliminary sketches so as to include and make explicitly evi-

4. See Lawrence Campbell, "Hopper: Painter of 'thou shalt not!'" *Art News*, LXIII (October, 1964), 45.
5. Edward Hopper, *Edward Hopper* (New York, 1948), 1.

dent only the elements of a work that his artistic judgment deemed indispensable.[6]

His method emulates his subject: the process of reduction and simplification strains for ultimate vacancy. As motion is annihilated and impermanent figures—people and small, movable objects—are eliminated, the silent space within and around large fixed structures becomes more dominant.

For all of his identification with artistic realism and naturalism, Hopper paints remarkably neat scenes. Inclined as he is to represent urban street scenes, he gives us few ash cans. His streets are clean, his tables are bare, his floors are swept. Hopper prefers very little furniture in his rooms and minimal clutter in his streets. It is as though the cleaning lady had just left or a strong wind had just blown through. Thus his realism is a realism of possibility, not probability. The combinations of arrangement, illumination, stillness, and bareness that he paints are seldom to be found in life, though the paintings are lifelike.

Thus, in a general sense, we arrive at the essence of Hopper's paradoxical art: simplicity and obviousness create dramatic mystery. Hopper's notorious disdain for abstract art, his almost belligerent realism, is certainly not the passion of a local color enthusiast or, least of all, a celebrator of some American scene school of painting. Although there is no firsthand evidence from Hopper's few interviews and writings, one might speculate that to Hopper the major defect of abstract art (which he called "decorative art") is that in it the mystery is in the initial statement of the work.[7] Certainly in nonrepresentational art the observer begins in mystery and struggles toward clarity. In Hopper's work, however, he begins in clarity, but the very clarity leads immediately into spatial and temporal bewilderment. From there he is led to other uncertainties: what is being signified; what is the significance?

As an artist firmly in the tradition of realism, Hopper is also what

6. See, for example, Brian O'Doherty, "The Hopper Bequest at the Whitney," *Art in America*, LIX (September–October, 1971), 72.

7. Hopper, *Edward Hopper*, 1.

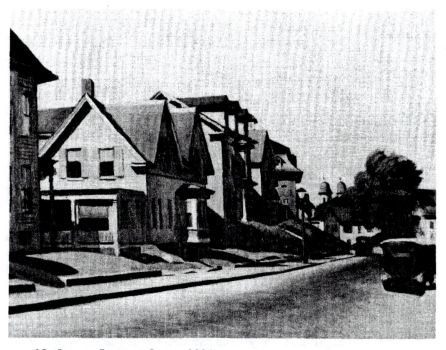

19. *Sun on Prospect Street*, 1934
Courtesy of the Cincinnati Art Museum, Edwin and Virginia Irwin Memorial

is sometimes called a modernist, an artist compelled by an aesthetic of honesty to communicate the artificiality of his depictions. Deceit in art depends on the conventional tricks of illusion. Paintings may effectively conceal their actual two-dimensionality and medium (canvas and paint), but they can only divert attention from their arbitrary square or rectangular shape and the timelessness and motionlessness of their physical forms. Painters who try to imitate aspects of the physical world primarily in some photographic sense, regardless of whatever emotional and aesthetic effects they wish to convey, defeat their purposes by emphasizing the frame, paint, and "falsehood" of the painting's constancy. Thus painters of this type use the frame as a window through which the viewer may peer at figures so arranged that the eye is directed toward the center; what is on the edges or outside does not matter or does not exist. Painters reduce the illusion-seeker's difficulties with time by painting static objects, such as baskets of fruit, or producing the illusion of movement (Bruegel's playing children do indeed seem to be moving).

Hopper has a totally different place in the realist tradition. He uses frames to conceal figures or objects of presumed importance. In Hopper's "simple" paintings, everything has to be important; there is no hierarchical arrangement. Furthermore, the recurrent doors, stairways, and windows are frames within frames, the opposites of trompe l'oeils. The interior and illusory squares and rectangles of doors, shadows, light, and architecture are allied with the geometry of the canvas itself and function as pictures within pictures. The apparently real scene is just as apparently a picture of a real scene. Hopper encourages us to acknowledge that we cannot see everything, that there are restrictive frames not only in paintings but in all perceived scenes. We have no eyes in the back of our heads. So doorways, bottoms of buildings, people, and rooms seem as pointlessly cut off by the edges of paintings as in the work of the poorest photographer. It seems an act of conscious perversity that in one of Hopper's best known works, *Lighthouse at Two Lights*, an otherwise almost classical representation of an imposing and dignified structure, the tip of the lighthouse is out of the picture. Even Hopper's obsession with windows paradox-

ically calls strong attention to the ways in which concealment is an important architectural consideration in the location of windows. We see into and out of windows, but our view must be arbitrarily restricted and focused by their shapes and positions.

Hopper, who loved the movies, sometimes likened his works to the single frame of a motion picture film, particularly a frame removed from a sequence taken by a moving camera.[8] Like many of his works, *Manhattan Bridge and Lily Apartments* has in the forefront the top of the railing of a bridge that extends horizontally from one edge to the other. It is common for Hopper to employ stark horizontals, such as a curb, a railway track, or a wall, at or near the base of his pictures. These are lines visually interrupted by the frame, but imaginatively endless. The scenes in which they appear seem arbitrary excisions from a movie taken by a horizontally moving camera. Less often the imagined camera moves vertically, as in *House at Dusk*, in which we see only the top stories of an apartment house.

Thus Hopper's unconventional framing techniques, together with his intensity and obviousness, disturb and puzzle us. Rather than conceal the falsifications in time and space, they exaggerate them. Actually they exploit the inherent paradoxes of all visual art by showing that the simple must be complex, that the revealed must be concealed, that the separate must be connected, that the active must be motion arrested. Hopper's empty spaces are unemployed containers. There is an enormous sense of potentiality in his works; both temporally and spatially they evoke the presence of more things than those shown and the inaudible presence of future and past sounds and movements.

As a painter of figures (human or otherwise) in contexts, Hopper is a recorder of discontinuities, disharmonies, and incongruities. He uses unchanging nature and the American past as Henry James uses Europe, as an environment in which to situate the present. His attention is drawn to those settings, certainly abundant in America, in

8. See Gail Levin, *Edward Hopper: The Art and the Artist* (New York, 1980), 58. This edition has been indispensible for my study.

which a building is in an inappropriate place or a structure does not harmonize with the surrounding landscape. Spindly, slightly crooked telephone poles stand before anachronistic Victorian houses; a gaudily illuminated drugstore window stands beside a darkened doorway and a deserted and absolutely dark street.

In *House by the Railroad* (20), a massive and pretentiously ornate house is seen from ground level behind a banked railroad track. The track is almost precisely parallel to the bottom edge of the painting. Although the house is geometrically centered in the painting's frame, its front is seen from a sharp angle; it is turned away. Its colonnaded porch and dominant tower, designed to be majestical, are partly obscured by the restricting angle of vision and the severe shadow. The side of the house receives the direct sunlight and is the portion of the house seen most clearly and fully. Since the lower part of the house is severed by the tracks concealing the bottoms of the windows and bases of the front pillars, the presumed intention of the architects— to create a stately dominant building—is in the process of being nullified by nearly accidental circumstances of time of day (late afternoon), period of history (no doubt the track was laid after the house was built), and angle of vision (seemingly arbitrary, as opposed to the conventional frontal views or otherwise flattering perspectives of architectural magazines and picture postcards). One need not here resort to the routine vocabulary of Hopper commentary and speak of the "loneliness" or "beauty in ugliness" of the painting, but only remark that the house is defined by its context. Most of the context is negative: the absence of neighboring buildings, land, human beings, clouds, trees, and anything but the tracks, which are reddened by the descending sun and seen directly as a horizontal plane in the immediate forefront of the view.

Hopper's largest and most imposing houses do not blend with the physical world that contains them. *House by the Railroad* is an extreme case. Here the only earth to be seen is that of the track bed, heavily shadowed; otherwise there is no visible ground, since the land on which the house is built is unseen. Hopper's commercial buildings—stores, gas stations, office buildings—join abruptly with

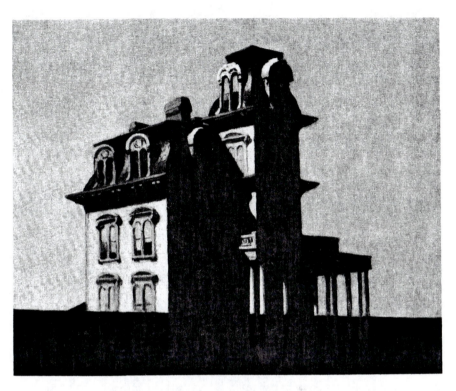

20. *House by the Railroad*, 1925
Museum of Modern Art, New York, given anonymously

streets and pavements in sharp symmetrical juxtapositions. Even
when his houses are placed on unpaved ground there is very little
shrubbery or landscaping effect, no delicate blurring of the distinc-
tion between the building and the land as is common in romantic
nature poetry and painting. In *Cape Cod Evening* and most of his
paintings of New England cottages, the house clashes rather than har-
monizes with the land on which it sits. There is no shrubbery, no
path or walkway, nothing to modify the sense of arbitrariness and the
unnaturalness of the house's location.

The house in *House by the Railroad* is a study in jarring contrasts.
The front of the house is obscured, and the side nearly faces us. The
building is further made to appear strange by the emphasis given to
minor and rather anomalous particulars, such as the red chimneys,
quite brilliant amid the surrounding grays, blacks, and soft whites of
sky and house, and a small, totally unidentifiable, triangle in the
lower left corner that seems to fuse the back corner of the house with
the railway track. These strange touches are characteristic of Hopper;
prominent spots of red and enigmatic black geometrical forms recur
in his paintings.

It is impossible to judge why Hopper likes to place something
bright red in pictures otherwise somber, dull, or prosaic. The red gas
pumps in *Gas* are unusually emphasized; they are large, almost pre-
cisely centered, and fully illuminated in the opposing context of
darkening blue sky and dark trees in the background and partially
cropped office, partially concealed attendant, and dull, pale-shadowed
pavement in the foreground. Here it is the red objects that are the
primary incongruity. Although more commonly the red object is pe-
ripheral and small, the redness still makes the object inappropriately
emphatic. In *Manhattan Bridge Loop* Hopper paints distant buildings
bright red and foreground buildings brownish gold; prominent dark
shadows of a foreground wall and a distant background building make
the whole perspective oddly complicated and unconventional. Small
red buildings may be more prominent than large ones, as distant
structures may be more emphatic than nearer ones because they are
darker. Many of Hopper's reds are gaudy, like the gasoline pumps and

the chimneys on the house by the tracks. Most of Hopper's women (especially the solitary ones) in coffee shops, hotel lobbies, apartment rooms, and train compartments wear red dresses. In *Carolina Morning* a haughtily postured woman in a bright red dress stands in the doorway of a shuttered building looking away from the monochromatic pavement, field, and sky that occupy most of the picture. Hopper's "scarlet women," all dressed as if for parties, have no place to go and look bored or anxious.

If red houses, clothes, chimneys, fireplugs, and barber poles are comically or pathetically ostentatious, the enigmatic black shapes like the mysterious triangle in *House by the Railroad* are sinister. They are an absolute black, mostly or partly concealed, and sometimes unidentifiable. At the top right of the line of shops in *Early Sunday Morning*, a perfect black square disturbs the horizontal symmetry of street, curb, sidewalk, shadowed lower story, red brick upper story, flat roof, and early morning gray sky. If the square is a portion of a background building, it does not look like one, for there is no apparent effort to create the illusion that the block is behind the row of shops. It looks like a square of black ink that has nothing to do with the painting of which it fills the upper right corner. But most often the black geometrical figures are recognizable, if obscurely so. Thus in *Hotel Room* in which a partially dressed woman sits on a bed reading a letter, the black square behind a chair and windowsill is presumably the dark night beyond the window frame, but one has to study it for a moment and even then cannot be certain. It may be a suitcase, like the equally black shape on the floor, which can be identified as a suitcase only because it is turned so that its three dimensions are revealed and a touch of brown (leather?) can be seen at the top. However, the black square, though fractionally a rectangle, minutely cropped at two corners, and probably formed by the night outside the room, is almost identical with the square in *Early Sunday Morning*. Hopper emphasizes the black shapes through the absoluteness of their blackness, their severe geometry, and their two-dimensionality that makes them appear first as geometrical figures. Sometimes the shapes are those of buildings, as that of the black sil-

houette in the lower right corner of *The Lighthouse at Two Lights*, but most often they are the blackness of the darkness seen when looking into interior doorways or outward from interiors. The black geometry is the absence of light given dimensionless form by architectural frames.

It is futile and probably irrelevant to speculate on the meanings of the enigmatic peculiarities of Hopper's paintings. The blatant contrasting reds and the stark geometrical blacks are two opposing forces in the paintings, two of the more dramatic incongruities. The red is clear, the black obscure; the red of human making, the black a nothingness, though, in the cases discussed here, ordered to the point of symmetry. Tempting as it may be to speculate on the fragility of human efforts to contain the inevitable darkness, itself made all the more menacing by its tidy and ironic geometrical shape, it is enough here to indicate only that these "signatures" are among Hopper's ways of stressing odd relations, disconnectedness, the strangeness of the familiar, the endless possibilities of seeing order in disorder and the reverse.

II. Windows, Woods, Space

The prominence of windows in Hopper's works contributes most to their atmosphere of mystery and potentiality, for his emphasized windows almost always carry the dramatic current of his paintings. They are the abrupt and focused points of contact between enclosures and free open spaces, and thus occasions of ironic juxtaposition by their very existence. The human characters in windowed scenes are self-preoccupied, oblivious of the outside realm available to the viewer, but the viewer himself is ignorant of whoever may be looking through other windows. Hopper's window arrangements play on the endless dramatic and ironic possibilities latent in the proximity of interiors and exteriors, of obliviousness and perception. The extravagances with windows make various avenues of vision the crucial subjects, even if the avenues are unused by the human characters in the paint-

ings. Thus it is often the abstract states of seeing and being seen, or potential vision and actual visibility, that are dramatized.

But to begin this commentary on Hopper's windows we must first observe that Hopper both makes windows especially emphatic and uses them in an original way. Windows are the dominant elements in most of Hopper's buildings; if he does not focus on a window or windows to the near exclusion of the rest of the building, he stresses their prominence in buildings fully represented. He does so by making them especially dark or especially light, hence contrasting with relatively muted walls. The windows are most often bolder than the houses that contain them. Sometimes a number of windows in a line may look different from each other, an effect easily gained by Hopper's making some open and some closed, some shaded, some partially shaded, and others bare. Thus the windows duplicate each other but are also dissonances in the monotony of the walls that hold them. It is important that hardly anyone uses windows in Hopper's works; the people inside do not look out, and people outside do not look in. The windows are existential, not functional. In paintings often dominated by windows, human figures, when they appear at all, seem unconscious that the windows exist. As a result the windows, large and emphatic, have an absolute identity that would be compromised were the persons to use them or even to notice them.

In some of Hopper's most frightening paintings, windows become eyes, especially when they appear to be looking into other windows. When viewed from a limitless vantage point somewhere outside—as in *House at Dusk* and *Rooms for Tourists*—windows seem oblivious of the exterior space before them, but windows seen through other windows seem to have depth, the capacity to focus, and even intelligence. When Hopper's window paintings are studied in chronological sequence it becomes apparent that as he refines the motif of windows seen through windows, the observed windows become increasingly more like active starers into the interiors in which the observer of the painting seems located. The only human beings looking through any of Hopper's windows are the observers of the paintings. In earlier

works the windows of the rooms containing our presence are mediums allowing us to see passive, predominantly neutral windows on exterior buildings; in later works the interior windows are mediums allowing the exterior windows to peer, or blankly stare, into the rooms we find ourselves occupying.

But even in the earliest paintings, windows are not totally neutral backgrounds, mere realistic components of the confining urban environment. Four paintings, spanning the years 1923 to 1952, manifest the direction of the preoccupation; they reveal the ever sharper emphasis Hopper gives to exterior windows in studies of solitary women in apartment rooms.

Apartment Houses, from 1923 (21), is, for Hopper, oddly playful, even comic. It reveals a rather fat maid making a bed. The viewer is outside the building, very close to a window that frames the maid, the corner of the bed she is arranging, some furniture, and another window. Two windows of a building only a few feet away to the right of the immediate building are seen—one through the two windows of the room with the maid and the other directly, beyond the corner of the immediate building. Our focus is directed, or rather divided, by the heavy vertical window frame bisecting the painting. Aside from the profile of the maid's face, everything is strongly angular, since we look downward from a position facing the intersection of the window and the corner of the building. The overwhelming color of the painting is light blue, in different shadings: the maid's dress and apron, the frames of both windows in the house in the forefront and of those in the adjoining one, and the outer walls of both buildings. The play on perspective heightens the comic effect of the plump maid in tight quarters. She is squeezed in a small room, and the window to her back nearly rubs against the window of the apartment building a few feet away. There is little menace here, only the improbable survival of softening domesticity amid urban confinement and impersonality. Because the windows in the neighboring house are more distant, partially obscured by the foreground wall, and (the one on the right) partially masked by curtains, they are slitlike, and thus, in contrast to the much larger and totally open forefront windows, a little sinister.

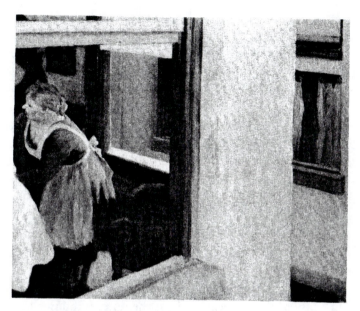

21. *Apartment Houses*, 1923
Pennsylvania Academy of the Fine Arts, Philadelphia, Lambert Fund
Purchase

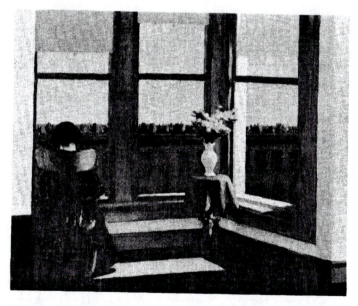

22. *Room in Brooklyn*, 1932
Courtesy of the Museum of Fine Arts, Boston, Charles Henry Hayden
Fund

The background windows are a slightly menacing touch in an otherwise innocent arrangement. The viewer, positioned in the unlimited space outside both buildings, is the detached and unaffected observer. He is amused, not troubled. As is unusual for Hopper, the fusion of exterior and interior conveys not discord but intimacy.

Hopper returns to the same general subject in *Room in Brooklyn*, 1932 (22). But here the viewer is inside the foreground room behind the back of a seated woman (on the left) and a table holding a vase of flowers (to the right of center) before three panels of a bay window. The window panels occupy most of the space of the picture. Through the windows we observe the top portion of a line of brick row houses beneath a cloudless pale blue sky. Our perspective here is not whimsically angular as in *Apartment Houses*, but starkly direct. The woman in the chair is viewed from a few feet behind. The woman, probably reading, assumes that she is alone. She is unaware of our presence, but also unaware of the other intruders: the outer windows looking in—at the woman, at us.

But as with *Apartment Houses*, the motif of unsuspected visibility, of the undetected impingement of exterior windows, is somewhat comic, though certainly sinister as well. As the plump maid is out of place in the cramped apartment further restricted by the nearby building, so is the prim woman in the delicate rocking chair seated before the row of tenement windows. The woman and the table with the vase of flowers share the forefront of the painting; they are a paired couple. (Indeed the table-vase-flower arrangement can easily be seen as a metonym of the woman.) Not only do they share the prominent space of the painting, with the table and vase actually nearer the center, but they have similar postures and shapes. Further, the blue cloth overhanging the wooden table essentially duplicates the woman's blue skirt draping over the wooden chair. These correspondences suggest an equation between the purely decorative function of the flower vase and the dark and self-concealing appearance of the woman; it is as though the flower vase were the woman's projection of herself—her self-exteriorization. As we regard the painting, the woman and the vase are arranged beside each other in the bay

window as figures stationed to be seen and as figures actually seen, both by ourselves and by the hooded windows in the background. The only purpose of the flower vase is to be seen, but its *being seen* is communicated as an indecency. The painting ironically plays on the unwanted and unrecognized accessibility of a quaint feminine gentility to an uncompromisingly utilitarian urban environment outside the tiny room. The large bay windows dissolve the implied illusion of the autonomy of the room. The title of the painting, *Room in Brooklyn*, precisely indicates its subject.

In *Morning in a City*, from 1944 (23), and *Morning Sun*, from 1952 (24), the illusion of exterior windows prying into the room containing the woman and the drawn-in observer is complicated and seems a more frightening violation of privacy and intimacy. In the first painting the woman is naked and stands in the center of the picture, facing the open window but not looking through it (a characteristic Hopper figure, she is thinking, unhappily, of something else); her bed, mostly sheets and propped pillow, is to her right. The movement from darkness to light is from right to left, primarily from the lower right corner (the blackness of the shadowed bedstead and floor, imperceptibly fused in lightlessness), through the dimly lighted sheet and rectangle of the wall, through the shadowed backside of the woman profiled against the darkened wall, to the sunlit front windows of the opposite building, which catches the rays from the morning sun to the left of the picture. The woman seems oblivious of any presence, including her own, but, in holding the towel before her body, appears defensive, protective, and yet vulnerable. The outer windows are quartered rectangles. Shades are halfway drawn, making the unshaded bottoms an absolute black—the black of measureless depth—and the halfway drawn shades are bisected by an equally black shadow. By the time of this painting Hopper seems to have realized that he could gain certain disturbing effects by modifying the illusion of depth; increasingly distant buildings and other scenes are made to seem closer to the windows through which they are seen. In the case of some paintings, including *Morning in the City*, they seem even something else than what they are. One illusion (the achievement of verisimilitude

through reduction of size and implied synecdoche—the windows of a building standing for a full building) diminishes, and another forms. The absence of foreshortening of the exterior window, the extreme two-dimensionality of the building facade, the domination of the building by its windows, the L-shaped blackness within the windows that makes these seem three-dimensional though the building containing them does not, the odd resemblance of windows, portion of building, and stubby chimneys to the top of some grotesque, eye-dominated head—these produce a surrealistic illusion emerging from and challenging the realistic illusion. Hopper's solitary women in their bedrooms, usually more or less naked, are especially vulnerable because they seem to feel safe. The woman in *Morning in a City* probably believes herself secure, though her shielding towel gives away her instinctive insecurity. The intruding sunlight provides the path of vision of the sinister windows, and the obscene, frightening quality of the picture is heightened by our sense that the windows have a more direct view of the woman than we do with our view of her shadowed backside and profiled front. The windows, of course, also see us. The woman is half sunlit, half shadowed, half defined by the outside, half by the inside. If, as suggested, the peering windows outside follow the sunlight in their line of vision so that both sunlight and windows are made to conspire in threat and menace, the same is subtly true of the interior darkness—the door, the bedstead, the unseen portion of the room at the defenseless back of the woman. Part of the effect of this painting is to reverse conventional associations, mainly those of light and interiority. Here is a bold variation of regular Hopper ironies: the demonstration that sunlight is not warming and softening, but ruthlessly exposing and harsh; that interiors are not safe and comforting, as curtains, door, and bed familiarily imply, but available to the exterior through windows and dominated by indefinite regressive spaces and planes of darkness in themselves.

Morning Sun is the final example of a painting of a solitary woman in an apartment room with windows revealing windows outside. Although less frightening than *Morning in a City*, it nevertheless contains tension. Sunlight dominates; indeed it produces a deathlike pall

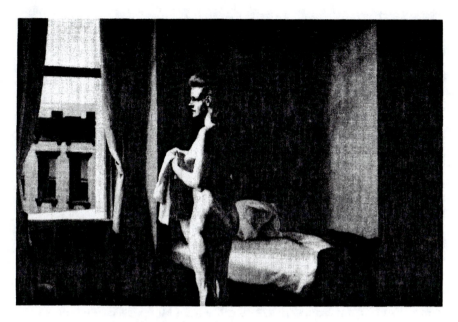

23. *Morning in a City*, 1944
Courtesy of Williams College Museum of Art, gift of Lawrence H. Bloedel

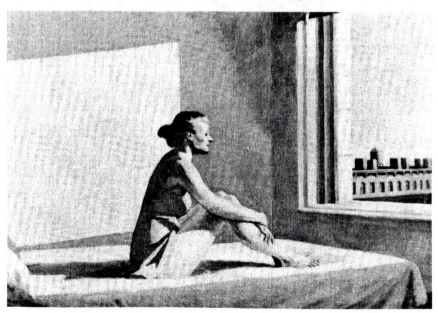

24. *Morning Sun*, 1952
Columbus Museum of Art, Ohio, Museum purchase: Howald Fund

on the woman in a red nightgown sitting on her bed, on the sheets of the bed, and, in a large tilted square, on the wall beside her. Even the interior shadows indirectly catching the light are a mild gray. The woman is mostly clothed, but securely clutches (thus defends) her bare white legs. She is distracted and impassive, but not so vulnerable as the woman with the towel. The role of the exterior windows in this painting also changes somewhat. A dozen or more small windows on the top floor of a neighboring factory are at a considerable distance from the foreground room. Since the exterior is mostly sky and the interior well lighted, *Morning Sun* is primarily a painting of light and space. Interior and exterior are both open and free; the room is not an unsuccessful separation but a fusion achieved through the accessibility of light through the window. But fusion is not harmony. If the crouched woman and the distant factory windows were removed, there would be a harmony—a harmony of nothingness, the condition of total lifelessness toward which Hopper's career seems to be leading him. But in *Morning Sun*, the subject of the painting is not all contained in its title: the tense, crouched woman sits on her bed as if it were a beach, in a room with nothing but a sheeted bed, a bare wall, a window frame, and a minute patch of brown floor; beyond the window is the distant factory, crowded with shadowed windows and chimneys, surmounted by the vacant sky. The woman suggests no rhythm or animation—few Hopper figures do—but some complexity, some finiteness and specificity only partially possessed by light. The factory windows and chimneys, though smaller because distant, have more presence than the woman, that is, more solidity, actuality, and power. Because of the focus given them by the window through which they are seen, and their two-dimensionality that subverts the foreshortened effects, we project in them vision. Since the distant windows appear tiny, the building containing them appears mainly opaque, light resistant. The sky above and the sun before illuminate the building without invading it. Further, the factory windows are invaders themselves, made through Hopper's illusionary trick to seem stationed as a miniature row of eyes just outside the interior window, almost within reach of the woman on the bed. The observer is the

audience of this static yet dramatic confrontation: of the enigmatic leering windows and the visionless (because preoccupied) woman.

Especially in the last three paintings of solitary women in apartment rooms, the impression of silence is very strong. A major reason must be that the intervening windows extend the obvious noise-lessness of the interiors to the areas outside the rooms, themselves normally not silent at all, though as seen in the paintings *apparently* silent. The illusion by which the interior silence is transferred to the exteriors is an achievement of illogic. The comprehensible silence of the interiors projects onto the exteriors—and thus onto the totality of the paintings—a somewhat incomprehensible silence. Thus through their silence these window paintings strongly suggest a metaphysical silence, a negative environment in which it is strongly felt that something essential is missing.

Likewise—again particularly in the last three paintings—the exterior silence is paradoxically associated with especially complex and active images, the window-eyes themselves. One of the reversals of conventional attitudes in the paintings is the representation of interiors as relatively free and spacious and of the external buildings as crowded together and congested. These external buildings reveal no interiors, only what appears as cramped, opaque, dense surfaces. These external buildings therefore seem attracted toward the vacancies of the interiors into which they peer.

In the four paintings of solitary women before windows facing other windows, there is the suggestion of terror. Ultimately it is terror that is one of Hopper's most important subjects; it becomes the essential effect of his silent configurations of light, rooms, buildings, people, windows, and wilderness (yet to be considered). All of these are joined with each other in Hopper's constructed world only with extreme discomfort and the probability of one's being dominated by one or more of the others. Hopper's terror consists of the fragile, the transient, the coherent, and the familiar being threatened by their opposites. Extremes of light and darkness overwhelm (or may overwhelm) color and form; exteriors master interiors; the nonhuman—buildings or forests—dominates the human. In this sense then, Hop-

per's paintings are about quiet, lonely, and obscure defeats, those which have happened, are happening, or are about to happen. The stillness is a melodramatic effect, but it is also a principal actor in the nihilistic drama, because silence is aligned to the always enigmatic force of imminent annihilation. Silence itself is an absence of something, and nearly all of Hopper's great paintings represent the approach or the presence of absence.

What draws us to the paintings of Hopper is his work with the artifacts of our culture—the buildings, rooms, and streets that vividly define our civilization. On the other hand, questions have been raised about both the effectiveness and the relevance of the nonarchitectural concerns of his work, notably the human figures and, to a lesser degree, nature. As previously implied, the human characters in Hopper's offices, bedrooms, and restaurants, mostly women, represent varying degrees of human remoteness and vulnerability. Whether we choose to speak of them as lonely, sad, or narcissistic, they are remarkably passive and impotent, prisoners of walls and playthings of light. They strike us as alien survivors, as stationary and expressionless as mannequins. They can also remind us of actors stationed by a theatrical director behind the lowered stage curtain before the first act of a play.

The place of nature in Hopper's work curiously alters over the course of four decades. In his early landscapes of Paris and Maine the artist is clearly influenced by French impressionism. His interest is mainly in optical effects: the blurring of details, the contrast of light and shadow. In the period from 1916 through 1918, when Hopper painted most of his landscapes and seascapes, the brushwork is heavy and seems rapid. The landscapes have a dynamism different from that of the better known urban scenes of later years; in the early work the drama is active, not latent, offering the fluid interfusion of trees and grasses as they are lightly stirred by breeze and sunlight. The seascapes of the same period reveal a similar interest in strong light effects, but they also reveal a fondness for massive solid structures. In the early phase it is coastal rocks that contain the qualities that Hop-

per would later give to buildings. The Cape Cod and Maine rocks suggest mystery, not the mystery within apparent clarity of the later geometrical paintings, but the mystery of inchoate shape and heavy concealing shadows. Neither the landscapes nor the seascapes of the early period are playful; to the contrary, they suggest the forbidding otherness of nature. The implied viewer of these scenes is nearly as much an intruder into prohibited territory as he more obviously becomes in the apartment rooms of later years. Hopper's nature is a foreign world; observing it we intrude into the unfamiliar, and we feel threatened by power and incomprehensibility.

In the twenties when Hopper concentrated on urban and suburban scenes, he seldom domesticated nature, that is, made it congenial to human notions of organization and beauty. His houses are rarely landscaped. The urban houses sit in concrete and the suburban and rural ones are placed mostly on barren soil; grass is patchy; shrubs and trees are sparse. The Cape Cod houses seem placed arbitrarily amid fields of dull yellow weeds. From the late twenties on, Hopper used nature in quite different, indeed opposite, ways: either as totally domesticated or as totally wild. Plots of grass are perfect carpets in *Hodgkins House* (1928) and *Sun on Prospect Street* (1934). However we also note in these two works the beginning of what is to become a major Hopper emphasis—the intrusion of trees as a dark, alien mass in the background of symmetrically designed and neatly arranged houses. Since Hopper's skies are nearly always of a single solid color, only the trees suggest the asymmetry of nature.

A relatively early work, *Stairway* (1925), forecasts the place of nature in some of Hopper's mature work of the forties and fifties. An anticipatory painting in other ways as well, *Stairway* places the viewer halfway down an interior stairway before an opened front door revealing what appears to be almost solid, dense woods—certainly "dark and deep," though more harrowing or oppressive than "lovely." The only qualities in the painting that distinguish it from similar subjects of twenty years later are the nearly direct point of view, the mostly conventional geometrical pattern, and the slightly blurred lines, of

staircase, door, and walls. Further, the woods function mainly as negation. The trees are so lacking in individual definition that they appear only as an obscure mass, a dark vacuum.

In some paintings, like *Early Sunday Morning*, Hopper achieves the same effect through shadowy squares and rectangles, not through organic presence. As Hopper develops he comes to use trees not as neutral background or as incidental contrasting instances of disorder, but as details of forests. The trees are mostly green, not black; they are seen both individually and collectively, only partially distinguishable from each other. These forests, lurking beyond windows or beside houses, are as alien to man as in the early landscapes, but they are threatening as well. Like the eyelike windows, they are sinister intruders, but their threat consists in more than espionage; it is a threat of inscrutable power.

Between 1939 and 1960 Hopper painted six major works dealing with the close proximity of dense threatening forests and oblivious defenseless houses. Human figures appear in some of these paintings, not in others. In each of the six paintings we find striking common elements: the sense of limitless depth in the dark green woods and the impression they give of leaning (even creeping) toward the houses; the whiteness of the houses; the fronts of the houses and the persons within or outside of them turned away from the woods and seemingly oblivious of them; and brilliant red coloring within or related to the white structures. The red objects are gaudy and trivial expressions of human gaiety; in paintings suggestive of doom they project absurdity and silliness, so that Hopper's irony verges on cruelty. In *Cape Cod Evening*, from 1939 (25), a man crouches and a woman stands in front of their house; the woman, her arms folded and a scowl on her face, seems angry, indifferent to the collie in the open field that occupies the ground outside the house; the man beckons toward the dog. The intruding forest forms a square, comprising almost exactly the upper left quarter of the picture. As with the forests in most of the paintings now under discussion, the pine trees reach forward toward the house—the tip of one branch actually crossing over the edge of the dormer window—and draw the eye backwards

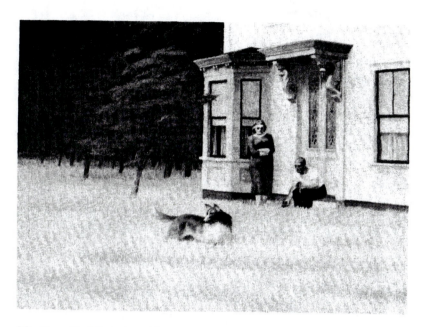

25. *Cape Cod Evening,* 1939
Courtesy of the National Gallery of Art, Washington, John Hay Whitney Collection

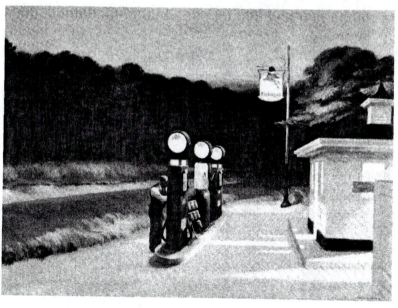

26. *Gas,* 1940
Museum of Modern Art, New York, Mrs. Simon Guggenheim Fund

into ever increasing impenetrability and darkness. The house, as in other paintings, is foolishly ornate, especially the window moldings and door cornices, but obviously fragile. The man, woman, and dog are each in their own way apprehensive, but apprehensive about the wrong things.

In *Gas*, from 1940 (26), the threat of forest is perhaps less extreme, because the line of trees is more distant and also on the other side of the road. The line of trees stands motionless, but its latent force is implied in its heaviness and darkness; its depth and impenetrability are in alliance with the approaching night, and thus make the strongest dramatic force in the painting. Here the human figure, both partially concealed and dwarfed by the bright red, theatrical-looking pump, is turned away from the woods and alone in a desolate scene. The white office seems a hollow shell; the pale driveway seems a clean beach fronting the narrow road. The parallel rows of orange grass on each side of the road suggest the opposing camps in a battle about to be fought. If the forest is massed potency, the gas station is formal, conceited impotency—the gas pumps immobile and rigid as busbyed grenadier guards before the prim little office with its lookout cupola perched on the roof—a child's toy version of a frontier fortress. The Mobil flying red horse hangs high on a pole, a parody of a defiant flag. The station attendant, wearing vest and tie, making the final tidying adjustments in his first line of defense, presides over a small, immaculate outpost of progress in a wilderness.

Other paintings continue this basic pattern, some focusing on the comic or satiric implications of the forest-building contingency, some on the terrible. What is always present is dramatic expectancy, a silent indefinite pausing before a doom that the eye anticipates, though the mind and even the imagination cannot conceptualize. Woods, after all, do not attack houses. But the concrete dramatic tension of these paintings is too powerful for us to want to reach for symbolic equivalents. We should not seek to make intelligible these forces of strength and weakness that Hopper has rendered so lucidly in their unintelligibility.

In *August in the City*, from 1945 (27), the structure facing the

aligned trees on the other side of a road is a considerably more for-
midable fortress than in *Gas*. Rather, at first it is made to seem for-
midable. Since we see only a side of a large corner window and half of
a door beside it, the building's size is unclear, but the thickness of the
walls and the nearness of our point of view suggest largeness as well
as strength, as the turreted corner and elaborate gothic door cornice
indicate that the apartment building is an imitation castle. Further,
the red table cloth, though almost the precise center of the picture, is
both small and subdued by shadow, and thus not such an absurd con-
trast to the woods as are the gas pumps. The statue inside the room is
mostly concealed from us and, more important, from the trees. Actu-
ally everything relating to the defensive structure superficially sug-
gests its impregnability, everything except the large windows—which
make the solid, deep, and wrongly positioned door to the far right
irrelevant—and the exposing light. Unlike the light on the gas sta-
tion, this whiteness is external, from the sun. It is directed like a
searchlight funneling across street and pavement to the rounded sur-
face of the building, exposing the openness of the windows, the flim-
siness of the curtains, the sense of inappropriate decoration and bar-
ricaded anxiety amid the interior clutter.

Seven A.M., from 1948 (28), is probably the most sinister of the
paintings in this grouping. In contrast to the earlier forests, the massed
trees here are very close to the white building but abnormally, perhaps
even unrealistically, dark to be seen from such close range. Even the
nearest bare tree trunks are hardly detectable amid heavy shadow. The
drugstore, truly a deathly white, is total facade. Compared to the
bright showcase window containing but a clock, two small posters,
and four small bottles, the interior seems empty, irrelevant, and so
small as barely to exist at all. By its brilliant external whiteness, in
sharp division from the forest, this building is made to appear solely as
surface. The clock is the center of the painting, the converging point of
four diagonal lines: one leading downward to the lower right along the
reddish brown side of shelving within the store to the picture on the
poster in the window; one following the intersection of the pillar and
cornice to the right corner of the right upper window; one indicated by

a line from clock to the silhouetted ledge leading into the lighted trees
at the upper left; one passing from clock through the bases of the three
foremost trees in a trapezium of black. As center of everything, the
clock faces precisely in the wrong direction (as do the animate figures
in *Cape Cod Evening*), looking away from what we recognize to be the
locus of energy in the scene.[9]

Little needs to be said about *Second Story Sunlight*, from 1960
(29), another version of white house–green forest confrontation. The
house is prim, stilted, and sharply angular: its opaque front windows
and side window of abstractly layered squares manifest its hollow-
ness. That the visible portion of the house is a second story and that
the man and woman on the porch are as wooden and artificially posed
as figures in newspaper ads—and of course, look away from both
woods and sun—all heightens the sense of fragility and vulnerability.
The dominant structural line of the painting is a diagonal running
from lower right to upper left—from base of dark forest to ludicrous
red chimney, from tangled dark obscurity to childlike clarity. That
the tree branches themselves parallel the central diagonal whereas
the twin triangular roofs of the house bisect it makes the trees appear
true and the house false, the trees natural and permanent, the house
artificial and transitory. The "sunlight" of the title, like many of Hop-
per's sunlights, illuminates to annihilate the flat white surfaces of
the house, but the deep woods are impenetrable.

9. The clock and the time it registers, precisely seven o'clock, give the painting an
obvious melodramatic urgency; they make it impossible to disregard the tension of the
painting caused by the contingency of the invulnerable and the vulnerable. In many of
his works Hopper is not only very careful in indicating the times of day and the seasons
of the year in which his situations are observed (his titles often specify these), but he
favors those times, such as dawn and dusk, when human activity is least evident, or—in
terms of the dramatic situations of the paintings—least threatening. Thus the buildings
in *Gas, August in a City*, and *Seven A.M.* are seen mostly as undefended. Particularly in
Seven A.M. one may be tempted to consider time as the theme of the painting. Surely
time—along with its close associations with process, transience, decay, and death—is in
close alliance with the powers of nature embodied in the forest, just as the fragile build-
ing is in fact a short-lived rather than permanent structure, as it was probably intended
to be. But this kind of interpretation of the painting, while consistent with the dramatic
situation that it represents, is unnecessary and too restrictive. The kind of nihilism evi-
dent in Hopper's more mysterious and frightening paintings defies rational and moral-
istic definition.

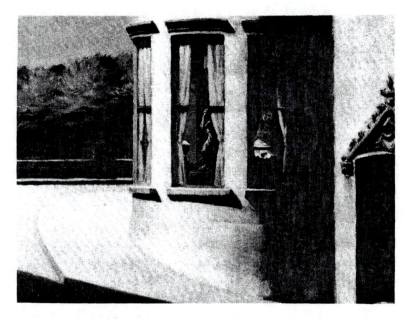

27. *August in the City*, 1945
Norton Gallery and School of Art, West Palm Beach, Florida

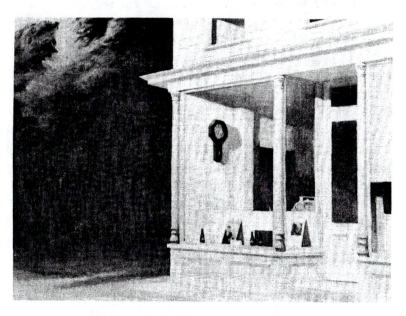

28. *Seven A.M.*, 1948
Whitney Museum of American Art, New York

Sun in an Empty Room, from 1963 (30), seems to represent the situation of *Second Story Sunlight* from inside the house. It is probably Hopper's barest, most silent painting; there is room, window, forest, light, shadow, and nothing else. Its silence and emptiness completely achieve what many of Hopper's other works hint at or anticipate—the complete annihilation of human life. Put another way, *Sun in an Empty Room* is Hopper reduced to his essence, rather achieving his essence. The painting tells us what "to be" means to the artist. If the direction of his career and the story of each painting is the process of stripping away, here is the painting in which there is nothing left but light, space, and nature. It is revealing that Hopper retains nature, though it is nearly excluded from this painting. The thin rectangle of woods is the discordant element in the painting, and since the window through which we see it is the medium of the sunlight that enters the room, the view of hovering forest becomes ontologically associated with the perfect austere and abstract geometry. The painting represents a baroque irrational causal identification of the mystery of wilderness with the clarity of pure coherent design. Without human presence, the conventionally accepted subordinate and intelligible relationship between light and wilderness dissolves. The relationship becomes the absolutely dominant one and beyond comprehension.

It is impossible to ascertain whether the human figures in Hopper's later works are intentionally lifeless, but a few things are clear: that Hopper in his youth painted convincingly real portraits and human bodies, that the "realism" of his nonhuman structures is undeniable, and that the general theme of Hopper's work is antihuman. It is appropriate that the people look so lifeless, whether or not they are made so intentionally. His human beings are dwarfed and menaced by the buildings they have erected; in contact with sunlight, shadow, and forest they are overmatched. In the works focused on here, they are not just puny but are about to be annihilated, sometimes placed on, in, or near houses about to be obliterated. Sometimes, as in *Gas* and *Seven A.M.*, the focus is on the houses that are about to be annihilated. *Sun in an Empty Room* represents not immi-

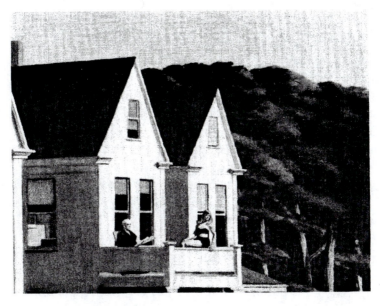

29. *Second Story Sunlight*, 1960
Whitney Museum of American Art, New York

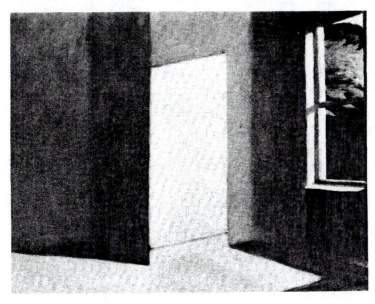

30. *Sun in an Empty Room*, 1963
Private collection

nent annihilation but nothingness, or a situation as close to nothingness as Hopper wishes to achieve—a state of existence controlled by the discordant complicity of light, shape, and shapelessness. Hopper has eliminated human beings, and made the elimination obvious by doing away with the beds, curtains, and pictures usually found in Hopper interiors. All that he chooses to retain of the animate are the forest and the process of vision itself.

Visual process is the dependence of eye on light rays, and in *Sun in an Empty Room* as in another late painting, *Rooms by the Sea* (1951), the exchange is abstractly conducted through windows and doors (seen and unseen). Voyeur once more, the observer is in the presence of pure light transference. We are more than ever intruders in an alien world, but this totally nonhuman one is a world whose own penetrating powers far exceed our own.

More obviously than in any other painting, the silence of *Sun in an Empty Room* is both negative and positive. As Hopper strips away people and objects in his works, the sense of silence intensifies. Simplification makes us more conscious of silence—of silence as an unnatural absence. But this precise absence, this severe emptiness, is also the oppressive content of the painting. No painting better manifests "the magic power which transforms the negative into being." In *Sun in an Empty Room*, we discover what silence really is—that is, nothingness—and so we learn why it terrifies us.

Epilogue

ALTHOUGH none of the following passages bears directly on either America or silence, they may direct attention to the major philosophical and aesthetic issues that have consistently engaged me in this study of silence in American art.

We have art in order that we may not perish from Truth.[1]

. . . she found herself, for the first moment, looking at the mysterious portrait through tears. Perhaps it was her tears that made it just then so strange and fair . . . : the face of a young woman, all magnificently drawn, down to the hands, and magnificently dressed; a face almost livid in hue, yet handsome in sadness and crowned with a mass of hair rolled back and high, that must, before fading with time, have had a family resemblance to her own. The lady in question, at all events, with her slightly Michelangelesque squareness, her eyes of other days, her full lips, her long neck, her recorded jewels, her brocaded and wasted reds, was a very great personage—only unaccompanied by a joy. And she was dead, dead, dead. Milly recognized her exactly in words that had nothing to do with her. "I shall never be better than this."[2]

Here we face the astounding paradox of what is called Dante's realism. Imitation of reality is imitation of the sensory experience

1. Friedrich Nietzsche, *The Will to Power* (London, 1910), 279. Vol. XV of Oscar Levy (ed.), *The Works of Friedrich Nietzsche,* 18 vols., trans. A. M. Ludovici.
2. Henry James, *The Wings of the Dove* (New York, 1909), 220–21. Vol. XIX of *The Novels and Tales of Henry James,* 24 vols.

of life on earth—among the most essential characteristics of which would seem to be its possessing a history, its changing and developing. Whatever degree of freedom the imitating artist may be granted in his work, he cannot be allowed to deprive reality of this characteristic, which is its very essence. But Dante's inhabitants of the three realms lead a "changeless existence." And still more: from the fact that earthly life has ceased so that it cannot change or grow, whereas the passions and inclinations which animated it still persist without ever being released in action, there results as it were a tremendous concentration. We behold an intensified image of the essence of their being, fixed for all eternity in gigantic dimensions, behold it in a purity and distinctness which could never for one moment have been possible during their lives upon earth.[3]

From my early commentary on Edgar Allan Poe's "Silence—a Fable" through my final words on Edward Hopper's *Sun in an Empty Room*, my contention has always been that the art of silence is an art of extreme concentration. It is an art that seeks essences, just as its opposite, an art that gives expression to the usual noise and commotion commonly associated with modern realism, must partake of the superficial, even of the misleading. In the characteristic art of Agee, Evans, and Hopper, human life itself is often a superficiality. Hence life is explicitly eliminated in Agee's long passages that detail the clothing and the houses of the sharecroppers, in Evans' photographs of cars, streets, and houses without people, and in Hopper's paintings of deserted houses and stores.

In citing Nietzsche's idea that art protects us from "Truth," I mean to suggest that "Truth" is the totality of incoherent energies and activities that always surround us. An art directed toward or even absorbed in silence effects a release from the directionless acceleration that Henry Adams especially recognizes as one of the most maddening conditions of recent history. The incident in *The Education of Henry Adams* in which the author purchases what is putatively a

3. Erich Auerbach, *Mimesis*, trans. Willard Trask (New York, 1957), 166–68.

sketch by Raphael is a minor but deceptively relevant event in which he dodges, however uneasily and unsuccessfully, the destructiveness of pointless time itself. The art of silence intensifies and perhaps exaggerates the inclination of much literary and visual art to be static and still. This exaggeration is especially obvious in those works of Agee, Evans, and Hopper wherein transitory and functional things like overalls, automobiles, and stores are represented as though they were timeless icons. In this sense then the recurring paradox of the art of silence is a version of the traditional paradox of still life painting in which the mutable is rendered as immutable. Of course in the instances of modern realism that concern me, the mutable is inorganic rather than organic. The distinction between an apple and a 1930 Ford automobile points sharply to the distinction between traditional art and the modern realism considered here. Yet an automobile by Walker Evans has much the same kind of classical formality as a pear by Cézanne.

In the passage from *The Wings of the Dove* Milly Theale achieves an overwhelming, even transcendent, self-recognition through observing a Bronzino portrait of a long-dead woman who bears a close physical resemblance to her. The precise stillness of the painting, its very "deadness," brings home to Milly those essential, if ambiguous, private qualities that under the circumstances compel a detachment from the cavortings of a group of English socialites at a country house festivity. This achievement is in fact not far removed from such fictional works as "Big Two-Hearted River" and *A Death in the Family*, wherein static physical phenomena, like the bank of a river or the corpse of a father, are apprehended by fictional characters both as "real" and as "art." The characters in the stories give to the objects they observe the same wondrous attention that Milly gives to the Bronzino portrait. Also, in each case there is an almost involuntary release from the usual urgencies of motion, conversation, distracting sound (that is, any sound), and especially the casual use of thought itself simply as a means of provisionally responding to the affairs of the moment. The result is an approximation of a transcendental experience. The photographs of Walker Evans and the paintings of

Edward Hopper represent not just a logical but an inevitable elabora-
tion of the imagination of the silent objects that these crucial fic-
tional experiences so emphatically detail.

Auerbach's commentary on *The Divine Comedy*, though it ana-
lyzes a work whose theological assumptions have no place in modern
realism, astonishingly suggests the kind of effects that we especially
notice in the works of Agee, Evans, and Hopper—the amazing syn-
thesis of the most lucidly and recognizably "real" with the condition
of eternity. Realism obviously cannot attain this nearly rarified effect
without a strong atmosphere of silence, nor without a silence that
penetrates with utmost urgency into the consciousness of the reader
and observer. The physical silence, the simple absence of noise and
motion, becomes a metaphysical silence. In some works of fiction,
like *A Death in the Family*, the characters themselves reach this con-
sciousness, and in some works of visual art, like Evans' street scenes,
the observer attains the perception, even as he may realize that the
ephemeral subject of the photographs would logically rule out any
relation to the eternal. But in Evans' photographs of children in *Let
Us Now Praise Famous Men* there is no contradiction between the
transcendent effect of the image and the worth of the subjects. In
their stilted poses these persons achieve nothing less than the "fame"
of immortality. On the other hand, in the later paintings of Edward
Hopper, the empty and threatened rooms and buildings come very
close to attaining the eternity of nonbeing. With their vast differ-
ences—in medium and in attitude toward their subjects—Agee, Evans,
and Hopper are preeminently artists of silence. Their dedication to
apprehending the world in silence gives to their art a spirituality that
nearly transcends realism itself.

Index